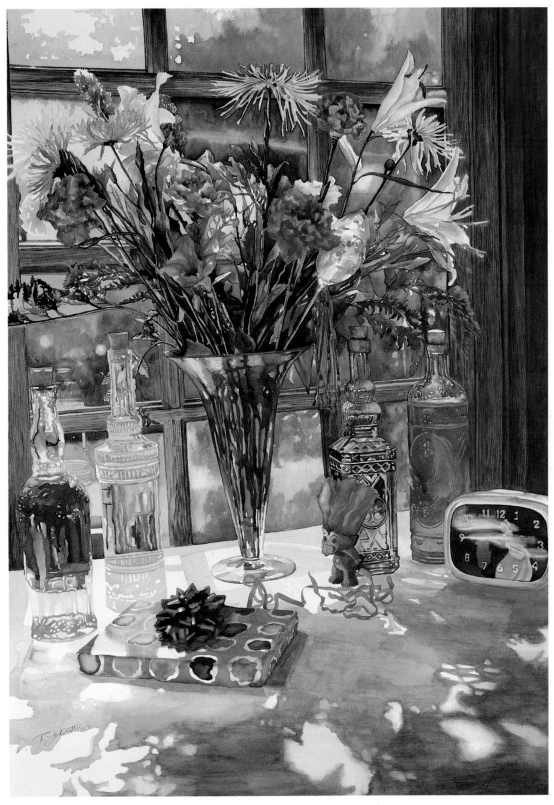

TROLL BANQUET
Teresa Starkweather
40" x 30"

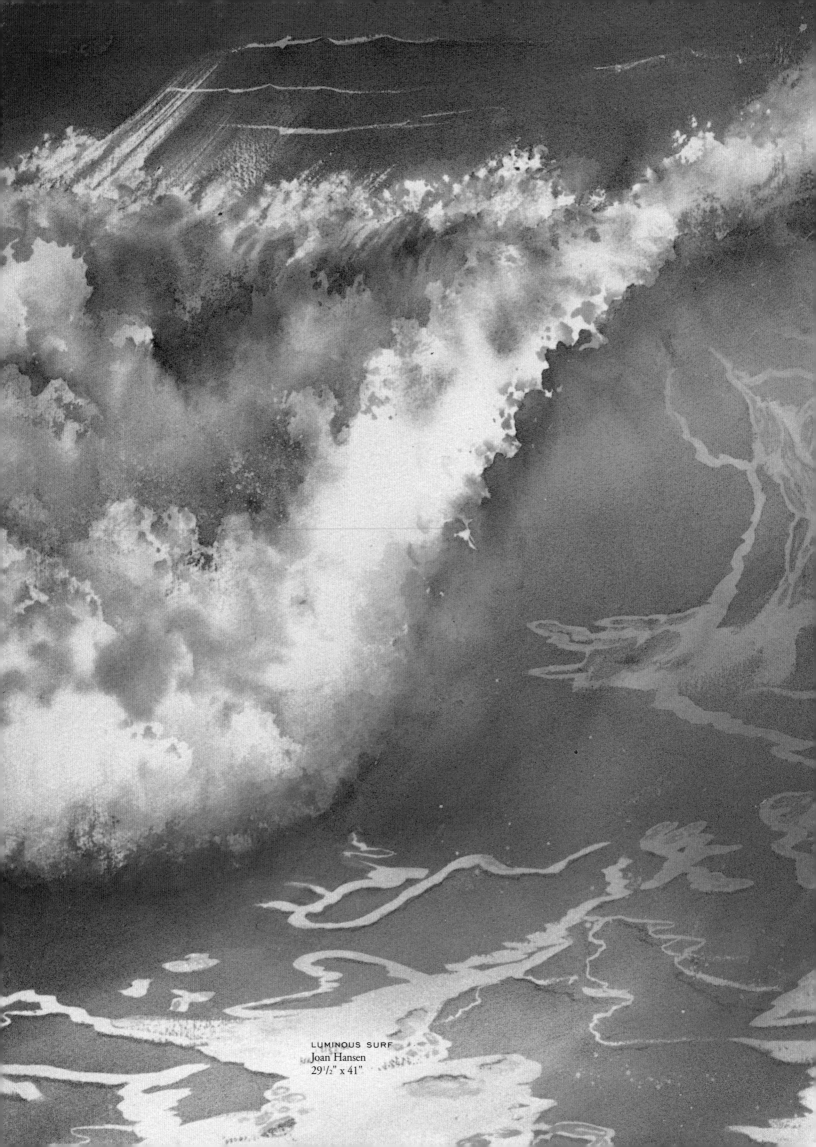

LUMINOUS SURF
Joan Hansen
29¹/₂" x 41"

splash 4

The Splendor of Light

Edited by Rachel Rubin Wolf

NORTH LIGHT BOOKS
CINCINNATI, OHIO

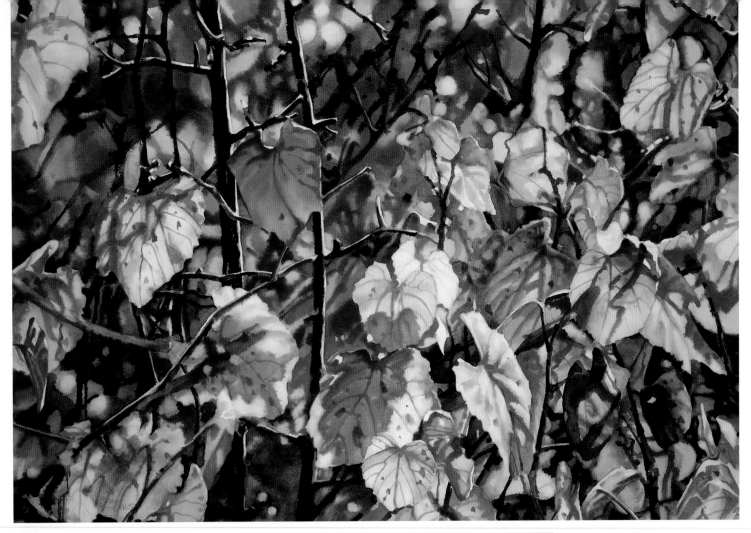

ONE RED LEAF
Karen Frey, 22" x 30"

Thanks to all the wonderful editors at North Light and designer Sandy
Kent. But we couldn't do it without all of you splendid artists who so
graciously send us your slides and offer us your hearts so generously. Thank
you for enriching our lives. Let your light shine so we can continue to
celebrate the splendor of light together.

Other fine North Light Books are available from your local bookstore, art supply store or direct from
the publisher.

00 99 98 97 96 5 4 3 2 1

Library of Congress Cataloging-in-Publication Data
Includes index.
 1. Watercolor painting, American. 2. Watercolor painting — 20th century — United States. I. Wolf,
Rachel. II. Title: Splash four.
ND1808.S66 1990 90-7876
759.13'09'048—dc20 CIP

ISBN 0-89134-349-0 (1), ISBN 0-89134-503-5 (2), ISBN 0-89134-561-2 (3), ISBN 0-89134-677-5 (4)

Edited by Rachel Wolf
Designed by Sandy Conopeotis Kent
Cover art: *Three Giant Russians,* 30" x 23," by Claire Schroeven Verbiest.
The permissions on page 138-141 constitute an extension of this copyright page.

North Light Books are available for sales promotions, premiums and fund-raising use. Special editions
or book excerpts can also be created to specification. For details, contact the Special Sales Manager,
F&W Publications, 1507 Dana Avenue, Cincinnati, Ohio 45207.

METRIC CONVERSION CHART

TO CONVERT	TO	MULTIPLY BY
Inches	Centimeters	2.54
Centimeters	Inches	0.4
Feet	Centimeters	30.5
Centimeters	Feet	0.03
Yards	Meters	0.9
Meters	Yards	1.1
Sq. Inches	Sq. Centimeters	6.45
Sq. Centimeters	Sq. Inches	0.16
Sq. Feet	Sq. Meters	0.09
Sq. Meters	Sq. Feet	10.8
Sq. Yards	Sq. Meters	0.8
Sq. Meters	Sq. Yards	1.2
Pounds	Kilograms	0.45
Kilograms	Pounds	2.2
Ounces	Grams	28.4
Grams	Ounces	0.04

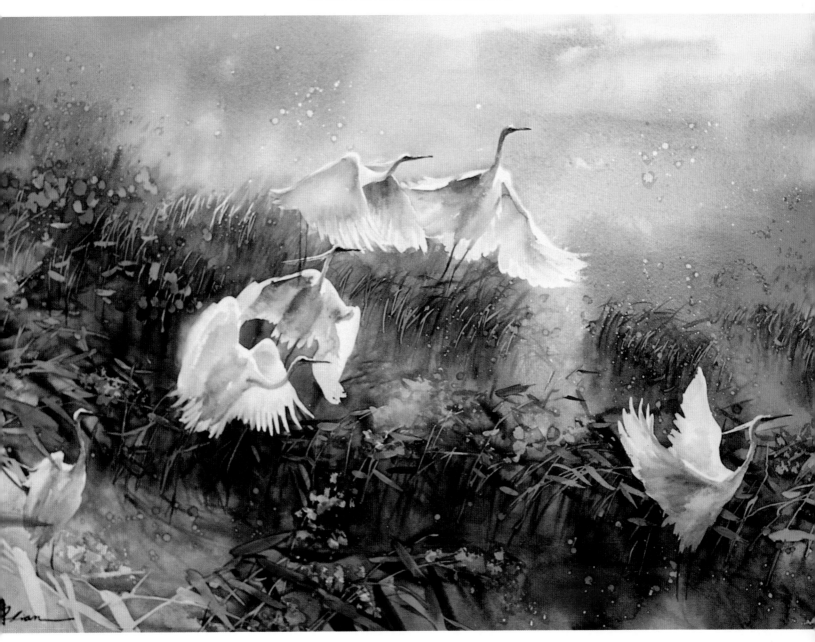

#1 MORNING FLY
Quan Zhen, 21" x 29"

Table of Contents

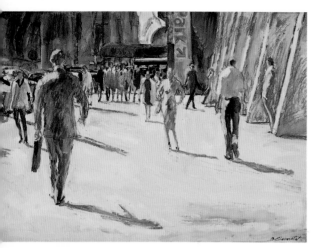

PART ONE

A Celebration of Sunshine...12

Catch those spectacular fleeting moments when the sun lights up the scenery, like raising the curtain on a stage play.

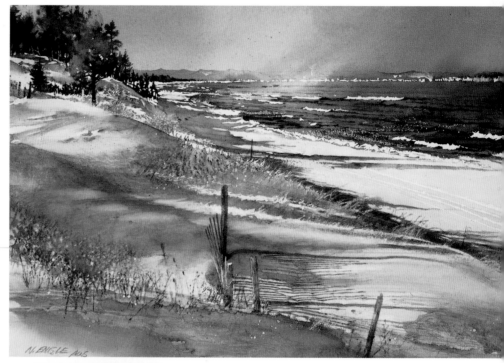

PART TWO

Setting the Mood with Light...46

Awaken to the emotions light can impart to your painting, from life's dark mysteries to its brightest moments.

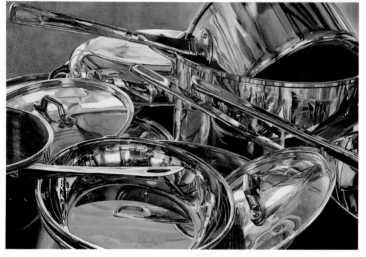

PART THREE

Design Your Painting with Light...68

Enjoy the fascinating patterns that are created, whether geometric or organic, by the partnership of light and shadow.

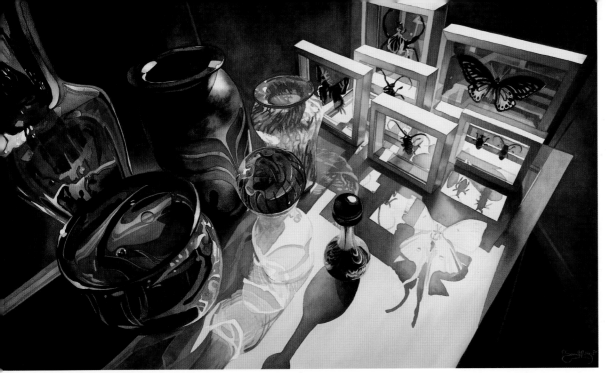

Illuminate your painting with light emanating from within or by a symbolic light, expressing your thoughts or feelings.

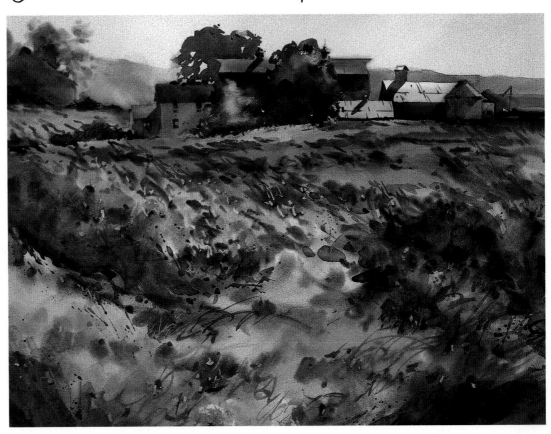

Harness the power of light to transform an ordinary subject into something exciting, tender, or even mystical.

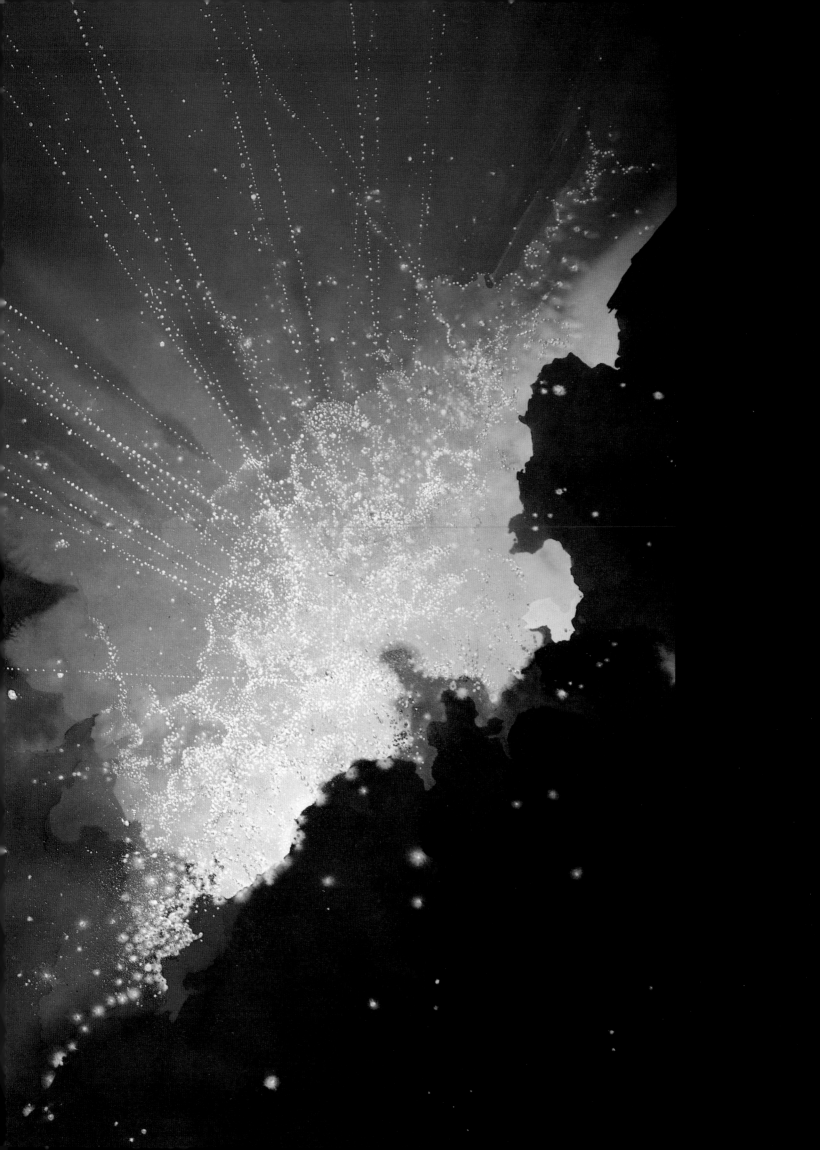

IN THE BEGINNING GOD CREATED THE HEAVENS AND THE EARTH.

NOW THE EARTH WAS FORMLESS AND EMPTY AND DARKNESS WAS

UPON THE FACE OF THE DEEP . . . AND GOD SAID, "LET THERE

BE LIGHT" AND THERE WAS LIGHT. AND GOD SAW THAT THE LIGHT

WAS GOOD —GENESIS 1:1-4

ORION GALAXY
Gayle Denington-Anderson
44" x 27½"

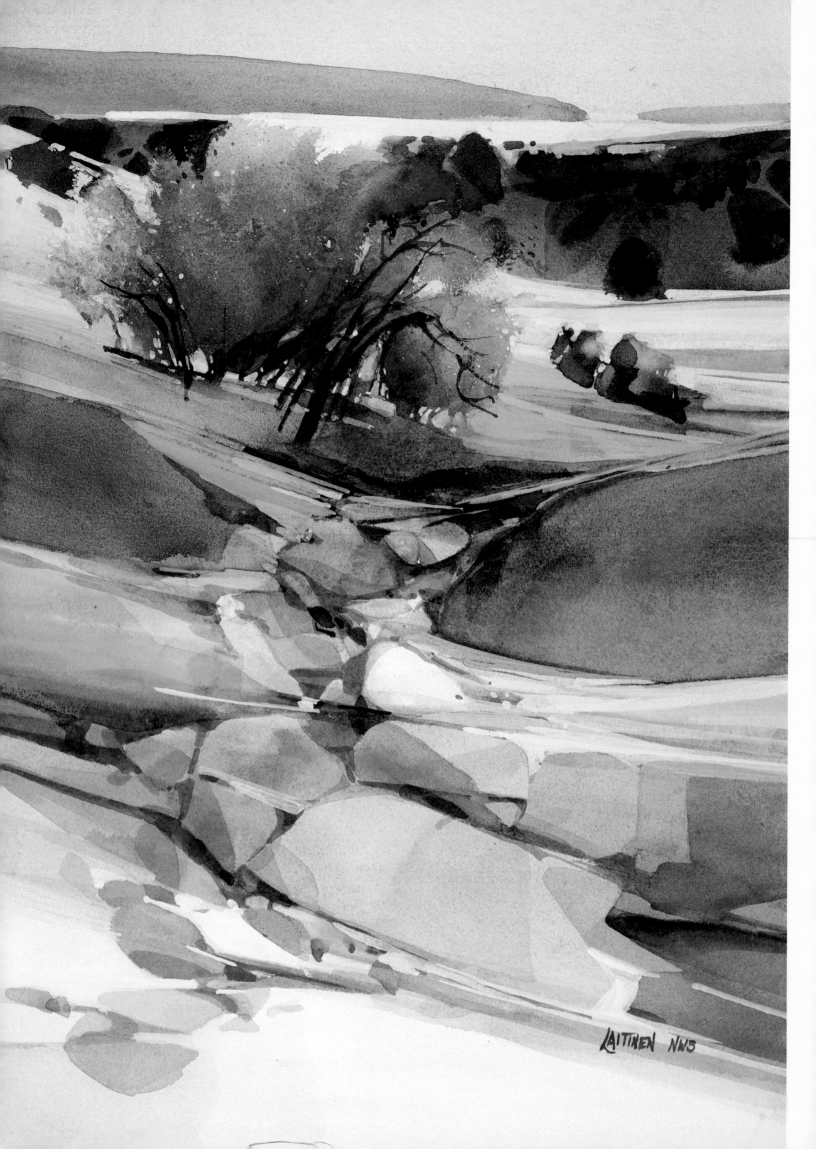

LAITINEN NWS

Introduction

Light. By its grace we comprehend our world. By its beauty we discover wonder. We are enlightened by its illumination, stunned by its beauty, astonished at its sheer power. We have known it all our lives, yet it remains one of the true, utter mysteries.

All of the artists in this book echoed in their writing that same sense of wonder at the splendor of light. So unanimous was the sentiment, I actually had to edit it out in most cases, simply because it would have been too repetitive for the reader.

But we are agreed . . . light is the reason to paint, the cause for celebration. Robert Reynolds says, "Light in all its forms may be the single most important tool available for an artist to express mood and drama in a painting. It has been used to symbolize knowledge, truth, goodness and, foremost, spirituality. It is an enormous resource for an artist to utilize during the painting process." Joan Hansen reminds us, "To the watercolor artist, paper is light. By carefully painting around the light, and subtly juxtaposing dark and mid-values, the artist creates drama and life."

Our theme, the "Splendor of Light," seems to have hit an inspirational nerve. We received a wealth of wonderful entries—too many by far for this volume. It is clear that, no matter where the future of art is headed, we will always gasp at the awe-inspiring magic light works on our world.

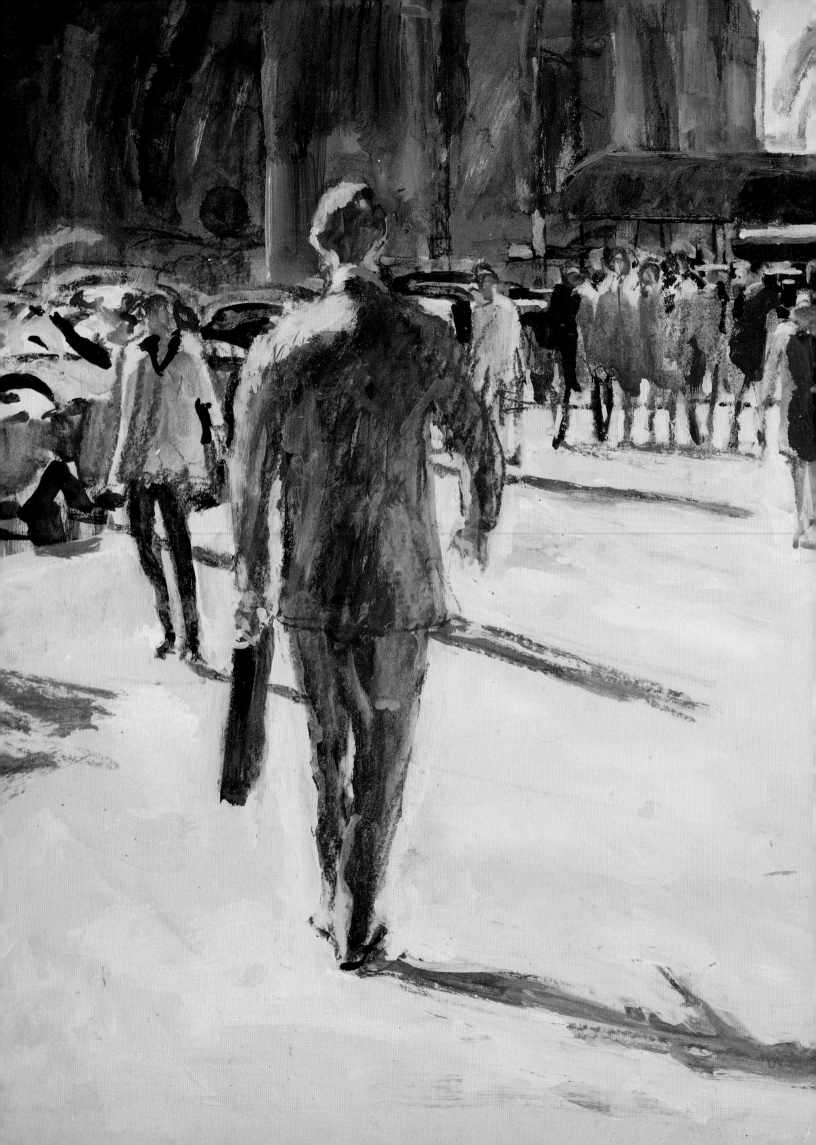

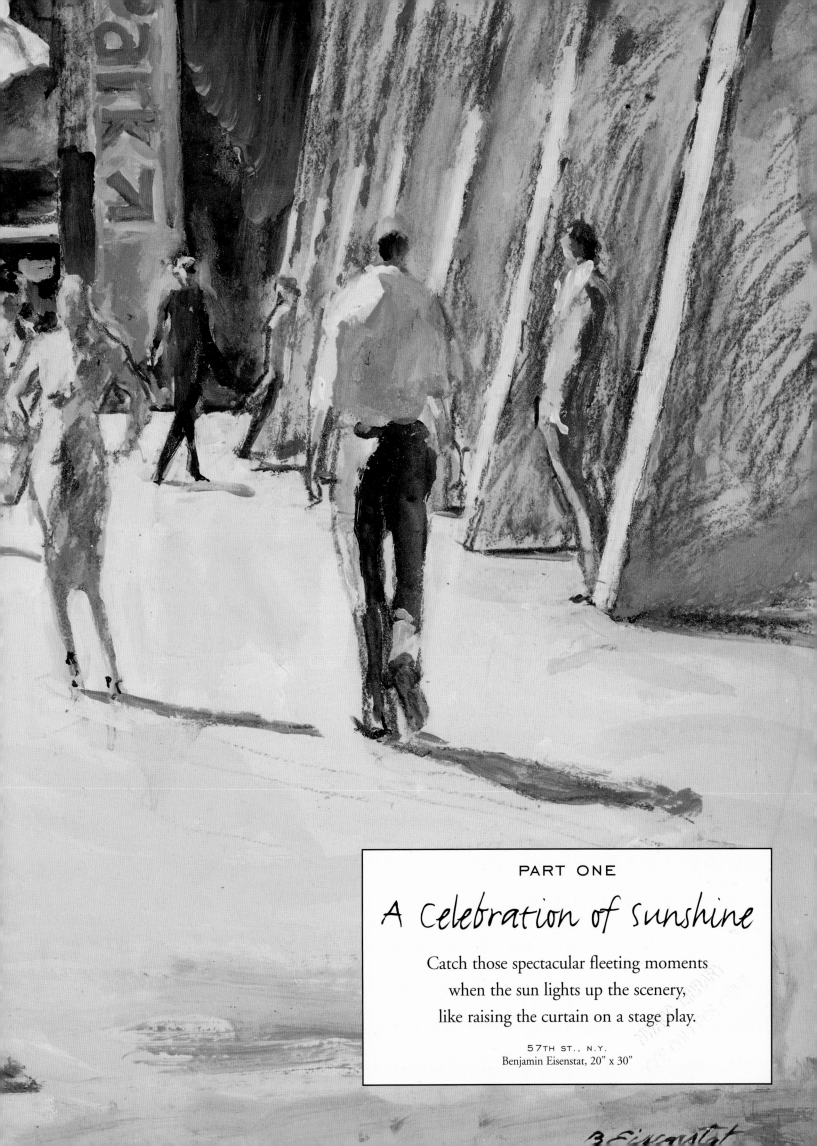

A Celebration of Sunshine

Catch those spectacular fleeting moments
when the sun lights up the scenery,
like raising the curtain on a stage play.

57TH ST., N.Y.
Benjamin Eisenstat, 20" x 30"

Light Triumphs After the Storm

MARY LOU KING

"Titan Triumph" is an expression of that fleeting moment when a smile of light touches the terrain after the dark clouds of a thunderous, flashing rainstorm have passed. Color is reflected light that our eyes process, and the two cannot be separated. It is through color and light that the incredible, often unexpected, beauty of the landscape can be explored in paint. When you watch the light play over the landscape, the colors change constantly. It looks soft and seductive, then it looks harsh and frightening. It's the same land, only the light has changed.

TITAN TRIUMPH
Mary Lou King
22" x 30"

"Titan Triumph" is done primarily in transparent watercolors. Working with underpaintings and glazes to achieve richer transparencies, King first applies layers of strong, vibrant, warm colors and then subdues them with cool glazes. In the shadows some pigmenting colors are used.

Try a Sponge for Backlit Leaves

LOREN KOVICH

The effect of light on Montana's landscapes is a constant source of inspiration for dramatic paintings. That's why I always bring my camera along on my floating and fishing trips. I like high contrasts in my work and when I saw the backlighting in this scene near the Missouri River I knew it was one of those "have to do" paintings. Besides the challenge of the light coming directly at me, trying to capture the feeling of a warm late afternoon was incentive enough to do this painting in watercolor.

MISSOURI RIVER AFTERNOON
Loren Kovich
22" x 30"

The sky and foreground shadows were done wet-in-wet. To get the effect of the light coming through the trees I used a small natural sponge, painting the yellow sunlit leaves first, then the green shaded leaves. When the leaves were totally dry, I used a liquid mask on them so that the cliffs in the background could be painted right over the trees. Three glazes were used to get the cliffs dark enough.

Let Your Paint "Drift" to Get a Feeling of Movement

WILLIAM H. CONDIT

I painted this transparent watercolor on location approaching the mountain town of Georgetown, Colorado. On this particular mountain a dark rain cloud appears almost every day. The light on the mountain constantly changes as the cloud moves in and passes the sun. Then everything suddenly lights up in the moment shown in my painting. It is like raising the curtain on a stage play. The houses at the base of the mountain seemed to "turn on" as the cloud passed allowing the sun to break through. The colors on the wet mountain intensified my use of strong color.

SUN AND RAIN ON THE MOUNTAIN
William H. Condit
21" x 13⁷/₈"

I wet the area where I'm going to apply pigment and allow it to drift down on the paper. It is controlled by the amount of water and pigment in the brush. This drifting effect, when dry, gives the area a feeling of movement. Transparent watercolor is meant to "flow" . . . thus the drifting cloud.

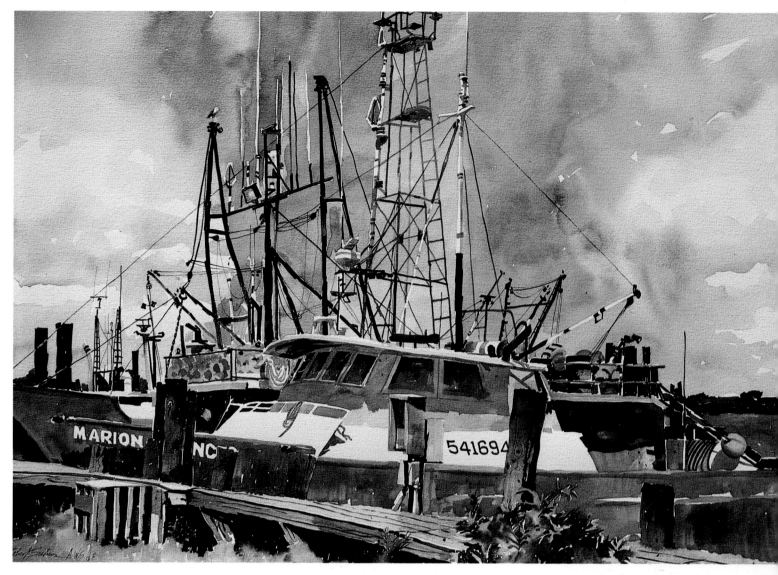

Work on Location to Feel the Excitement

ROBERT SAKSON

Whether the brilliant sun of the New Jersey shore or the sun filtered through the windows of an old building or shop, light is the absolute "power source" that sets a mood and involves the viewer. All of my works are done on location. If I cannot finish a painting in one sitting, I return at the same time each day until the work is completed to capture the same lighting conditions. I concentrate on a strong relationship between lights and darks, leaving the white of the paper for my strongest sources of light.

"Marion Francis," a no-frills painting, was done at the fisherman's dock in Barnegat Light, New Jersey. It is a "thinking" painting with no gimmicks. I concentrated on the excitement of these boats going to sea for weeks at a time on a wide open ocean, and the feel of the sun and the wind as she sits at the dock in readiness for the next trip "outside."

MARION FRANCIS
Robert Sakson
22" x 30"

I do loose contour drawing, with enough latitude left for plenty of painting. Paint is mixed directly on the paper, working wet areas where needed and leaving dry areas of paper for crisp edges. There is no use of any masking fluids or masks.

Feel the sparkling, Blinding Maine Light

JUDI WAGNER

In "Monhegan Lighthouse", the challenge was to hold on to the mood of brilliant day, exhilarating air, and the mystery of shadows that explain shapes. The main attraction of this scene at the Monhegan Museum (or Lighthouse) was the sparkling, blinding light on a very special clear day in Maine. There was a strong emotional pull to catch this time of day with its brilliant sunshine slamming into the building. The contrast of the darks on the foreground building and cast shadows over the shape of the boat added mystery and challenge. But it was the crackling sense of light that really grabbed me, so I wanted to make that dominant.

MONHEGAN LIGHTHOUSE
Judi Wagner
22" x 30"

To express the impact of the strong light I left a large portion of the white paper, keeping marks on that area to a bare minimum. I flooded in the sky with clear water, and then blues, deliberately keeping it fresh and spontaneous like the mood I was trying to capture.

Catch the Glow of sails Upon the Water

DAWN HEIM

Natural sunlight is by far my favorite source of light. It reveals underlying colors that you don't see on an overcast day, or by artificial light. Probably because my own life is so hectic, I lean towards painting serene subjects that allow me to escape within my painting. It is really important to me that I convey to the viewer the same feelings that inspired me to paint the image.

In "The Ghost of the Yankee Clipper," it was the spellbinding effect that the tropical moonlit sky had against the sails and the water. The sails had a glow of their own, and their reflection seemed to dance upon the water.

THE GHOST OF
THE YANKEE CLIPPER
Dawn Heim
21" x 29"

I prefer not to use masking fluid. I paint around the white areas instead. When I need a soft edge I apply the pigment with one brush and use a separate brush for water. This gives me a clean transition. Each consecutive layer is applied the same way. I sometimes will paint up to twelve layered washes to achieve the depth I desire.

Interpret Nature's Timeless Beauty

ROBERT REYNOLDS

In my home area in central California, I am captivated by the late afternoon light that strikes the coastal region, thrusting dark and light patterns of shapes onto the masses of land and water below. Caressing the face of nature with light has become a significant concern in my work. The celebration of our special and necessary alliance with nature benefits all of us. The artistic interpretation of its timeless beauty continues to be my principal objective . . . and pleasure.

RED HORIZON
Robert Reynolds
37" x 27"

Placing the sun within the composition forced me to relate all the forms to the radiance of this single light source. The sky was done by a number of wet-into-wet intervals, each time waiting until the previous paint was dry. Facial tissues were used to soften many of the cloud edges as they were drying.

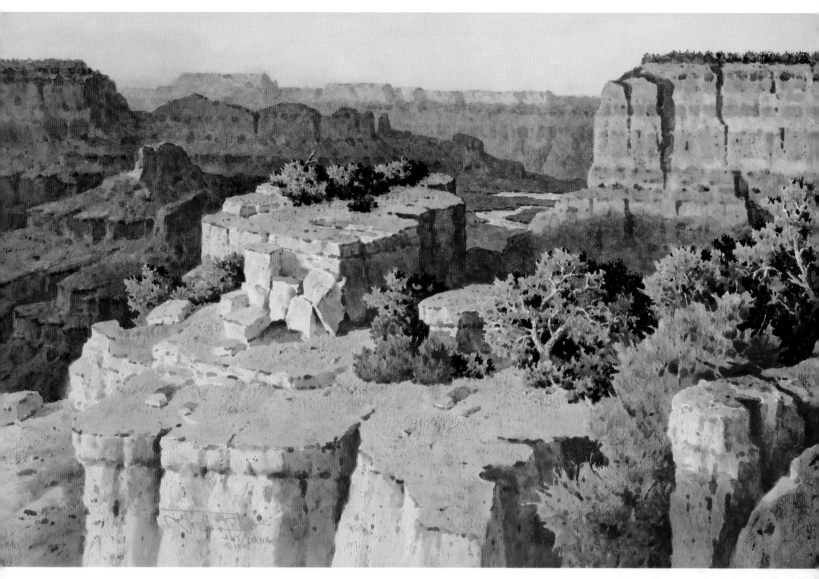

sketch on site to Capture a Dramatic Scene

JOSEPH BOHLER

Joaquín Sorolla y Bastida (1863-1923), the famous Spanish painter, once said, "Light is the life of the subject it touches." As I sat one afternoon on the South Rim of the Grand Canyon and painted a small watercolor of this scene I saw light bring the canyon to life. I again became aware why most landscape painters prefer early morning and late afternoon. The enhanced colors of golds in the light and blues and purples in the shadows convinced me to paint this larger, more complete painting.

OCTOBER GOLD—GRAND CANYON
Joseph Bohler
22" x 30"

"October Gold—Grand Canyon" is a transparent watercolor painted on Arches, cold-press 444-lb. paper. Dry brush was used to suggest texture and detail on the rocks and trees. I used several hogs' hair bristle brushes for scrubbing certain areas that needed to be softened such as the edges of the rocks in the foreground.

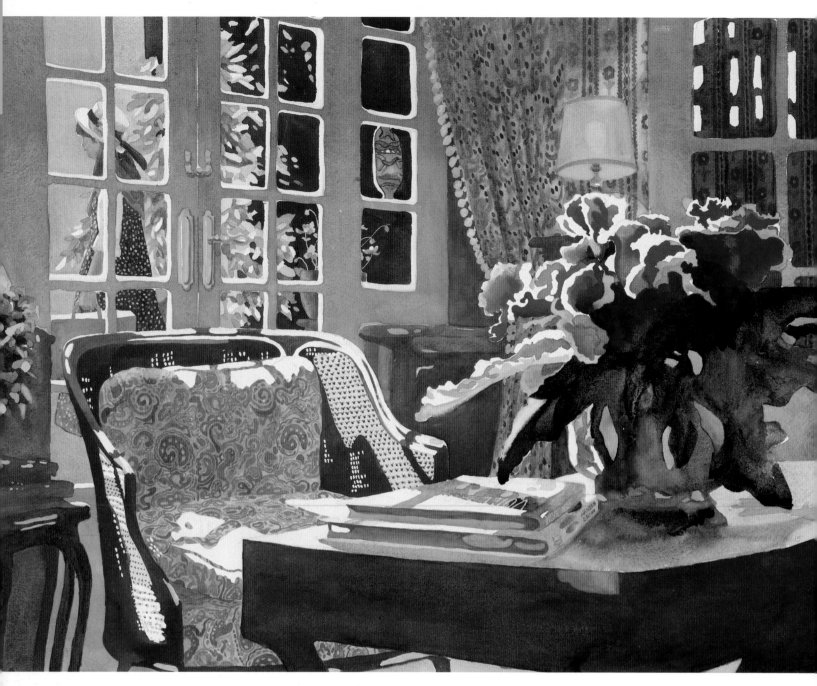

Appreciate Natural Oppositions

PATRICIA HANSEN

The shadows falling across the paisley print fabric of the chair captured my attention and imagination when I first viewed this room. The rich darks contrasted by the intense sunlight brought to mind the fact that there must be opposition in all things. In order to appreciate the light, there must be dark. To make a wonderful red, there has to be a dull green.

"From Her Garden" incorporates these contrasts to create a place one would feel comfortable entering. The darks make it feel cozy and comfortable whereas the lights invite one to enter and enjoy what the room has to offer.

FROM HER GARDEN
Patricia Hansen
22" x 30"

I painted around the whites rather than using resist except on the wicker parts of the chair and in the pattern on the woman's dress. All the prints in the room were painted first, then glazed over to unify the patterns.

RED SHAWL
Cheryl Campbell
30" x 22"

I first work wet-into-wet letting pale colors run together, saving the light areas. I do not use black but layer pigments to create rich darks. For the rusted surface of the metal pitcher, I sprinkled table salt on the slightly dry paint. For the rough wood grain on the chair, I applied small amounts of paint to the paper and glided them over the surface with a dull paring knife.

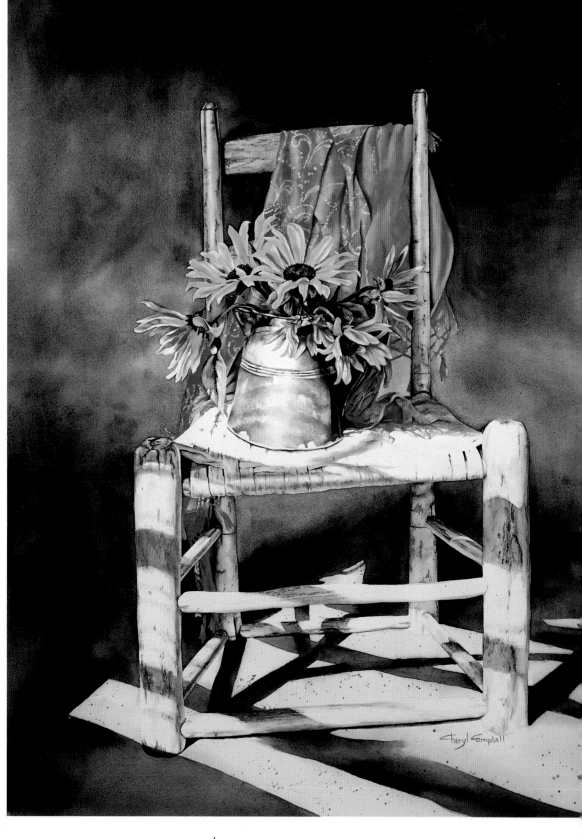

Recognize Your Golden Opportunities

CHERYL CAMPBELL

A celebration of sunshine after a week of rain! The somber clouds finally moved aside and the sunlight streamed through a window creating golden bars in the dark room. Light and contrast instantly captivate my attention. This was my golden opportunity. I placed my chair in the shafts of sunlight, added a bouquet of sunflowers, draped my shawl over the rungs and voila!

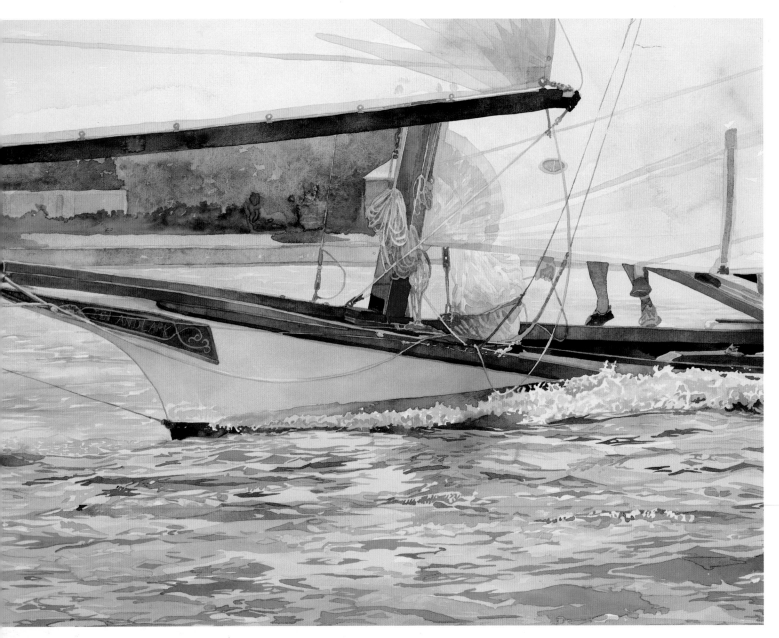

Celebrate the Transient Light of Sails, Boats and Water

MARC CASTELLI

This painting is about the qualities of light found on sailboats in mid-afternoon, on a river. Being an artist/sailor has enabled me to see and paint racing sailboats in a unique way. The intimacy of participation provides me with opportunities to experience the marvelous light that cascades down through the sails, reflects off the water and creates numerous visual effects. When light shines on the sails, they become beautiful reflective surfaces. When the light comes through the sails, they become a glowing surface of wonderful transitions from shadow and shade to translucence. All this time the sail stays light in value, yet dark against the sky. This visual tension is also present in the white hull against the bright background. Escaping the "light-meter" constraints of a camera is a must in order to play with the transient light of sails, boats and water.

LARK LIGHT/ISLAND LARK
Marc Castelli
22" x 30"

Once a drawing has been established, light is pulled from the paper. My first colors are wet, light in hue, and are distorted by blotting, pouring, throwing, flooding and tilting the surface. It is from this glowing piece of paper that the subject is regained by careful painting to the drawing.

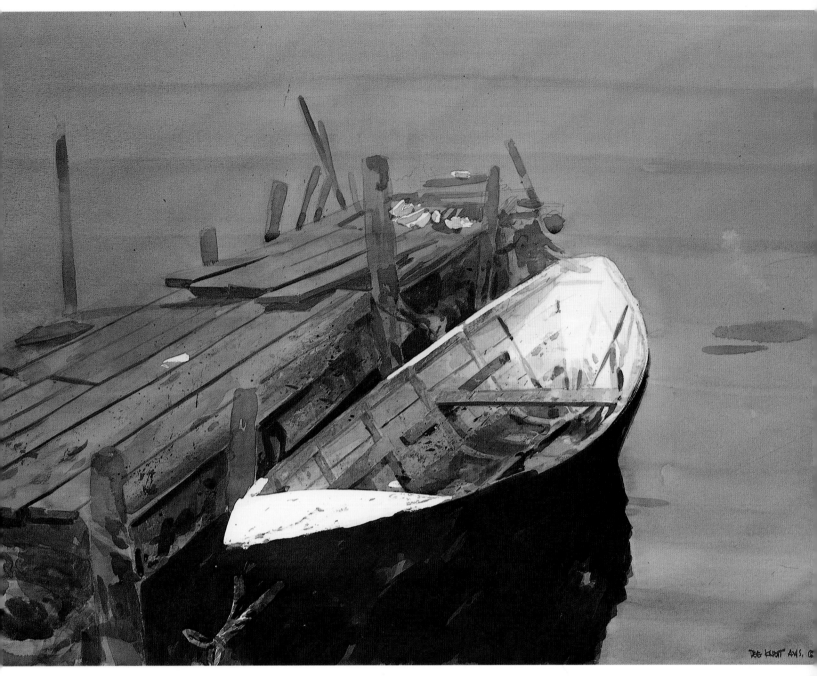

Softened Light Filtered Through the Mist

DEE KNOTT

My morning hike along the shoreline uncovered pure excitement. While I was observing a small dory nestled alongside a well-worn dock, the early morning sun came out behind the fog and, suddenly, in a matter of moments, the beautiful dory was drenched with patterns of light. The light filtering through the mist rimmed the small wooden boat of juniper and, upon seeing the light interacting with the dory, I was overwhelmed with chills of inspiration.

DORY
Dee Knott
23" x 31"

I left the white of the paper untouched in crucial areas by using masking fluid. I rarely use it but since this painting required a multitude of layers and washes, I felt on this occasion it was necessary to avoid restricting the freedom of my brushstrokes.

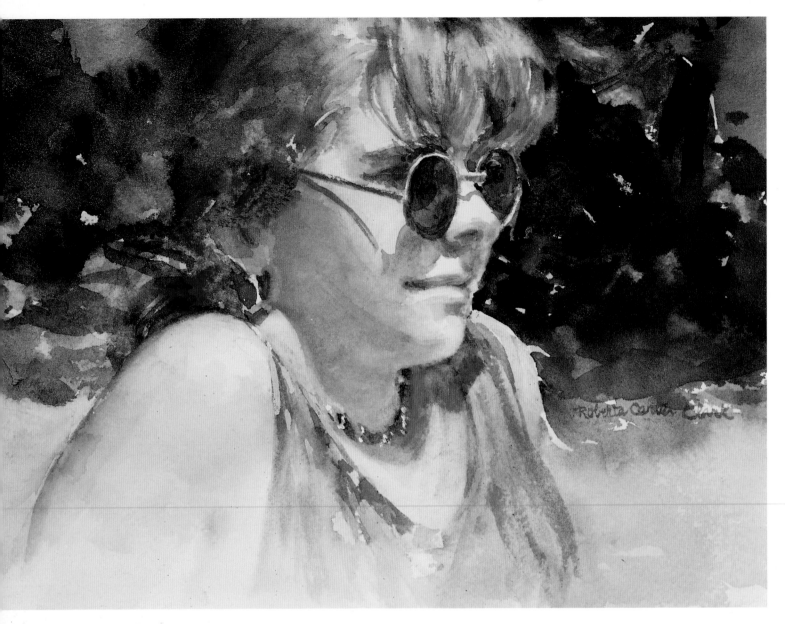

Watch for the Way Light Falls on Things Around You

ROBERTA CARTER CLARK

I'm a person who loves light—lots of it—I don't even like curtains on my windows. For me, the way the light falls on something can be reason for making a painting. While I was teaching a workshop at the Pocono Manor Inn in August, I noticed Molly, the lifeguard, watching the children at the pool. Her fair skin actually shone in the strong sunlight and the dark pines behind her intensified this glow. But it was the unusual blue sunglasses and the shadow pattern they cast upon her bright cheek that made me want to paint her. Fortunately, one of my students had her camera ready and snapped Molly's picture for me quickly.

MOLLY IN BLUE GLASSES
Roberta Carter Clark

I floated the Cobalt Blue of the glasses into the shadows on the face and, to emphasize this color even more strongly, I repeated it in the bathing suit and the trees. I kept the edges razor sharp where I wanted you to look, and the other edges diffused, making those on the face appear even more crisp. There are tiny touches of white gouache in her necklace and the rim of the glasses on the far side.

I like to vary my color on virtually every brushstroke. After completing the underpainting on a soaked sheet of watercolor paper, I dry the surface with a hair dryer. Subsequent washes are then applied on the dry surface while the back of the sheet is still wet. The moisture in the paper allows time to fuse brushstrokes of similar value while varying the color. Hard edges are maintained where needed.

Vary Your Color on Every Brushstroke

MARK LAGUE

The single thing which has always compelled me to paint is a strong desire to paint light. My chief concern as a student was to render a convincing representation of the light as I saw it. Now I primarily work from value studies done on location. The study for this painting was done on an overcast day. I have learned to rearrange, edit and invent light shapes to strengthen my work, but my passion for painting light has remained as strong as the first time I picked up a brush.

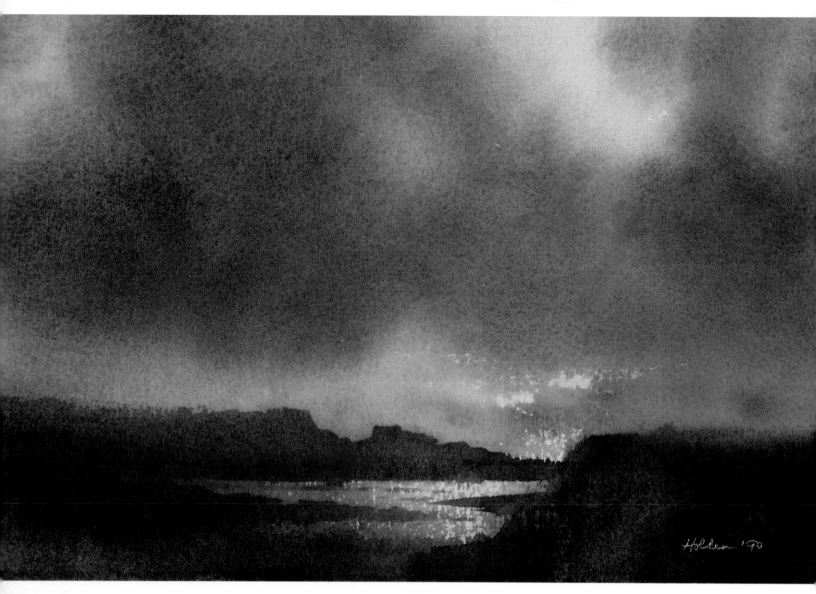

Paint the shadow side of Light

DONALD HOLDEN

Leonardo da Vinci (1452-1519) said "Shadows are areas of lesser light." Shadows aren't mere darkness; they're filled with subdued light and subtle color. This painting is a study of the shadow side of light. The storm is just ending and the sky is brightening. I was really trying to paint two kinds of light: the luminous shadow shapes and the fragments of brighter light breaking through between them.

Studying Turner's many unfinished watercolors—his so-called "color beginnings"—I was amazed to discover that he often painted the light before he painted the forms in the picture. He toned the paper with the colors of the prevailing light in the landscape. Then he painted the details of the picture, allowing the light to shine through. I followed a similar process.

MENDOCINO STORM I
Donald Holden
7¹/₂" x 10³/₄"

I first toned the entire sheet with a golden wash of Yellow Ochre—with an occasional blur of pink or blue. This all seems to disappear but the underlying "color beginning" fills every inch with its delicate light. This is most obvious in the wet-in-wet sky and the flash of light on the water.

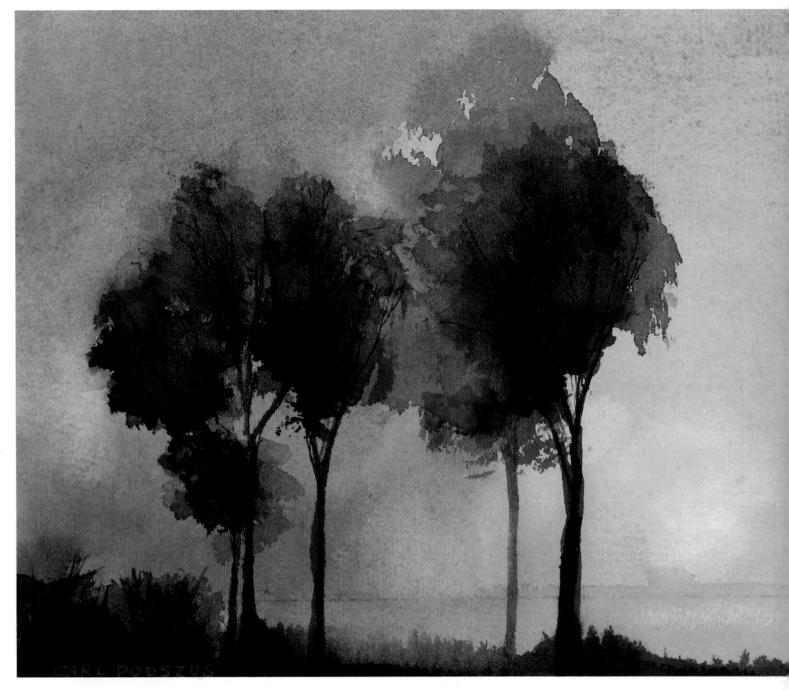

Discover the Golden Light of Italy

CARL PODSZUS

I had been travelling in Lombardy, driving from Milan to Padus on a painting trip that would take me to Venice. While breakfasting, I witnessed the sun breaking across Lake Garda. For years I have been obsessed with the golden Italian light, the same light that charmed the artist Perugino, and became a trademark of his famous pupil Raphael. What particularly entranced me about the scene before me was the dramatic light. The focal point was highly illuminated, but quickly melted into an enveloping background, with warm light filtering through the trees along the shore. I love to paint in the early morning and early evening when the buildings, trees and landscape are lit up like stage settings.

FIRST LIGHT, LAKE GARDA
Carl Podszus
8" x 10"

My travel sketchbooks are different from the papers I use in the studio. The paper in these books are a blend of cotton and synthetic fibers that prevents the paper from swelling and buckling when wet. This was a direct sketch done on site.

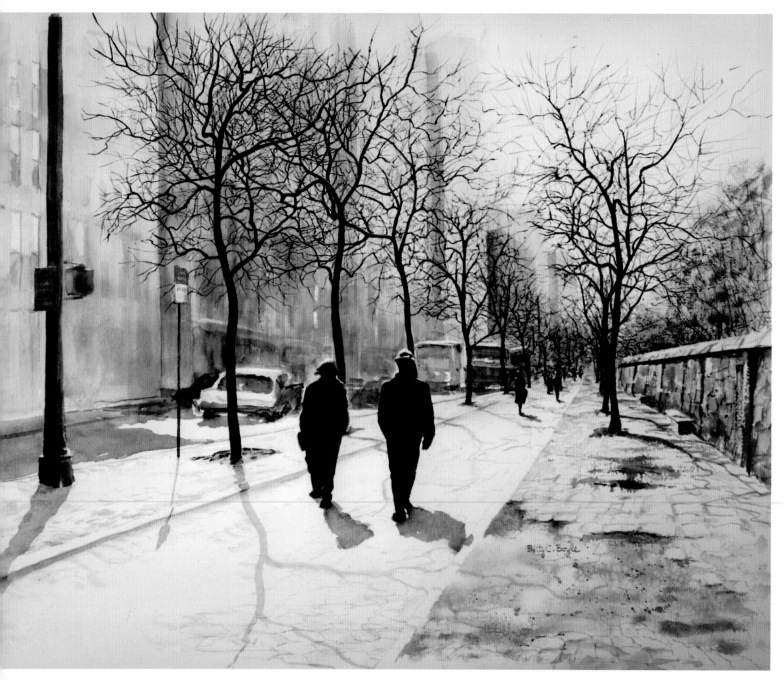

Look Into the Sun for Impact

BETTY BOYLE

Something within me makes me try to capture a subject I've seen. On a crisp morning in the city of New York, that "something" caught my attention as the bright early sun cast the strong shadow patterns across the scene before me. I snapped many photographs into the sun (which the rules say not to do), giving impact to an average city street scene, bringing on that urge to paint it.

MORNING IN THE CITY
Betty C. Boyle
24" x 28"

On heavy cold-press paper, I began with a loose, very light sketch. I then masked out the halo effect that backlighting creates on figures and other highlighted areas. Working traditionally with light to darker washes, I tried to keep the luminosity throughout. When the underpainting was complete, I broke another rule. With a brush already filled with shadow color, I touched the tip into India ink. This whisper of black accented my darkest darks to give me the contrasts which first caught my eye.

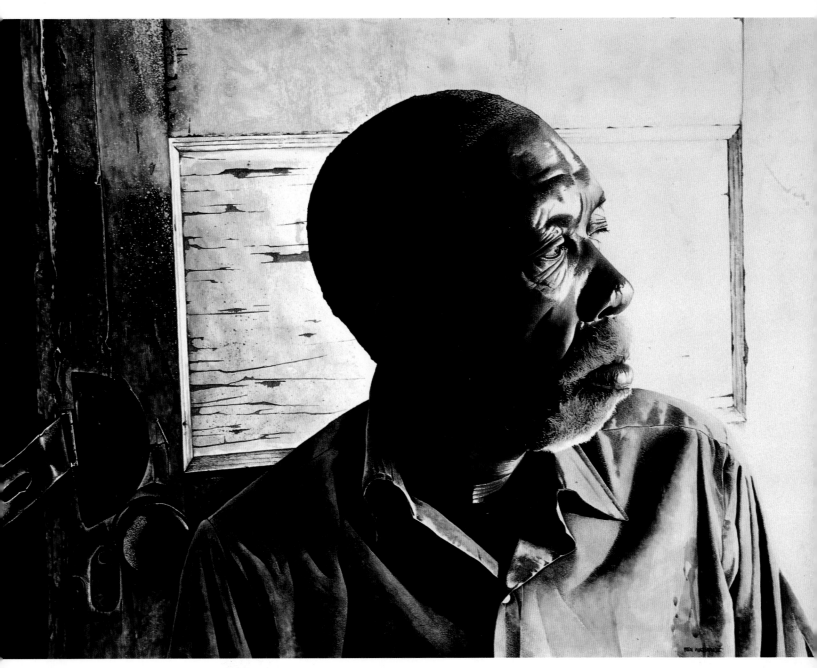

Light Gave Import to the Moment

BEN WATSON III

Light can change the mood, shape and importance of everyday people and things. I consider light my creative partner. In the painting "Beyond Our Dreams," it was the light that brought my attention to just how important a moment it was. It turned an ordinary conversation into a mental image that branded itself into my memory for a few weeks before I could actually paint it.

BEYOND OUR DREAMS
Ben Watson III
21" x 28"

I painted broad washes over the door using spatter and handprints to create textures. I then used controlled drybrush to render detail to the wood, door hinge and knob. A combination of colors and values shapes the figure. To finish, I went back with lighter drybrush for the hair and the details of the face where the light was strongest.

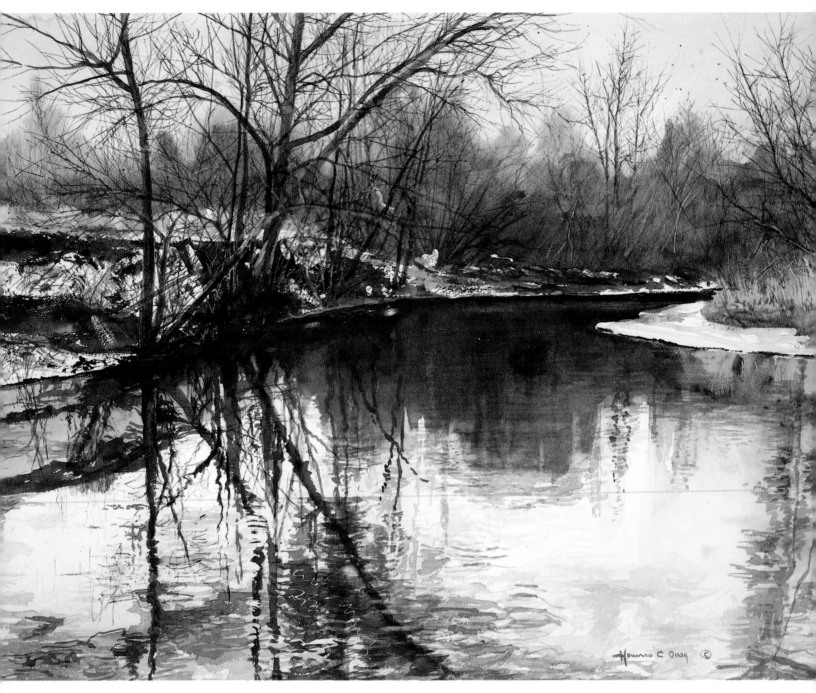

Deepen the Richness of a Wet Landscape

HOWARD OLSON

It had just snowed that morning and the sky was still overcast, but the landscape had that deep, rich color unique to after a rain shower or snowfall. I wanted to capture this color but keep the soft light of the scene. To keep the subtlety, I mixed warm and cool colors and avoided the use of bright colors. I depended upon strong value shifts of light and dark on the water and the snow to make the colors richer, and to break up the larger masses of the painting with smaller shapes and patterns to add balance.

REFLECTIONS
Howard Olson
20" x 24"

I painted wet-on-wet for the sky, background trees, and a small area in the water where the grass is reflected. I used a masking fluid for the snow and some of the light areas on the water. However, I did not apply all the masking fluid with a brush, but applied some of it with a pen and some with a toothbrush. I also did a little scrubbing out with a stiff acrylic brush on the larger trees in the foreground and some of the horizontal shadows on the water.

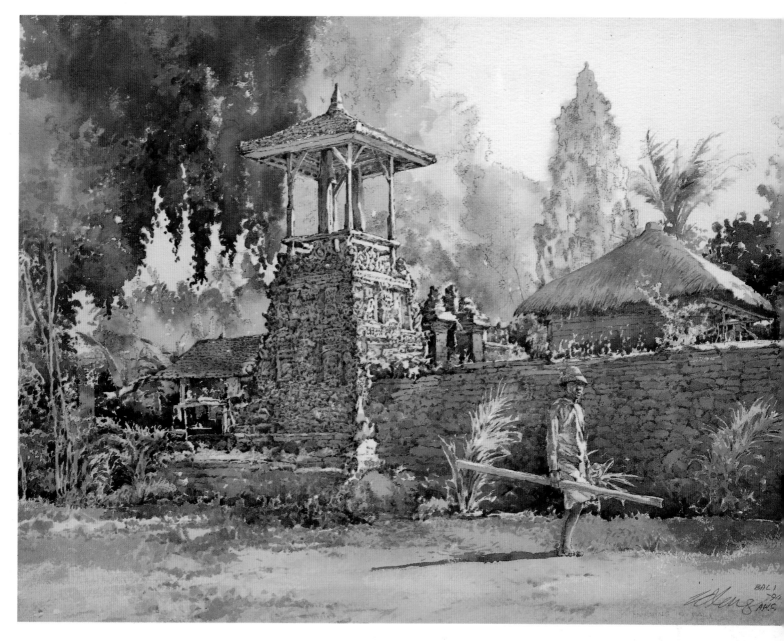

Rising to the Morning of the World

ONG KIM SENG

The Indonesian island of Bali is an island of light all year round. The rustling palm trees, lush paddy fields and villages by the active volcano, Gunung Agung, when immersed in the morning light, are scenes considered divine to many artists. I visited Bali many times to paint this paradise of light known to many as the "morning of the world." Early one morning my neighbor's fighting cock woke me up to paint this painting. The light was magical as it penetrated through the morning mist onto the old drum tower of the village temple. It was a hard decision whether to add Putu, the farmer who walked past, to my painting.

MORNING IN BALI
Ong Kim Seng
21¹/₂" x 30"

I often use a 4B pencil to draw in detail the outline of the main object, the most interesting part of the picture. The rest are supporting lines running into the main object. Before I lay in the washes, I use fine sandpaper to rub the surface of the weathered wall and the tower to create textures later on.

Paint With the Light Behind You

PAUL STRISIK

I have always been fascinated by the effect of light and the way it reveals the subject. Of course, good composition, design and other factors must be incorporated, as in any work of art. In "Autumn Meadows," the light effect is one of "flat light," meaning that the source of light is more or less behind me, causing shadows of objects to project into or away from the viewer.

AUTUMN MEADOWS
Paul Strisik
20" x 28"

There was no special technique used in this painting. It is straight transparent watercolor technique. Some lifting of color to create tree trunks was used.

Soft Winter Light for a Mood of Tranquility

DON DERNOVICH

Light sets the stage for the overall complexion of the painting, setting the mood. The painting of the "Frenchman River" is a depiction of late winter. At no other time of the year is the light and color so beautiful. The sun is very low over the southern horizon creating very long shadows. The "glow" of the reflected light off the surface of the water is particularly evident, and is the focal point of the painting. The whole scene is bathed in the soft winter light, imparting a mood of tranquility.

FRENCHMAN GLOW
Don Dernovich
21" x 29"

The soft appearance of the painting was achieved by spraying a fine mist of water onto the surface from a spray bottle while the pigment was still wet, until I needed more control with edges and details. The glowing reflections on the surface of the water were achieved by masking out the shapes of the ripples with masking fluid. They were then glazed over with an application of color.

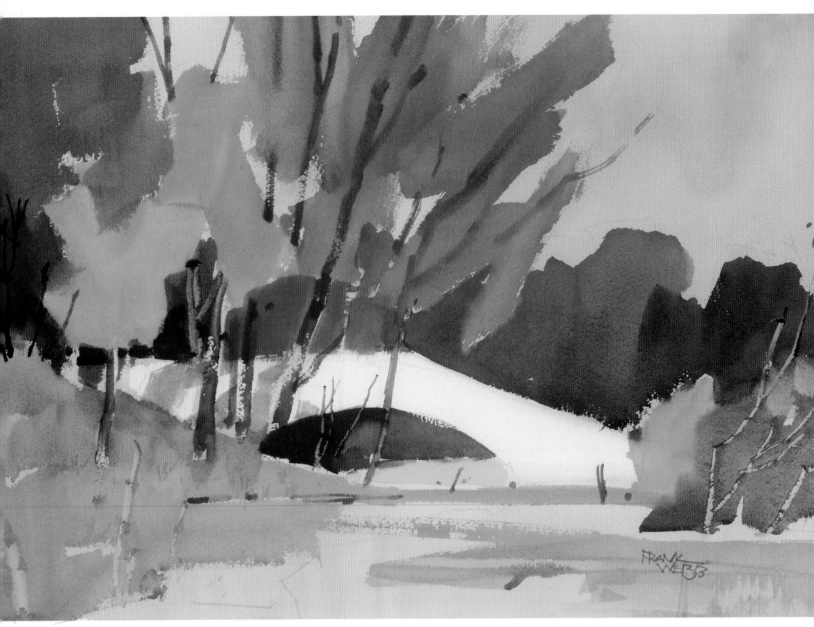

Create Light as Needed for Your Pictorial Purposes

FRANK WEBB

Light is the daily bread of the painter. According to the Book of Genesis, light was the first creation. It is the most beautiful of inanimate things. Here, as usual, I created light as needed for my pictorial purpose. The subject, the bridge, is left white to command attention. Ochre foliage gradates from darker at right, against the sky, to lighter at left, against darker trees. All large shapes are differentiated by contrasting values. But none of my arbitrary usage of values is necessarily unnatural. For instance, I cast shadows of tree trunks on the bridge. Though such shadows were not present, they could have been. On-the-spot drawing will furnish your mind with a rich vocabulary of light effects.

GLENNVILLE
Frank Webb
15" x 22"

No shapes in this painting were "built up" of multiple brush-strokes, but were directly applied with wide, flat brushes. Brushes were turned and twirled with each stroke. Negative lines were scraped into wet paint under the bridge and in the bush to echo the positive tree trunks. Simplicity. Just enough, and no more.

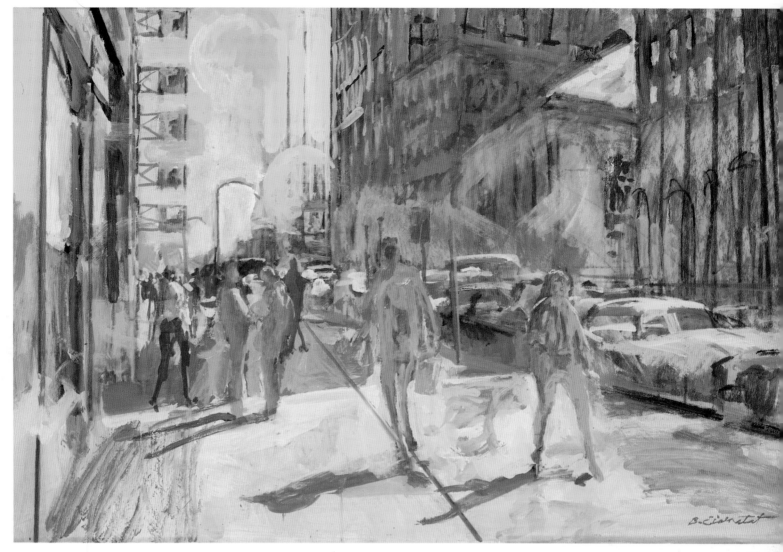

sunlight in the City

BENJAMIN EISENSTAT

Early painters studied mainly the natural world where light envelops softly and is unhindered. The urban world was generally ignored by most painters. Among the exceptions, Canaletto and Vermeer explored the sharper light that fell on impenetrable walls, reflected varying surfaces and cast geometric shadows. Impressionism had Monet, Renoir and Pissarro focus on Paris and soon light in the city was acceptable. For sixty years, my painting has been involved with variations of light in both urban and natural settings.

"Noon" is of Philadelphia's Broad Street, a mélange of historical buildings next to contemporary high-rises, with the skyline abruptly broken by gaps of parking lots. It is hectic and disorderly, and at noon in summer, hot.

I take photos on the streets to document the obvious, but also draw surreptitiously, usually behind a folded newspaper, making pencil notes on the spot to indicate the particular mood I hope to portray.

NOON
Benjamin Eisenstat
20" x 30"

To capture the humid but exciting atmosphere of Broad Street, I scrubbed heavy smears of full strength opaque watercolor topped with linear notations of both crayon and charcoal.

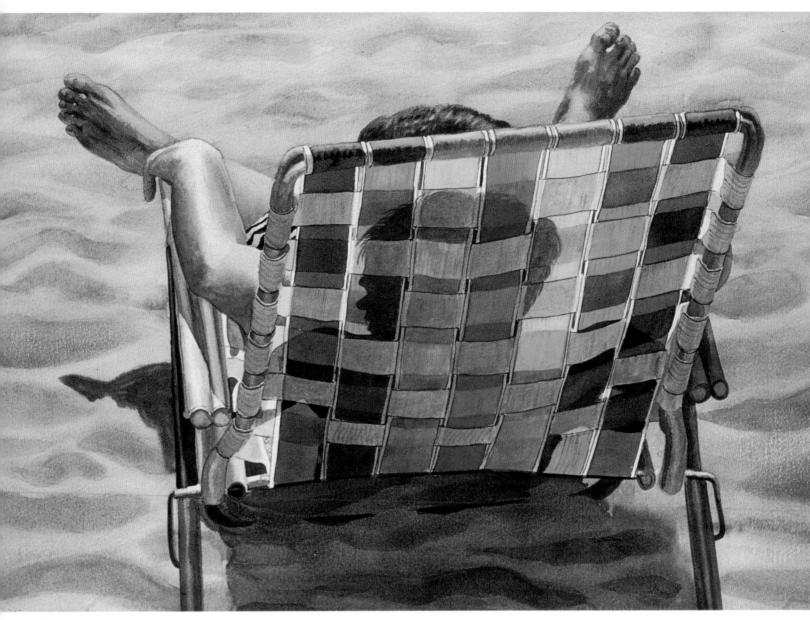

Observe the Effects of Light on the Beach

STEVEN JORDAN

The beach is a wonderful place to observe light and find interesting subject matter. "Laid Back" presented me with the opportunity to combine my love of color, light and shadow with my penchant for somewhat amusing images. In this case the shadow creates a subtle clue to the identity of the person in the chair.

In "Lisa" I was intrigued by how the light and shadows changed the fleshtones on the sunbathing figure as well as the reflections in her sunglasses. By using an unusual perspective, I was able to create an entertaining image.

LAID BACK
Steve Jordan
20" x 30"

"Laid Back" began with a careful drawing followed with a wash over the large area around the figure and chair. This area was then painted from light to dark in a transparent manner.

right
LISA
Steve Jordan
38" x 28"

"Lisa" was painted on a 30" x 40" sheet of illustration board with a smooth finish. Most of the surface was painted transparently with some opaque accents. The texture in the sand was achieved by spraying water into a wet surface.

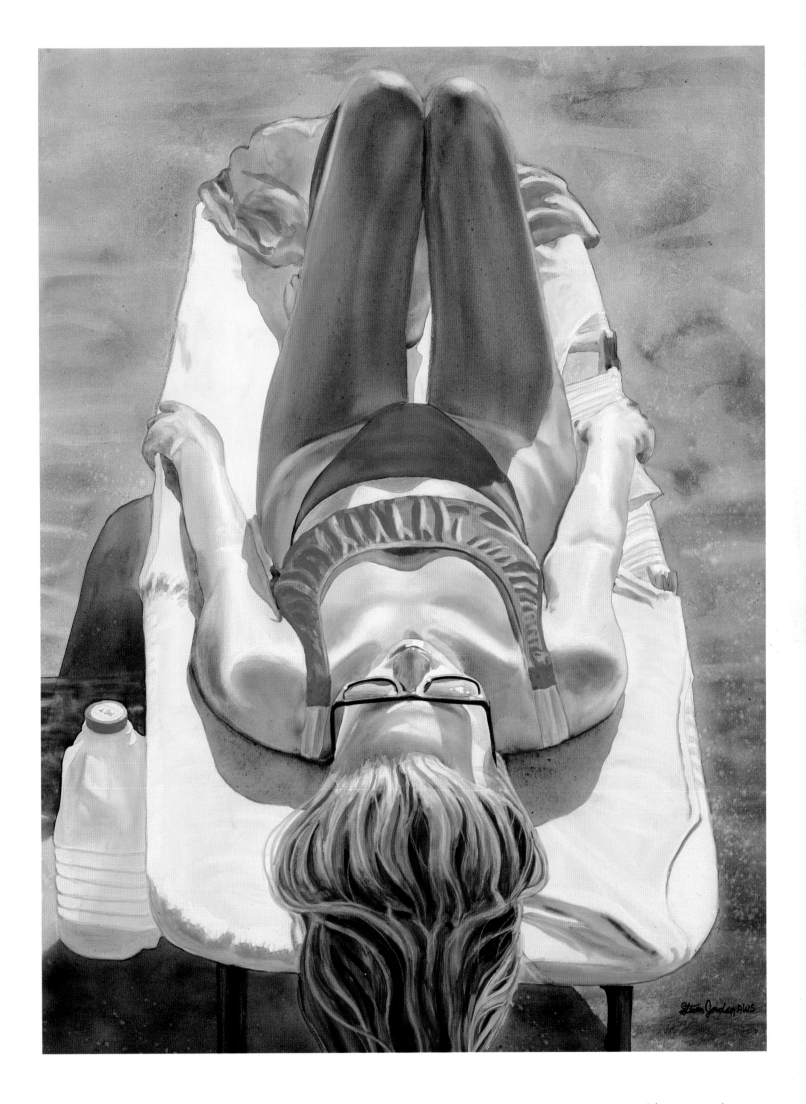

Catch Fleeting Moments When the Light Is Perfect

KAREN FREY

An ordinary subject can become extraordinary under the right lighting conditions. I often work from photographs and am always on the prowl for those fleeting moments when the light is perfect. In "Tiny Elvis—Up Close" I used backlighting to create strong value contrast and drama. This allowed me to use my light shapes as a way to reveal the subject as a silhouette.

TINY ELVIS, UP CLOSE
Karen Frey
18" x 24"

I am a straightforward painter. I start with an underpainting, mainly to establish and save those precious white areas. Then, using a wet-into-wet technique, I develop areas within the painting to completion.

Let Shadows Dominate for a Quiet Effect

MARION WELCH

In Manhattan, the patterns of light and shadow can be quite intricate. Even in full sun, the buildings are covered with shadows cast by fire escapes, awnings, window boxes and nearby trees. I must have passed this particular building a hundred times; the light is usually blocked by a taller building, rendering it flat and uninteresting. One morning, though, I happened to see this window suddenly lit up by just a few rays breaking through the trees. Immediately I was intrigued by the idea of a "dark" watercolor, dominated by shadows and emphasizing light by its almost total absence.

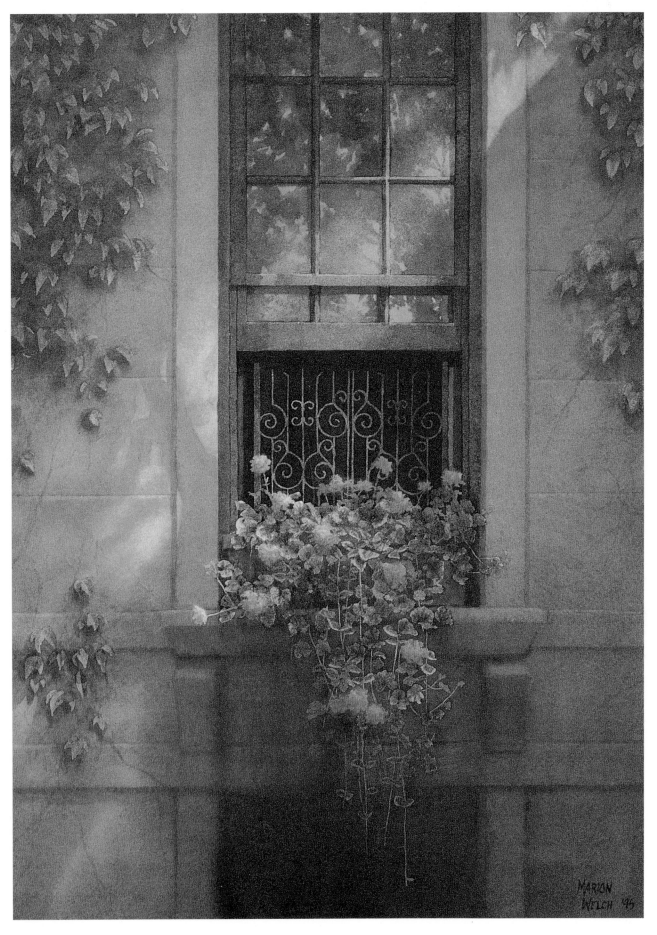

GERANIUMS
Marion Welch
13⅜" x 19"

The flowers, grille and windowpanes were painted first, then masked out to preserve highlights. The deep shadows under the window were achieved with a mixture of Thio Violet, Payne's Gray, and Hooker's Green, applied several times to damp paper. A small, flat, synthetic brush further softened the edges of the geraniums and chiseled out some additional highlights.

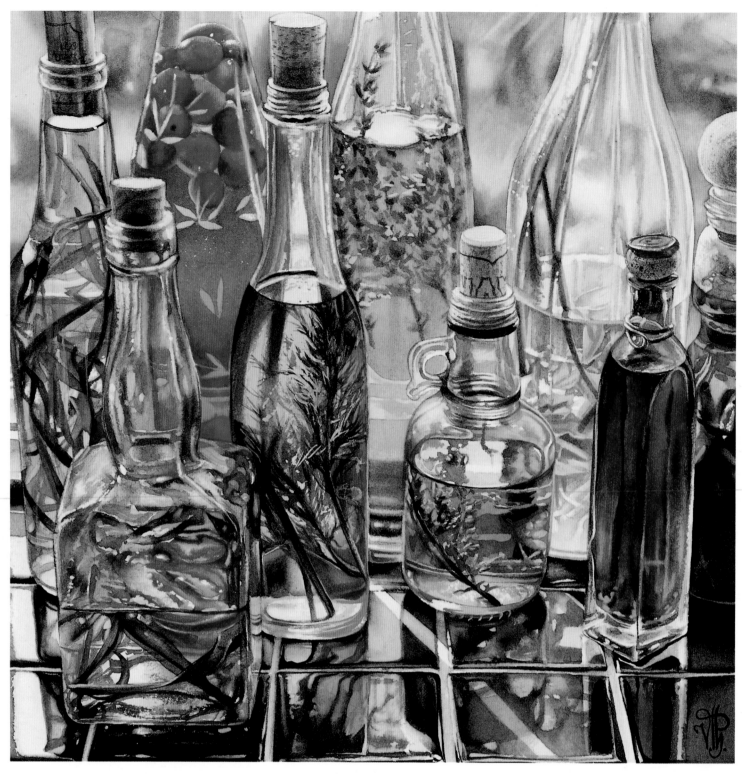

Use Direct Afternoon Light for Glowing Color

VIVIAN THIERFELDER

Benevolent light reveals the tangible world, bending around, refracted through or reflected from objects of various texture, density and color. Light also describes space, both positive and negative. My use of strong direct afternoon sun produces bold forms and dynamic shadows, making space between objects almost palpable and manifesting a wealth of detail. This light allows color to glow and thoroughly engage our sense of sight.

ALL BOTTLED UP
Vivian R. Thierfelder
8" x 8"

right
SOME LIKE IT HOT
Vivian R. Thierfelder
8" x 8"

I use a latex masking fluid to preserve essential sharp edges in the composition like the crisp reflected angles of a cut crystal vase. The flat edge of a craft knife is sometimes used to lightly scrape away a layer of watercolor paper to expose a "hit" of ultra white for highlights on glass or plate edges.

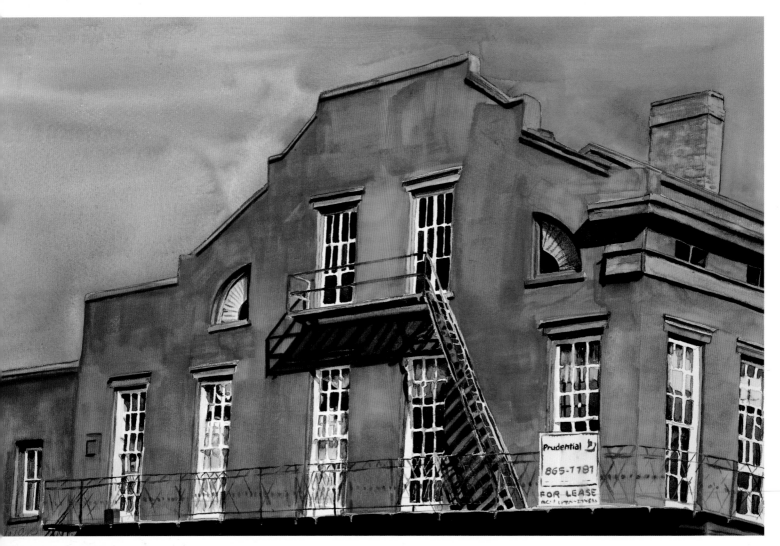

Try Staining Darks to Make Your Lights "Pop Out"

GERI GRETAN

The play of intense lights against deep, saturated darks is what is most inspirational to me. The subject for "Prudential For Lease" is a building in New Orleans viewed on a brisk, damp early morning. The sun broke through the clouds and lit the newly painted building like a young girl waiting to be courted. I loved the complementary colors in the building and how they glowed in early morning light.

Liquid Watercolors Bring Out Intensity

MELANIE LACKI

California coastal sunlight streamed through the skylight in my kitchen and illuminated everything in brilliant warm light—an inspiration to paint a still life. The intensity of the light caused the objects to mirror the hues of one another which made them glow as if lit internally.

PRUDENTIAL—FOR LEASE
Geri Gretan
11¾" x 18"

I create my darks by combining the staining colors of Winsor Blue, Winsor Green, and Alizarin Crimson with the occasional addition of Burnt Sienna and Hooker's Green Dark. I find that the lights "pop out" more effectively against these staining, powerful darks.

right
TOP BANANA
Melanie Lacki
12" x 9"

The new liquid watercolors I had started using recently made this painting more exciting. The intensity of their hues readily lent themselves to the bright reds and oranges of the nectarines, the yellows of the bananas, and the blues of the plates. I saved most of the whites by painting around them, but in a few areas used liquid frisket to mask them out.

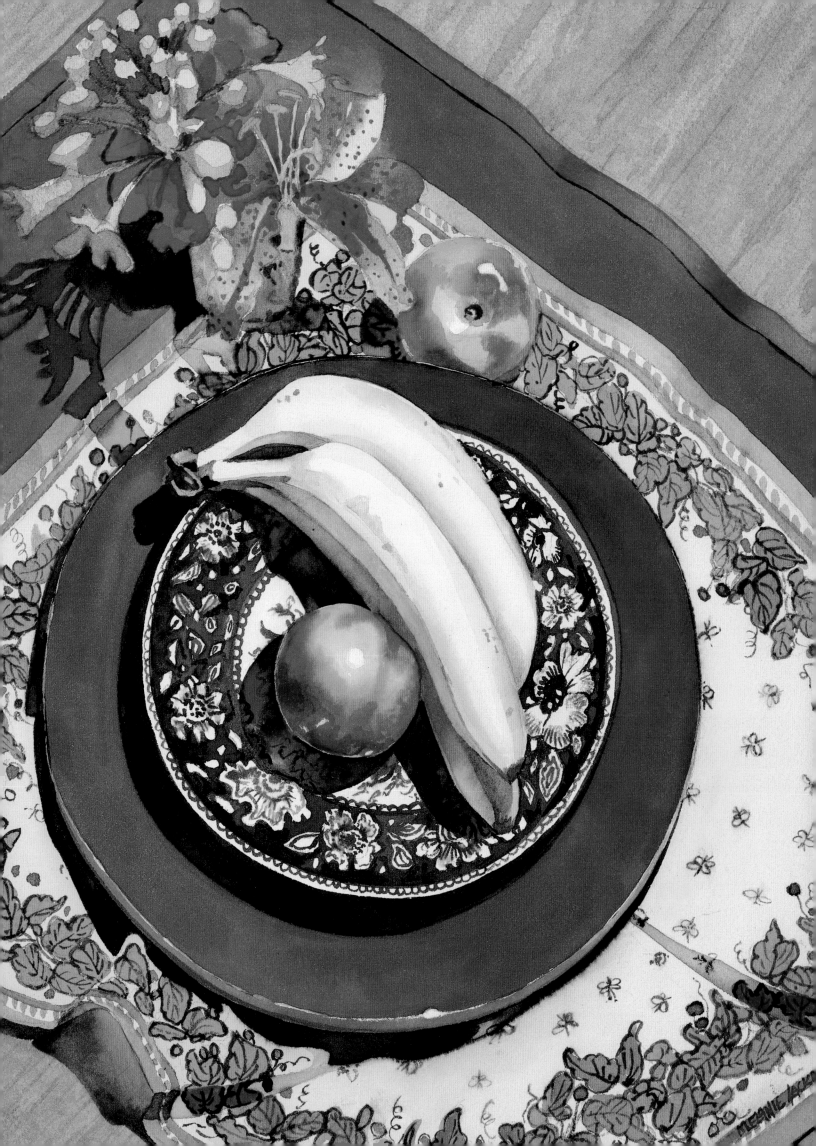

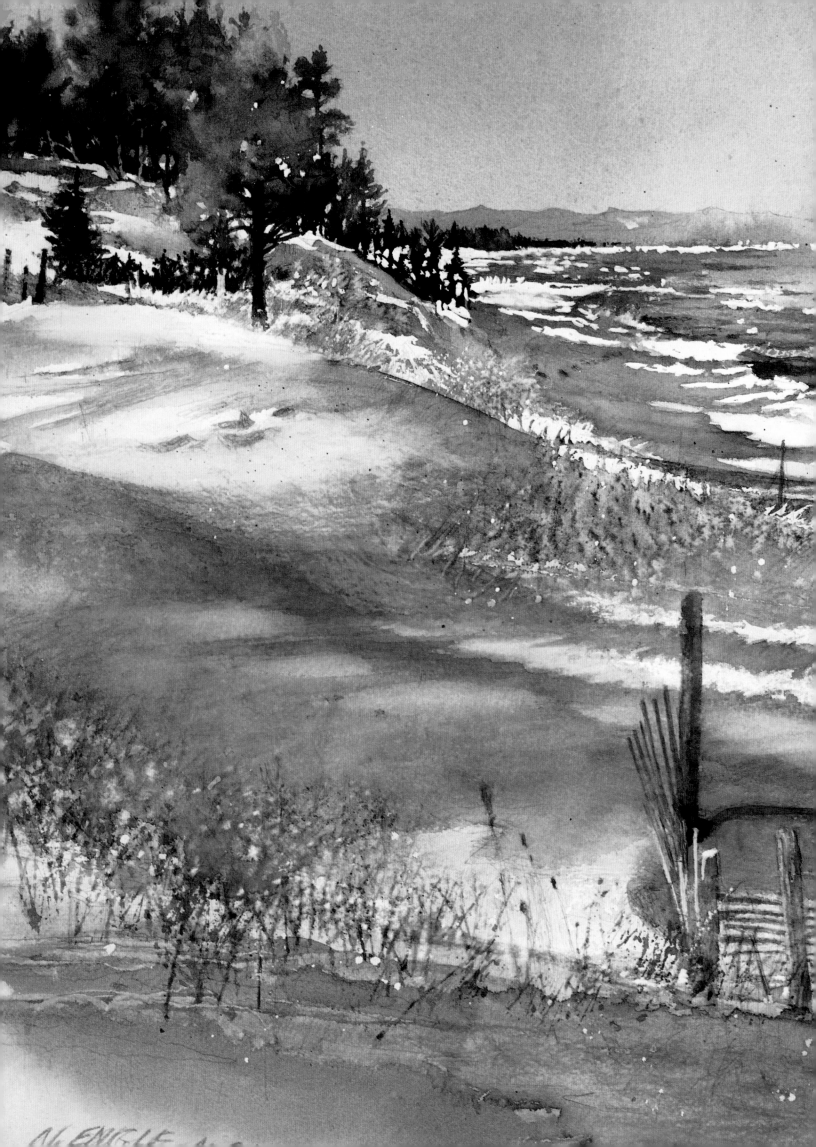

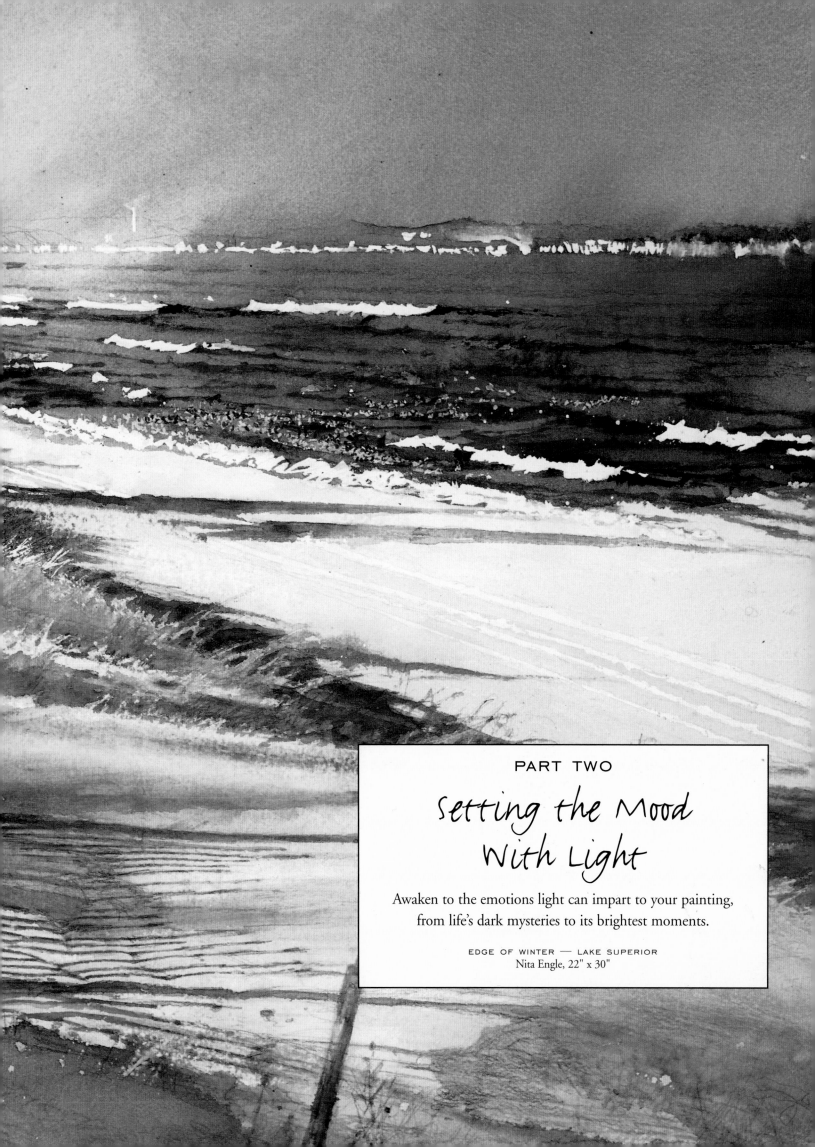

setting the Mood With Light

Awaken to the emotions light can impart to your painting,
from life's dark mysteries to its brightest moments.

EDGE OF WINTER — LAKE SUPERIOR
Nita Engle, 22" x 30"

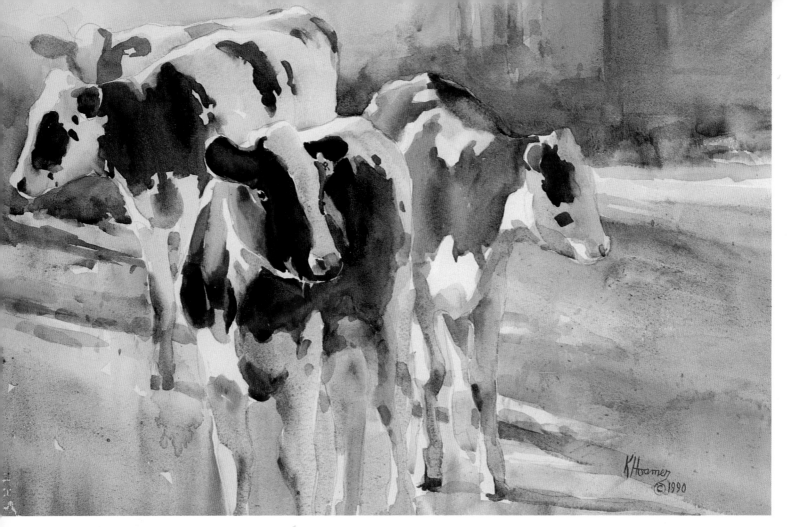

Exaggerate Subtle Changes in Color and Light

KEN HOSMER

The pristine quality of New Mexico light has long fascinated me. My purpose is to capture the essence or mood of the moment, and the quality of light is often a dominant force in dictating that mood. Since paint is very weak compared to actual sunlight, I often look for subtle color changes in light and shadow; then I exaggerate those changes in paint, using high-key, transparent color. In "Spring Calves," I was immediately entranced by the brilliant early morning sun dancing across these spotted calves. To capture this mood, I enhanced the color variations, using warm oranges and reds in the sunlight, and cool blues and blue-greens in the shadows. Instead of "black and white," the calves become an orchestration of colors. Painting is an exaggeration of reality, an illusion processed through the filter of the artist's perceptive vision, and most of all—a song of light.

Awaken to Soft Sea-Light

LINDA KOOLURIS DOBBS

My awakening to light and to painting came at the same time. For a realist, a mastery of light is essential. It portrays a passage of time, history, season, mood, temperature, emotion, atmosphere… In "Isla Mujeres Remembered '94," my concern was the stillness, the medium value shadows, the softness of morning light. The colors are subtle, not starkly contrasted as at midday. Harder to describe is the mood and quality of "sea-light," ever-present in this small island community.

SPRING CALVES
Ken Hosmer
15" x 22"

Using black-and-white ink-wash drawings as the primary reference, I painted "Spring Calves" very rapidly with transparent watercolor. This adds to the spontaneous paint quality, and allows me complete freedom to intuitively interpret color changes. I painted the darkest darks with a mixture of Phthalo Green and Carmine so that they are not actually black, but rather shift in color.

right
ISLA MUJERES REMEMBERED
Linda Kooluris Dobbs
27³/₄" x 18¹/₂"

I create my greys by mixing complements and other colors to give resonance to shadows. Some sponging was used for texture on the wall and acrylic was used to intensify a color, or for touching up where sharp edges were wanted.

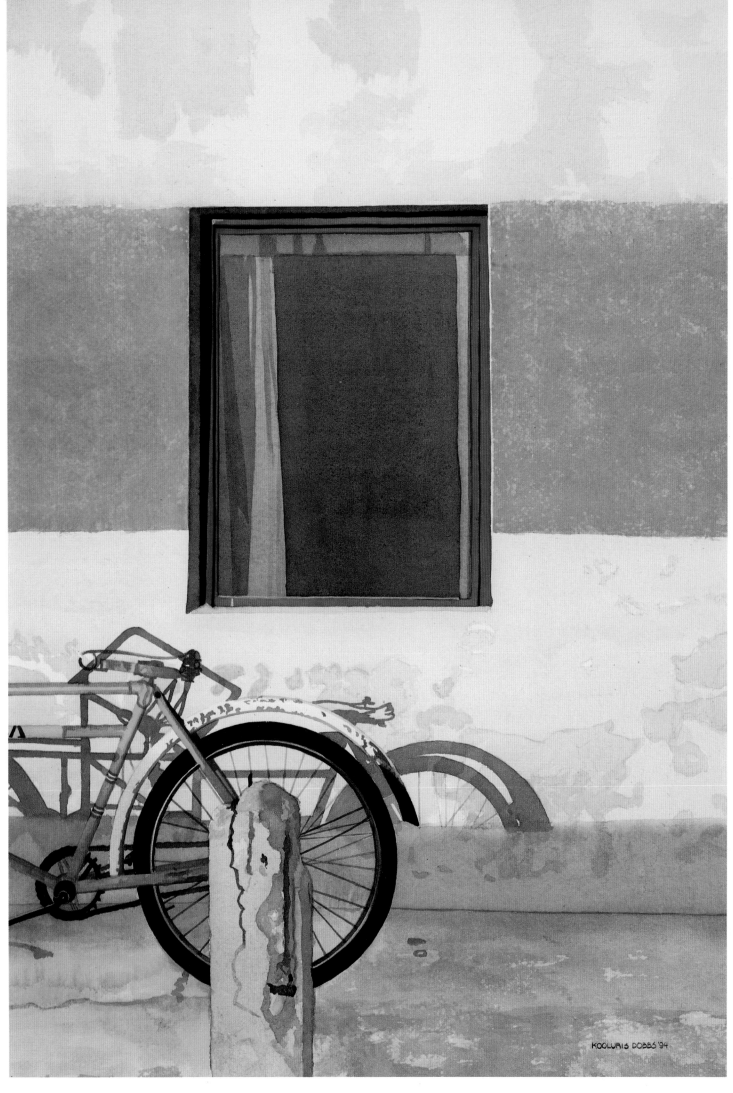

KOOLURIS DOBBS '94

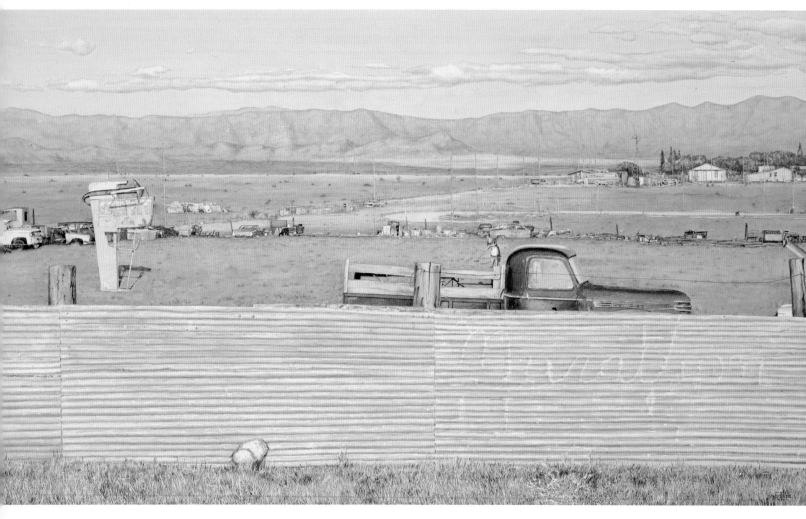

Recreate a Specific Atmospheric Condition

FRANCISCO VALVERDE

The original idea for "Deep Texas" began with the need to develop a theme with a specific atmospheric condition. Light as a subject is transparent and urges me to find a setting. I eagerly travel the roads and highways, exploring faraway places. "Deep Texas" is based on the desire to recreate an unidentified location during the first hours of a cold and sunny spring morning in the Texas desert.

A Soft Simple Background Gives the Eye a Resting Place

NEIL H. ADAMSON

I am on site at daybreak for most of my subjects, whether landscapes, wildlife, coastlines or marshes, so I can observe the misty or foggy haze that is over the water early in the morning. I love the mood it sets and the changing light up until mid-morning. I found the subject for "Great Blue Heron" in the Florida Everglades. I used the soft morning light to make the brightly colored bird, grass and lily pads stand out sharp and crisp. The soft, simple background gives your eyes a place to rest without conflicting with the rest of the subject.

DEEP TEXAS
Francisco Valverde
19¹/₂" x 34¹/₄"

After working for many days on the sketch, I transferred the drawing to Arches 300-lb. hot-press paper. Only the clouds and the trail left by the airplane in the sky were covered with masking fluid. I applied a series of controlled and delicate transparent washes in a classical manner from light to dark, letting them dry before painting over them with additional transparent glazes.

right
GREAT BLUE HERON
Neil H. Adamson
33" x 16"

Acrylic watercolor on Strathmore plate surface bristol or illustration board. I use the acrylic as a wash for sky and water, drybrush for the bird and lot of glazes in the lily pads and grass.

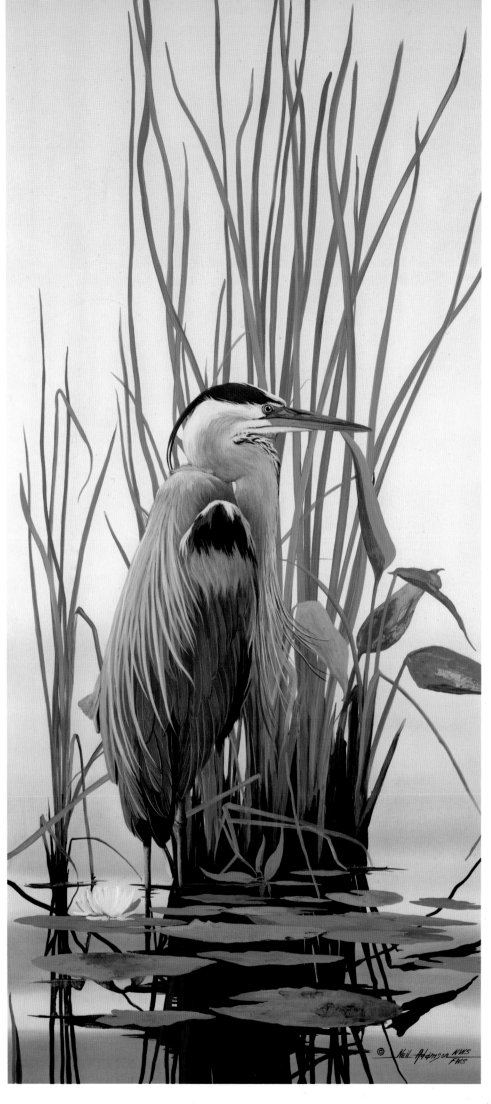

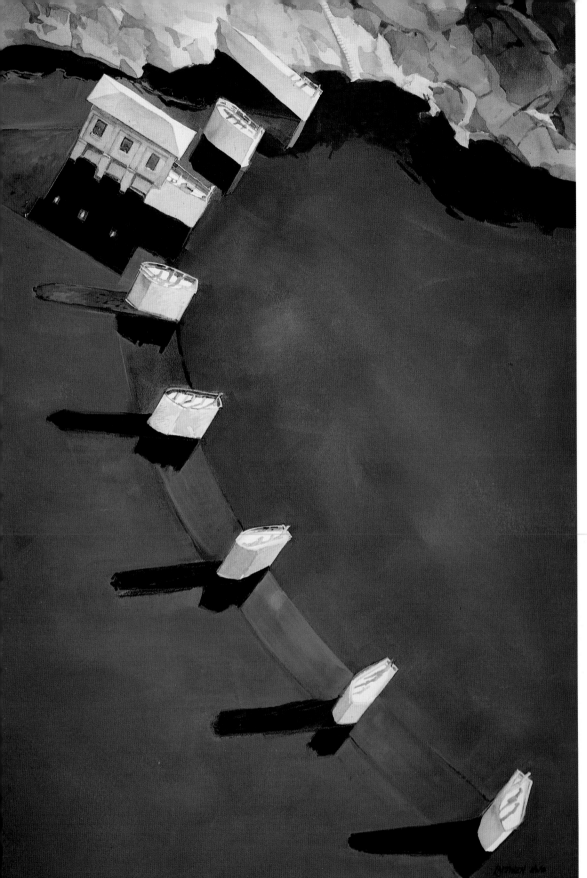

Add Gesso for Body and Atmosphere

DALE LAITINEN

In "Rotoring Over Melones," the view was from directly above, creating a starkness to the light that bounced back, giving a sense of eerie detachment from the subject. The deep blue of the reservoir was laid in with watercolor mixed with a small amount of gesso. This allowed a more even application over such a large expanse of paper by giving the pigment more body. I also gave a sense of opaqueness and thereby depth to the water.

ROTORING OVER MELONES
Dale Laitinen
41" x 29½"

I enhanced some edges with watercolor pencil over dry color. I built up the structure of the dam with an underpainting of yellow ochre, and semitransparent layers of gesso as well as some watercolor pencil. This helped create stark contrast in light between the superstructure of the dam and the deep blue of the water.

CODESTONE
Louise Cadillac
40" x 30"

The undecipherable characters embedded in the stones in "Codestone" were drawn into very wet washes with a pointed instrument such as an eyedropper dipped into alcohol. When the alcohol repels the water it produces phenomenal effects that can be somewhat controlled by the amounts of water and alcohol.

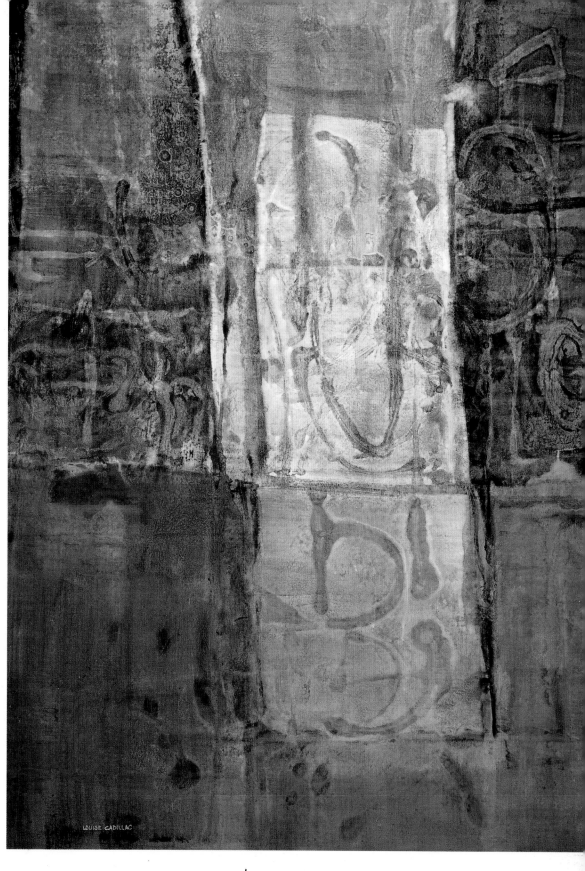

Impart Mystery with an Enigmatic Light Source

LOUISE CADILLAC

I often use light in my paintings to provide an extra dimension, in this case, to impart some mystery. In "Codestone," the light emanating from the cave stones is not only reflected in the water but is also submerged in the water. Part of the content is the mystery of the light source.

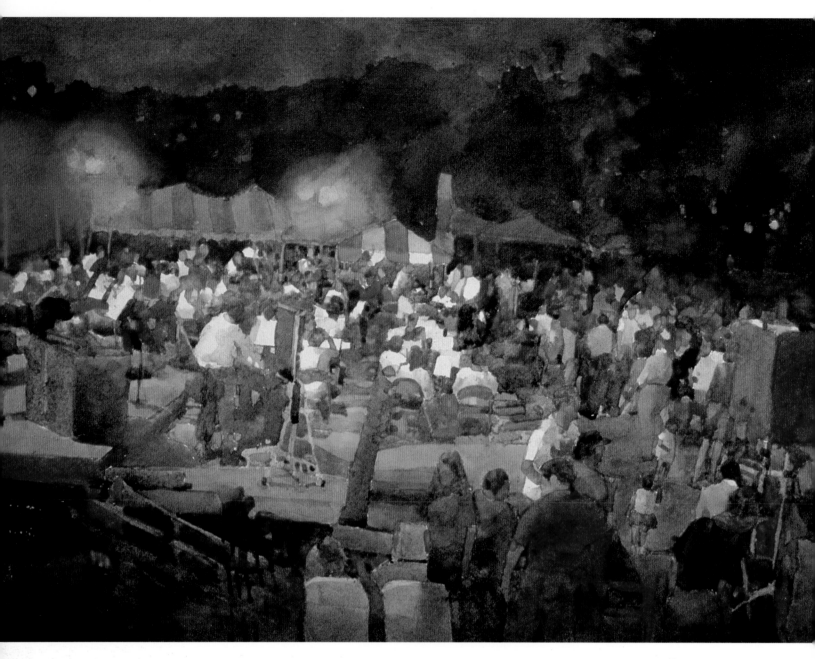

Capture the Energy of a Magical Moment

NIGHT MUSIC II
Anne Adams Robertson Massie
21½" x 29"

ANNE ADAMS ROBERTSON MASSIE

I enjoy painting happy occasions—capturing that magical moment. The Tour DuPont sped right by my house. The cyclists were gone in the wink of an eye—leaving the memory of their energy and effort and the interplay of dappled sunlight on racers, spectators and trees. On another occassion, the Lynchburg Symphony had an outdoor pops concert which began at dusk and finished under the stars. I wanted the challenge of a night scene. "Night Music II" recalls the booming climax of Tchaikovsky's "1812 Overture" and dear friends who play in the orchestra. The beauty of music is as transitory as light and always as full of emotion and feeling.

My paintings are straightforward transparent water-
color on Fabriano Artistico or Export Azione 140-lb.
paper with round brushes. Considerable time is
spent drawing and working out the design. The
painting is done in bits and pieces, linking one area
to another, but over the whole paper, with as loose
and spontaneous a brushstroke as
possible.

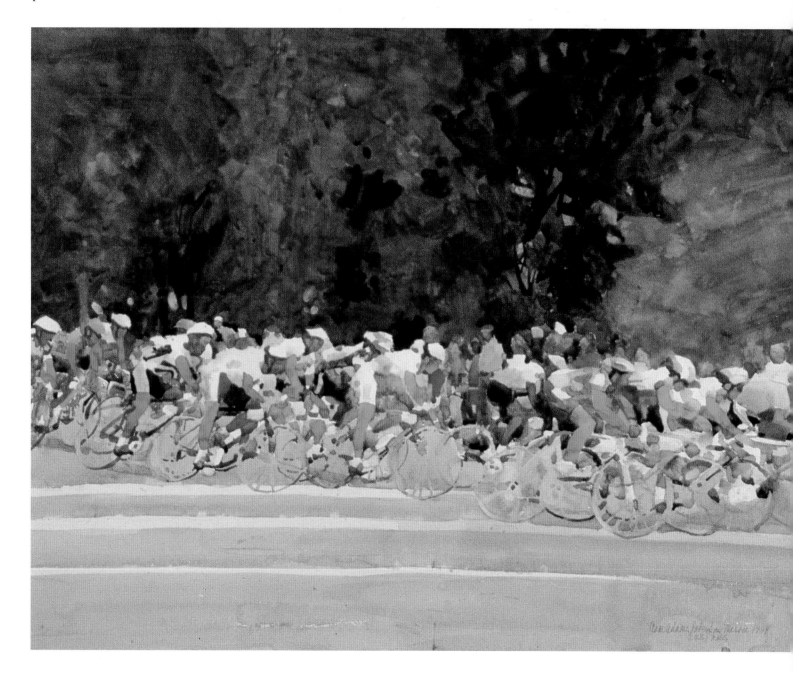

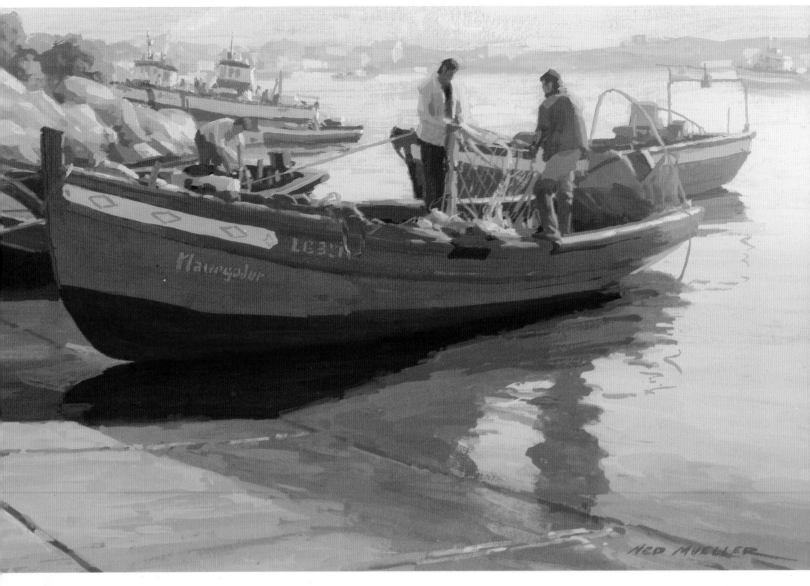

Push Your Colors to Capture a Quality of Light

LAGOS HARBOR—PORTUGAL
Ned Mueller
8" x 12¹⁄₂"

NED MUELLER

To capture the quality of light which creates the mood of this early morning scene, I "pushed" the colors, still keeping them in harmony. I made the warm colors warmer, and adjusted the cooler colors to be softer, particularly in the background and middleground. The brighter, colorful boats in the foreground glowed with all the brightness of the light shining off the water, so I used more "pure" colors to play against the overall quiet mood of the painting.

I underpainted this scene with various transparent tones of Flame Red, greyed down with various mixtures of Cobalt Blue, keeping the value relationships close to those I wanted in the finished painting. This created an overall warm mood and gave a little more life to any cooler tones laid over them. The final washes were more opaque, using gouache.

ANTICIPATION BRAZIL
Marilynn Derwenskus
30" x 22"

For this image, I used stencils and masking tape initially to reserve white space. As I developed the painting, the white spaces were painted and black checks were added. I enjoy the juxtaposition of contrasts: light colors versus dark, fluid paint versus flat, calligraphy versus washes.

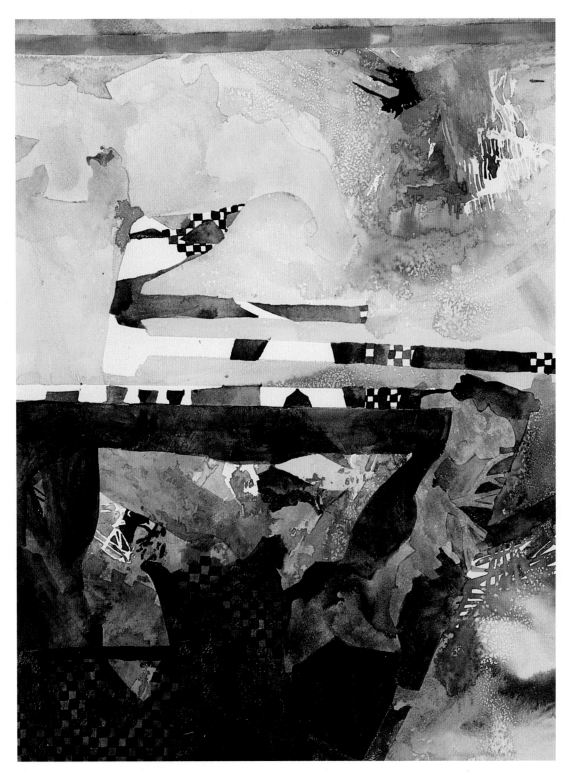

Shape Your Impressions With Light

MARILYNN DERWENSKUS

I use light to develop ambiguous, non-representational space in my abstract watercolor paintings. I painted "Anticipation Brazil" as I prepared for a trip to Brazil. I was excited and tried to capture the spirit I anticipated of this South American country. I expected a colorful and moving experience. Light helped me shape these impressions. The top of the painting is a receptacle for light, the Brazilian sunshine. The darks at the bottom suggest the mystery of Brazil by nearly blocking out the light. The strong value contrast strengthens the image and communicates two distinct moods—energizing sunshine and intriguing mystery.

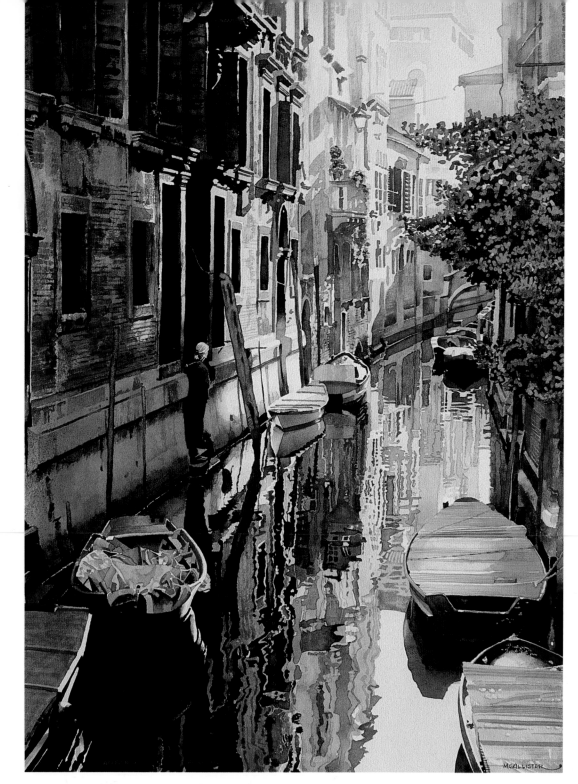

left
ANTICIPO—VENEZIA
William McAllister
42" x 30"

I started this painting in the pale tints at the end of the canal, working my way forward losing light and gaining darks on the way. Some masking fluid was used in the tree leaves on the right.

right
PROSPECTING LONDON
William McAllister
22" x 15"

Untraditionally, I love watercolor for the depth of its darks. The matte surface of cold-press paper is better suited to this end than the hard surface of the oils that I used for so many years. I've never been afraid of going too dark.

Express the Mood of a City With the Quality of Light

WILLIAM McALLISTER

At times Venice can be surprisingly still and quiet. The hush of anticipation; the sound of faintly lapping water. There is a beauty in the vibrant mingling of sight and sound—it is art in the air.

The warm, welcoming facade in "Prospecting London" has been beckoning hungry or tired Londoners for 475 years. Turner painted views of the river Thames from its small terrace where meals and ale are still served. I very rarely render a scene with only man-made light sources, but this is the best lighting and time of day to depict the warmth and sense of continuity that I felt here.

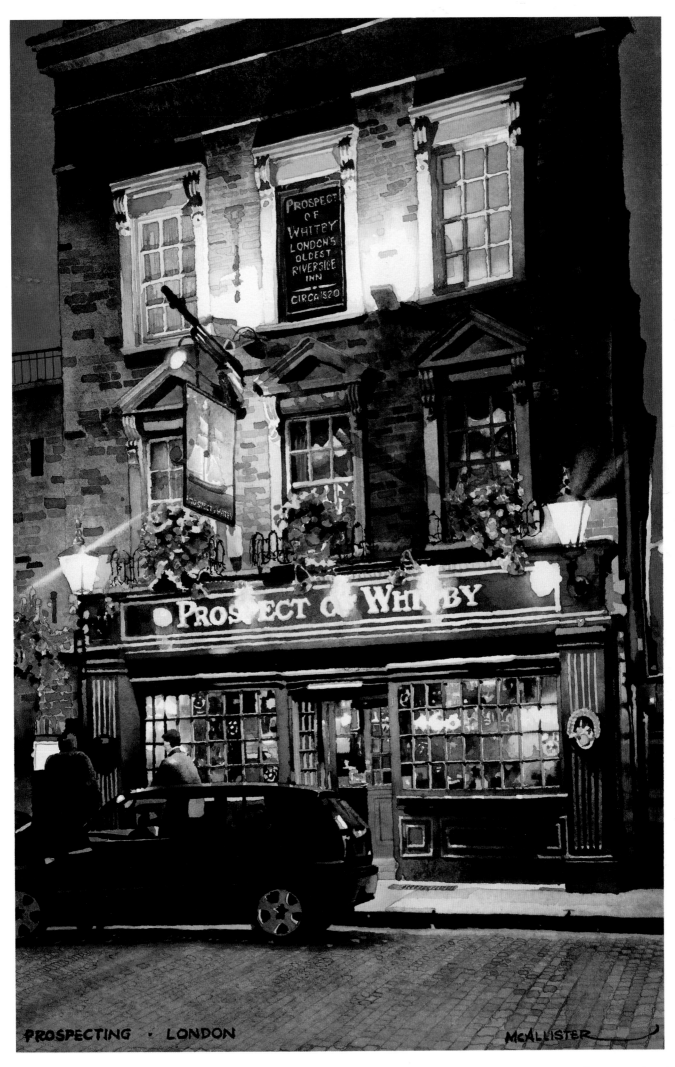

PROSPECTING · LONDON McALLISTER

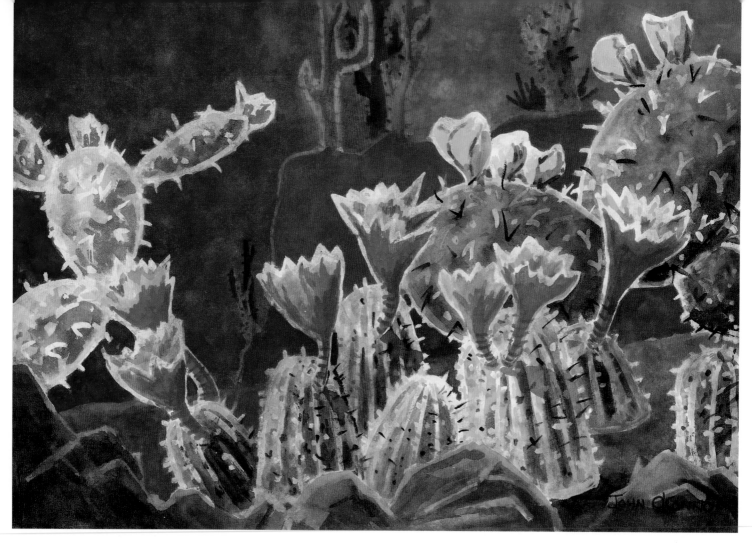

Spotlight Your Foreground for Extra Drama

JOHN O'CONNOR

I feel most satisfied with watercolor paintings in which light gives some extra drama for the interest and entertainment of the viewer. The light design of "Desert Song" involves spotlighting the foreground subject (cactus forms and flowers) against a darker, richer background.

Intensify Dramatic Lights to Heighten Mood

ARNE WESTERMAN

Light is the critical substance of painting. It generates the excitement, defines forms, and clearly delineates planes. I look for strong, dramatic lights and then intensify them to heighten the mood I want to express. Whenever possible, I use the white of the paper for the lightest lights, particularly in facial highlights. I usually paint on Lanaquerelle hot-press because the paper is ideal for my lifting technique.

DESERT SONG
John O'Connor
22" x 30"

Following a technique once shown me by Peggy Humphries, I "showered with" an old watercolor painting, scrubbing it down to a pale abstract pattern. On the dried "underpainting" I outlined the cactus forms, flowers and spines with masking fluid to give me "brush freedom" in laying on rich transparent colors. After a few layers of basic colors, I removed the masking fluid and painted around and through these areas.

right
HARMONICA PLAYER,
GRAND CENTRAL
Arne Westerman
21" x 14"

I start each of my paintings with a number of abstract thumbnail designs before I settle on a workable plan for a painting. At the final stage, I will start by painting the largest area, and then blend in adjacent area colors. I alternate lights and darks as I work so I have a good idea of the contrasts as they develop.

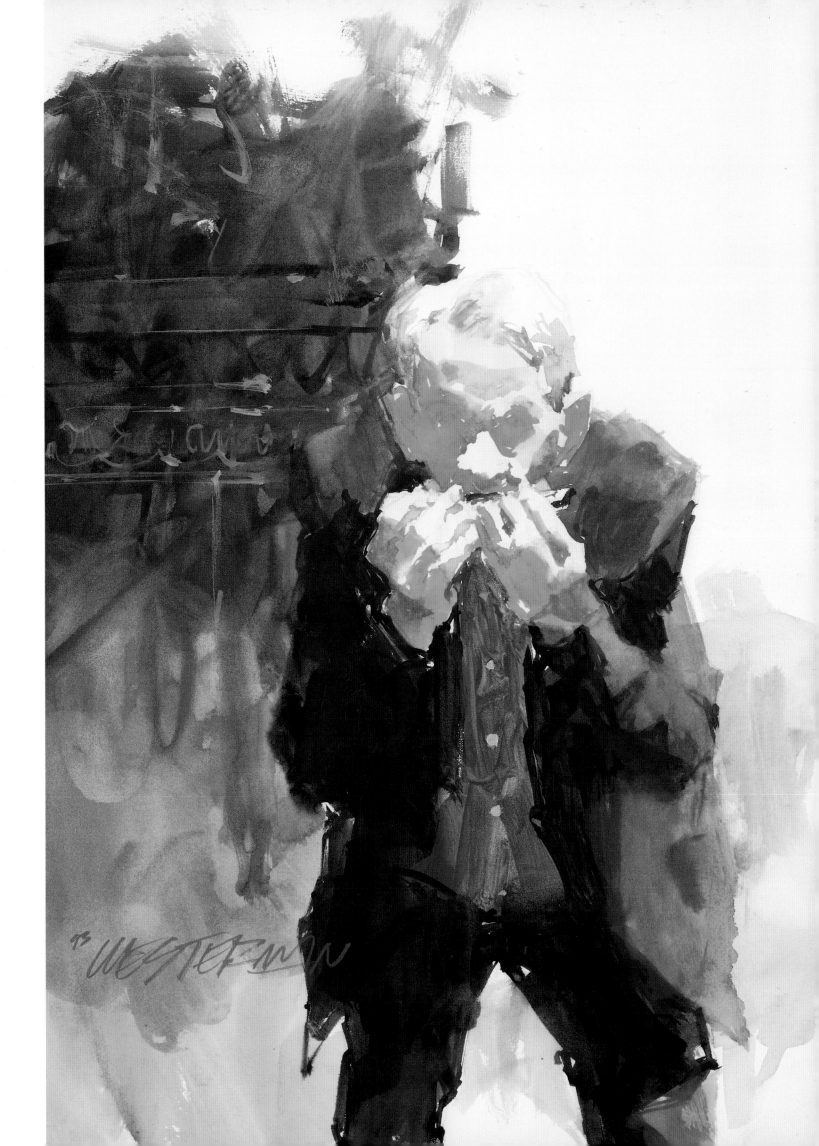

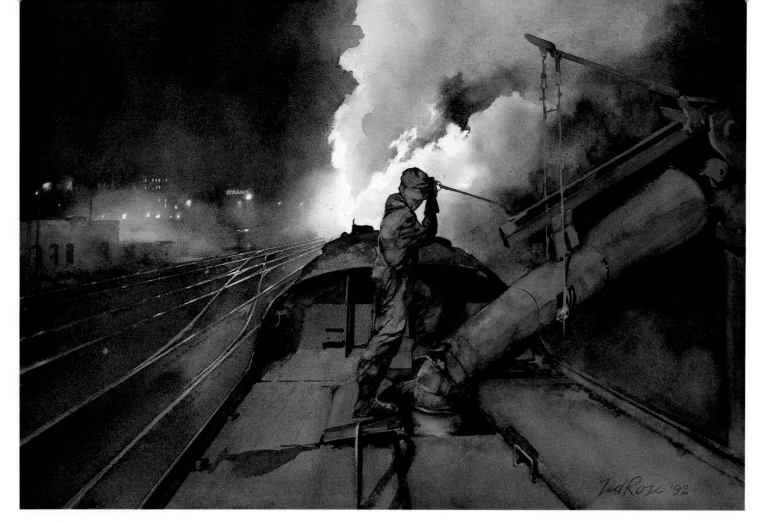

MIDNIGHT CALL
Ted Rose
14" x 20"

Denser Darks Contrast the Fluid Transparency of Light

TED ROSE

Dark against light defines pictorial structure, and is the critical procedure of painting. Greater paint densities in the dark areas cause opacity that, like dark itself, contrasts the fluid transparency of light and imparts an air of mystery. The use of certain pigments is the key here. One is Indian Red. Although it handles evenly in transparent washes and works well as a glaze, it's a wanna-be opaque that lends itself warmly to the dark variations possible in combination with Ultramarine, Mineral Violet, Naples Yellow Reddish, or Payne's Gray. Zinc White, too, is a useful color and a powerful modifier, especially for areas that want density without darkness.

My paintings are transparent watercolor without use of specialty techniques. For highlights, reflections and small lights at night, nothing is more expedient than a good eraser applied to dampened paper, allowing reconstruction of light in dormant darks.

Light and Snow

NITA ENGLE

Portraying light in "Sun and Skiers" was especially challenging because of the great expanse of snow which is, of course, also white. I wanted to create the illusion of a landscape flooded with light and purity, with great space and clean, cold air—the special world I experienced when skiing a mountain.

right
SUN AND SKIERS
Nita Engle
30" x 22"

The illusion of light comes from the central area of trees. Liquid was used above and below the trees, then the painting was tilted on its side to allow a continuous-tone wash over the trees—from dark olive through blues, red and yellow, and back to dark olive. Water was sprayed and run off to keep the paint moving. The tree shadows were added later.

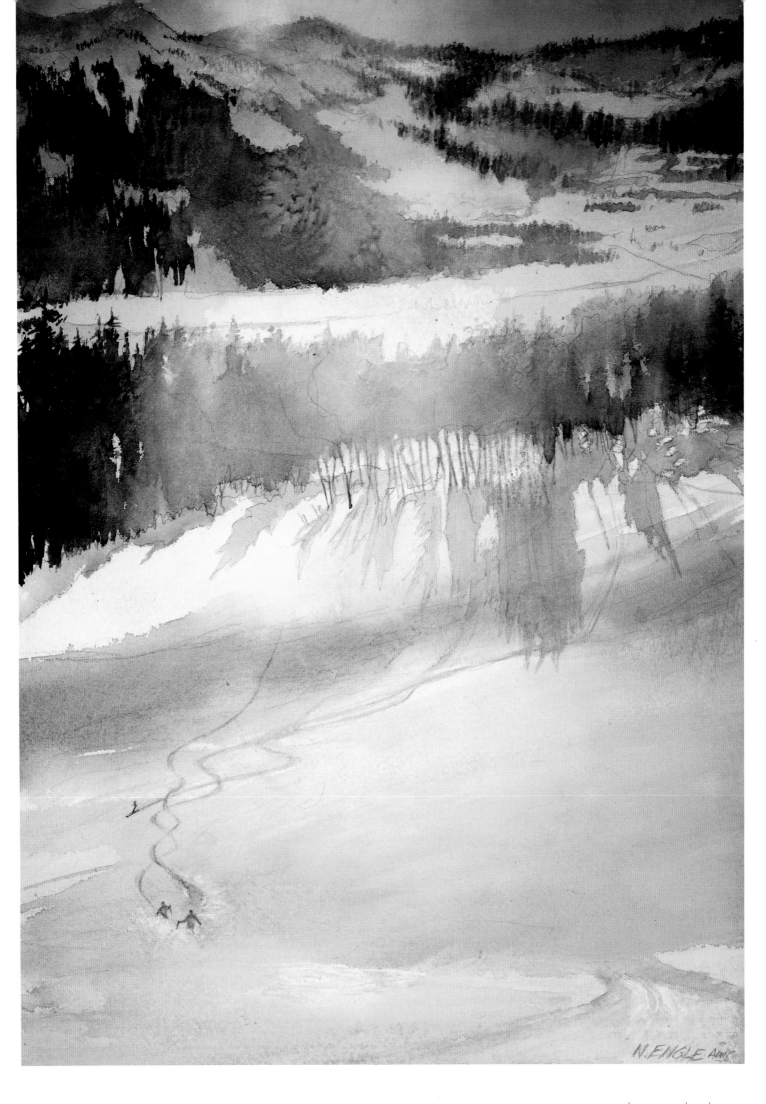

N. ENGLE A.W.S.

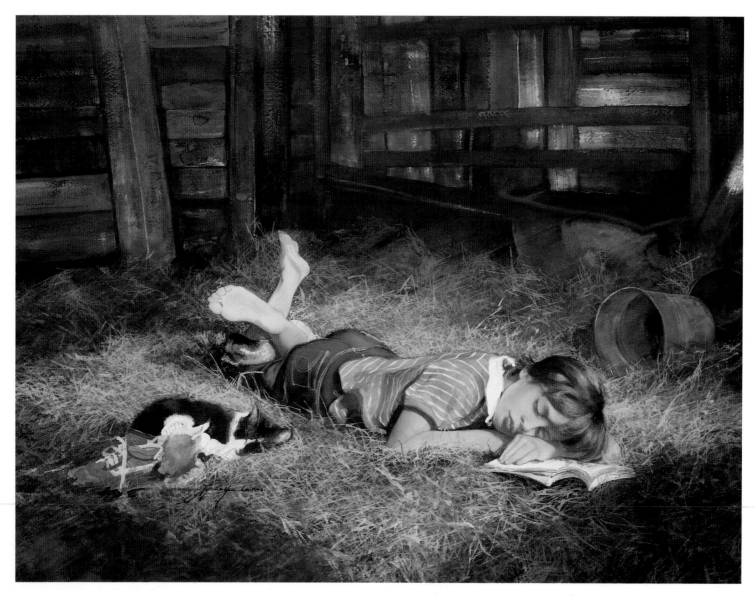

Create a Relaxed Mood With Dusty Shafts of Light

LYNNE YANCHA

To me, the splendor of light needs the contrast and mystery of darkness. The eye gravitates to the light and rests in the dark areas. In "Amber in the Hay," I chose to enhance the dusty shafts of light falling in a rectangle over the child and subdue all else so that the focus would remain with her. Creating a relaxed mood, one can almost smell the sweet hay, hear the soft breathing of cat and child, and only imagine what book has given wings to her dreams.

Scrub Edges to Create Atmosphere

LESLIE RHAE BARBER

I am inspired by subjects drenched in strong, direct light. The extreme range in values reflects my view of life, from its dark mysteries to its brightest moments. "Sunbathing I" invokes the intense warmth and comfort one feels from direct sunlight on a cool day.

AMBER IN THE HAY
Lynne Yancha
21" x 27"

I stumbled across the use of Liquitex White Acrylic as the means to correct the mistake or ruined white area. Since then, it has become an important tool in every stage of my work. Only at the end of a watercolor do I use the white directly from the tube as in Amber's collar or the book. It is usually mixed with a fair amount of watercolor and water.

right
SUNBATHING I
Leslie Rhae Barber
27 1/2" x 21 1/2"

For my saturated darks, I combine dark staining pigments, such as Winsor Green, Winsor Blue, Burnt Sienna, Mauve and Alizarin Crimson, layering with a combination of untouched paper and scrubbing for the lights. To create atmosphere and intrigue, I softly scrub found edges and lose others.

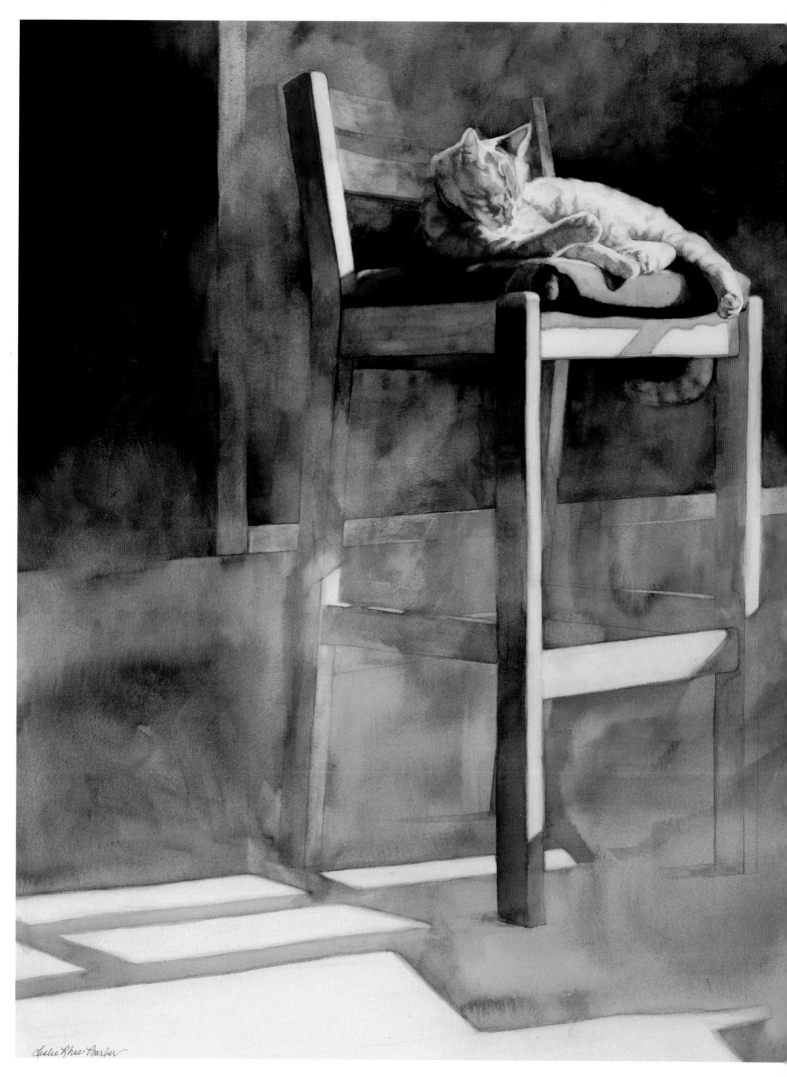

Leslie Rhee Barber

Express Feelings in Light or Dark

CAROL P. SURFACE

Design in art reflects our experience. In life, light gives energy and a warm, high-spirited feeling. On this premise, I use a variety of light shapes to express energy and movement. The brighter the feeling I want, the more light I'll use. By contrast, when I want to create more mystery and depth I'll use a lot of strong, rich darks. I strive for a marriage of the two that will provide a transition from one area of the painting to another.

NEW MORALITY
Carol P. Surface
22" x 15"

I tackled this with abandon, using lots of calligraphic strokes to contrast with the shapes I scraped away with a credit card. I was careful to save some white shapes to create a path for the eye, while I enhanced depth by laying in a series of wet-in-wet washes.

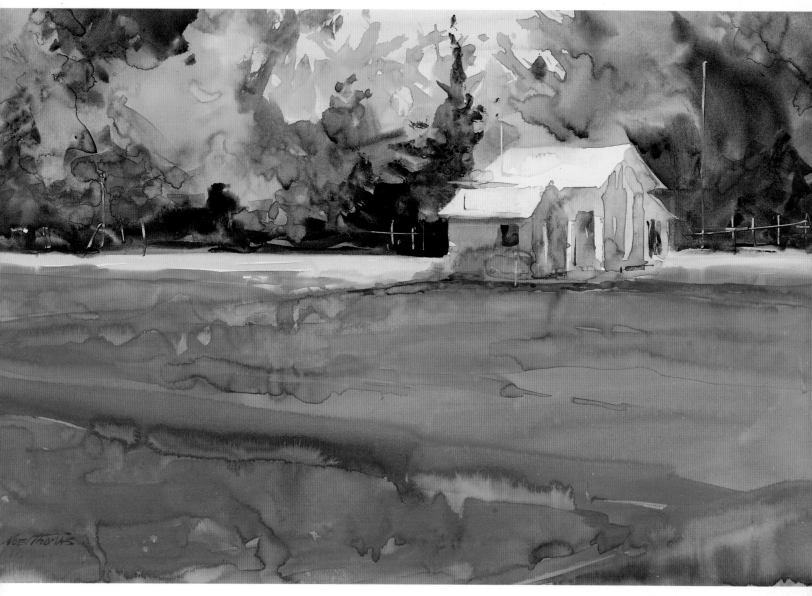

Search Your Memory for Beautiful Impressions

NOEL THOMAS

The quality of light and color in "Cranberry Bogs" was derived largely from memory, as my region of the Pacific Northwest is better known for its rain than excellence of light. These bogs border a road near my home. It's a locale I have always enjoyed for the isolation of the outbuilding and the seasonal play of light on the bogs and surrounding woods. To paint the impression of the light and color I have often observed there, I opened up the background trees to let in more light and allow the viewer's eye an escape. I exaggerated the horizontal yellow band between bogs and trees to imply bright sun. And finally, I introduced the beautiful alizarin red of ripe cranberries, a color which is largely hidden until October when the bogs come alive with color as the berries are floated out for harvest.

CRANBERRY BOGS
Noel Thomas
14" x 22"

I executed the painting directly on Strathmore plate surface bristol paper, saving the shed roofs to utilize the white paper, and with just a bit of pushing color out of the background to suggest a fence.

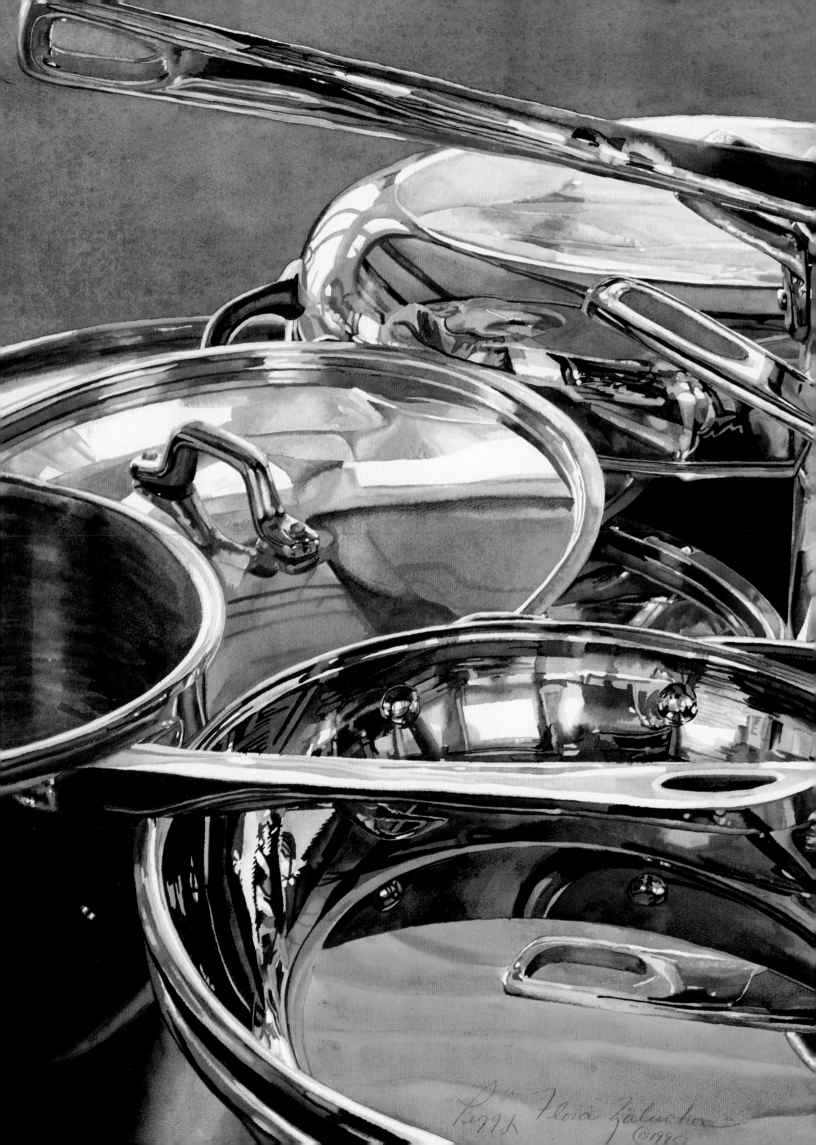

Peggy Flora Zalucha ©1995

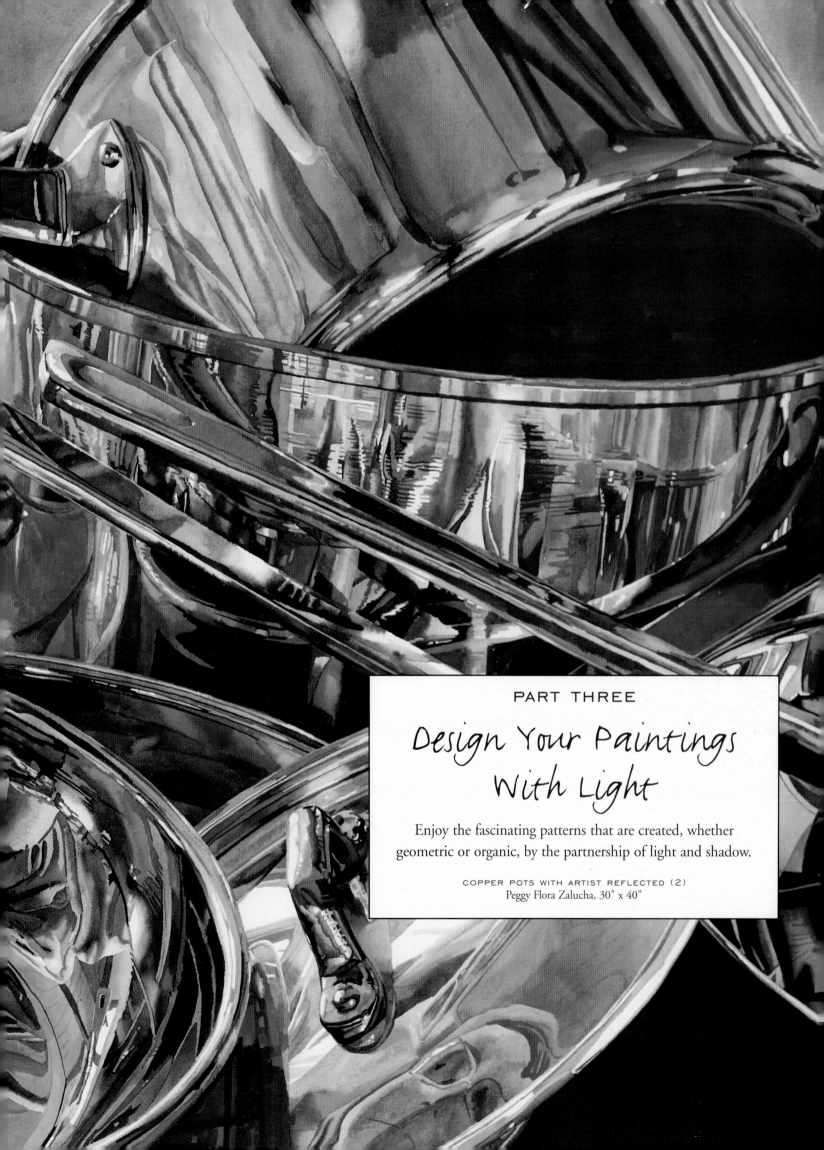

PART THREE

Design Your Paintings With Light

Enjoy the fascinating patterns that are created, whether geometric or organic, by the partnership of light and shadow.

COPPER POTS WITH ARTIST REFLECTED (2)
Peggy Flora Zalucha, 30" x 40"

Contrast Warm and Cool Light for Effective Abstraction

RICH ERNSTING

Most nautical paintings are pretty seascapes. I wanted to create a more diverse image using the dramatic contrast of warm and cool tones. The close-up and general views of the subject intertwine into one abstracted image. The intricate rigging and cool tones of the background propel the warm tones of the boat to the forefront, making this the focal point.

Orchestrate Values Into a Strong Abstract Design

DONALD STOLTENBERG

Light is the key, both as it is perceived in the subject and in the way it can be manipulated to give the painting a glowing life of its own. I tend to think of the subject as a light modulator, i.e., a series of forms with planes and hollows that swallow up, refract or reflect light. Then the painting is organized into an orchestration of values that build into a strong abstract design, a progression of soft tones, saving the purest whites, sharpest edges and strongest contrasts for final accents, the highest pitch or climax.

NAUTICAL DEPARTURE
Rich Ernsting
22" x 33"

Careful planning of light effects was essential. This took quite a lot of masking. The warm tones in the lower half were painted first. Then the warm tones of the upper half were masked out and the cool tones were painted.

right
S. S. AMERICA
Donald Stoltenberg
14" x 10¹/₂"

After indicating the main shapes with pencil, the paper is soaked and colors are floated on and allowed to run and mingle producing a very soft-focus pattern. When dry, the stretched paper is subjected to washing out of light areas and sharper edges by the use of a wet sponge through Mylar masks—a subtractive process. Dark shapes are then drawn and painted in with a brush—an additive process. These two methods are alternated, gradually building up form and detail. Spattering and paint applied in a ruling pen created texture and sharp lines and finally sharper accents of light are achieved through the use of Chinese White.

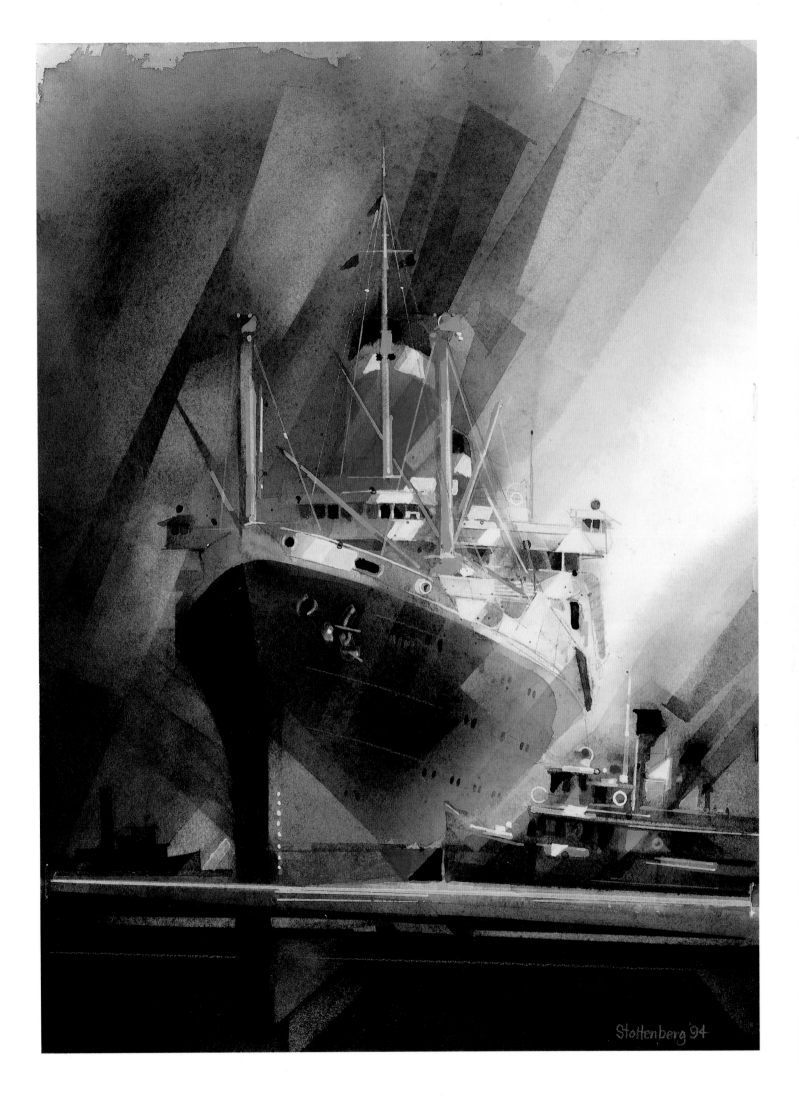

Stoltenberg '94

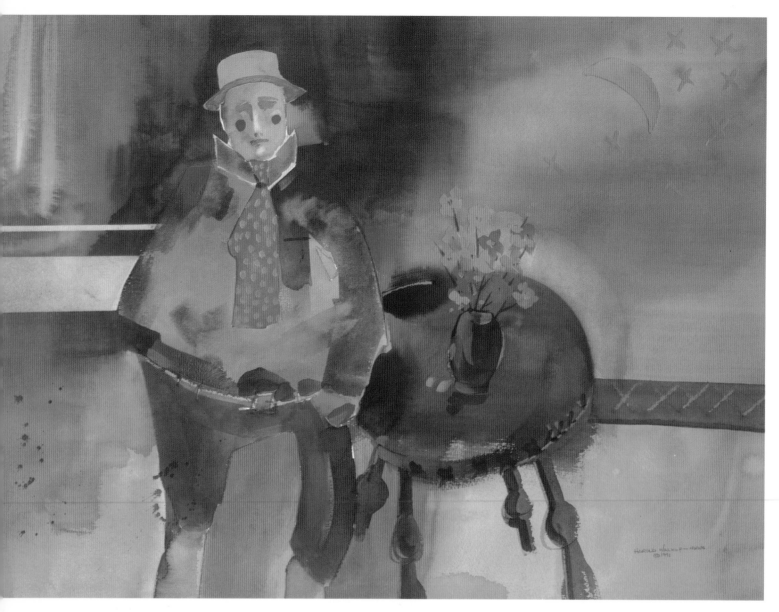

Set the stage, You're the Director

HAROLD R. WALKUP

Lights! Camera! . . . Placing a figure in a stage-like setting gave all sorts of opportunities to play with light and manipulate the relationship of the figure to the background. A spotlight effect left all four corners warmer and brighter, with the cools reserved for the figure and the immediate area around him. I emphasized the glow of light from the backlit areas by using darks and opaque color in the legs of the table and the moon and stars on the curtain in the upper right. A cast shadow would normally show beneath the table, but by back-lighting and putting another spotlight on the figure there were very few shadows to cast. This flattens the picture plane and relates the figure to the background.

THE APPRENTICE
Harold Walkup
22" x 30"

This painting seemed to need a lot of surface texture. Scraping into the wet surface, brushing clean water into wet paint to create back runs, spattered paint, and calligraphy were all used to create a feeling of "action" within the painting.

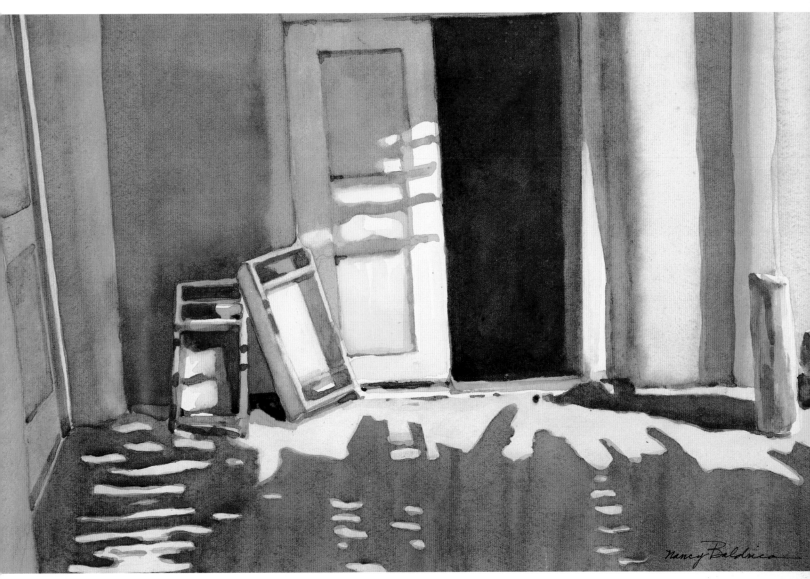

HACIENDA SHADOWS
Nancy Baldrica
15" x 22"

Notice When Light Creates Designs Upon a Scene

NANCY BALDRICA

I enjoy watching the seductive effects of watercolor pigment suspended in water when the lights come on. Of course the light is the paper. I have discovered the light is more brilliant when I let the painting paint itself. The less I touch the brush into water and paint, the brighter the colors. I painted "Hacienda Shadows" after visiting Martinez Hacienda in Taos, New Mexico. The light danced through the latilla (small wooden poles) onto the adobe walls, doors and floor, creating an interesting design of light and dark patterns. Since then, I have become attracted to subjects where light creates designs upon a scene.

For "Hacienda Shadows," I used liquid masking fluid to protect the whites so that I could freely apply color and water. I tilted the paper to let the paint run and mix by itself. This causes more granulation of the pigments and creates a beautiful texture (granulation is a settling of pigment particles into the surface depressions of the paper). After removing the masking fluid, I tinted some of the white areas with warm light and some with cool light. Then, the final touches were added—the darkest darks and details of doors and boxes.

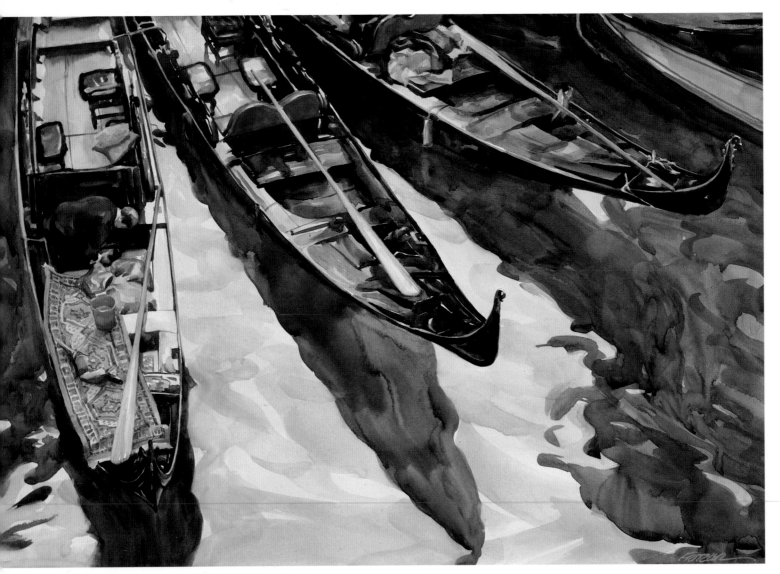

Design With shadows Cast Upon Water

GERALD J. FRITZLER

When light strikes an object a certain way, it gives that object its life, form and beauty. Late afternoon light is my favorite to paint. I especially enjoy backlit situations as the light catches an edge, top, or side of a subject, highlighting it against a darker-valued background. At the scene of "Gondolas," it was the interesting design of light and cast shadows in the water that caught my eye. The beauty of water is in how light accents its reflections.

Use Light as an Arrow

ESTELLE LAVIN

I use light as the instrument for drama in my paintings. In "Market at Vence," light is the arrow leading you through the painting . . . starting with the bright display of produce edged in shadow, through the darkest area of the painting and into the light once more.

GONDOLAS
Gerald J. Fritzler
18" x 26½"

I started with the darks of the gondolas and their reflections in the water, which immediately gave me the overall design pattern. I then carefully painted the reflection of the sky in the water, trying to catch its subtle movement.

right
MARKET AT VENCE
Estelle Lavin
40" x 25¾"

Masking fluid was applied to the edges of the crates and handle of the metal cart so that I could keep a crisp edge while applying washes for the dark interior shadows.

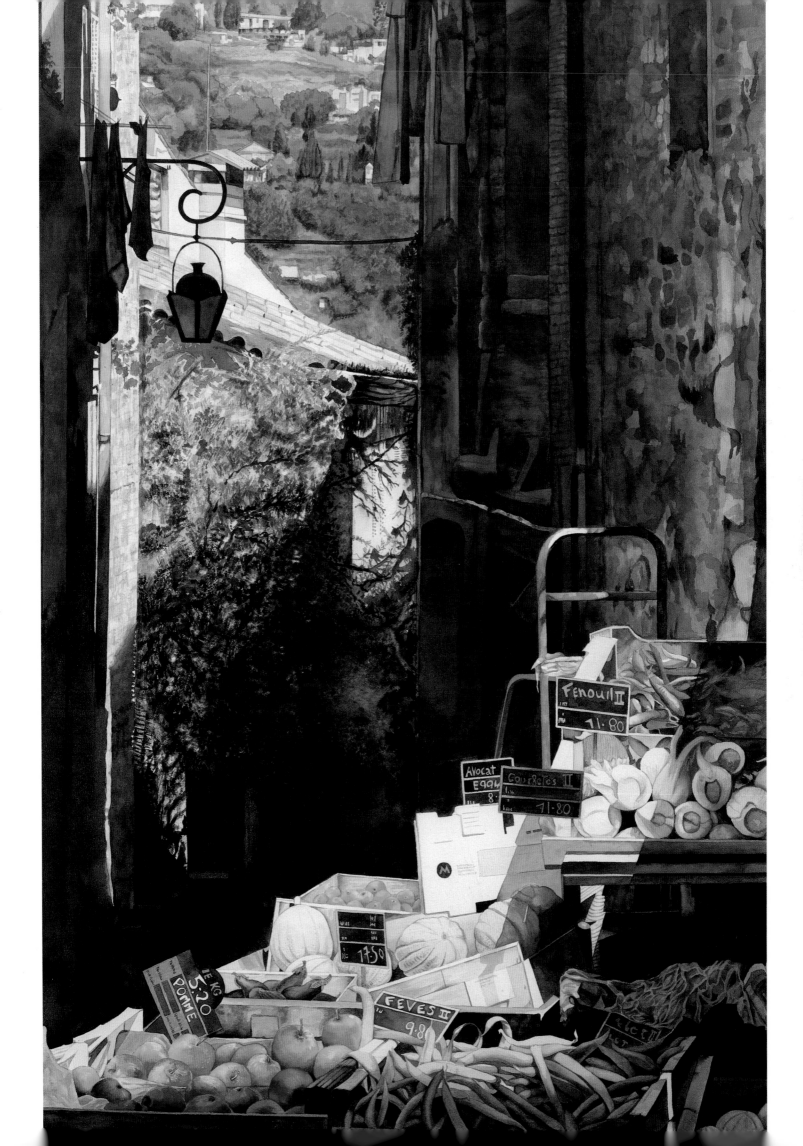

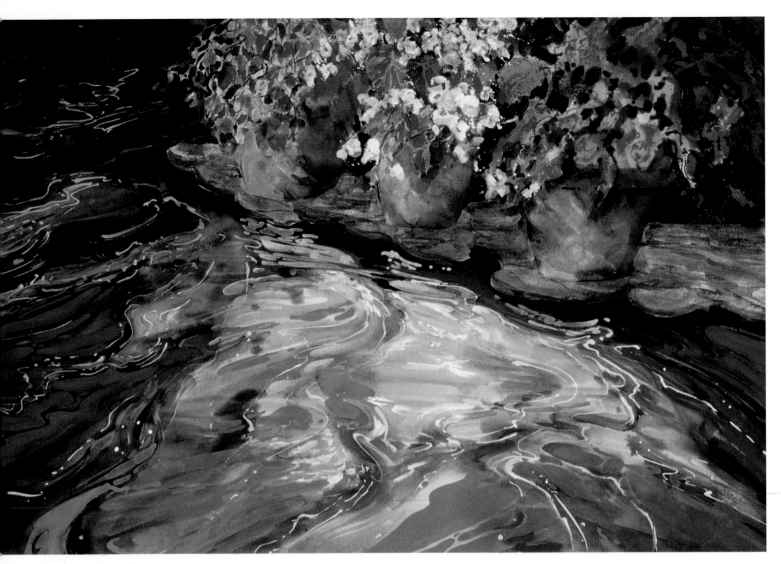

Water Reflections Create Rhythmic Shapes of Movement

BEV HAGAN

I had been painting water theme pieces for a couple of years and the shoreline reflections gradually became a study of light and sky reflection. My observations told me that the light reflecting on the crests of the ripples often repeated the colors and mood of the sky, not just the geology of the shore. The focus in "Pots Reflected" is in the foreground shapes and colors of light and sky dancing on the moving water's surface. Rhythmic shapes of movement and light start in the distant upper left and become stronger, larger, more defined and lighter toward the middle right. The clay pots are a more dominant part of the reflection than the flowers which add sparks of color. Detail in the painting is concentrated in the light effects on the water's surface.

POTS REFLECTED
Bev Hagan
30" x 40"

A wet-in-wet start in bold color with subsequent dark staining layers set the stage for the painting. To increase the textural interest, the flowers and pots were splattered with white acrylic and painted over in watercolor. To finish, bold, light blue shapes were painted on the water's surface to describe how the light plays on the undulating crests of the water.

My approach to watercolor is quite traditional, working from light to dark. Cerulean Blue is one of my favorite colors; I use it to mix light grays and accents of cool color. Occasionally, I use masking fluid for thin highlights, but usually I paint around the whites.

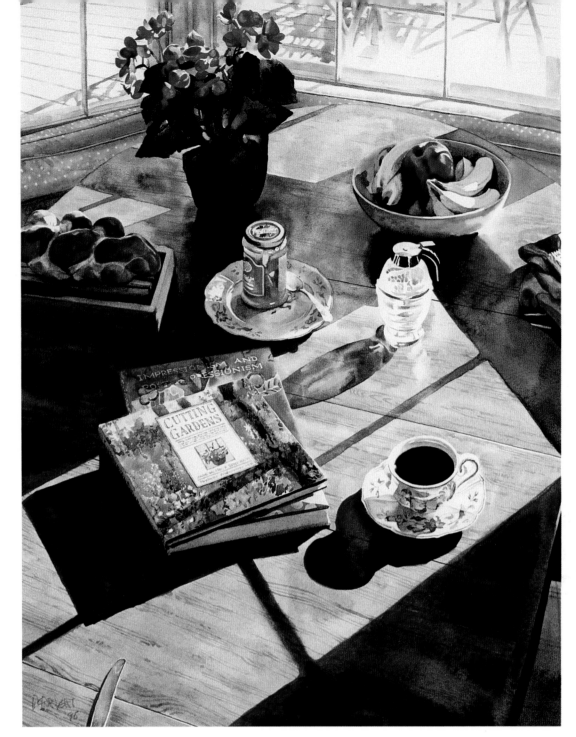

Backlighting Creates Strong Geometric Patterns

WILLIAM C. WRIGHT

Light became the focus of my work since I began setting up my still lifes outside during the summer. I encountered strong backlighting that cast abstract shadow designs unifying the whole arrangement. Some objects blended into the background while others stood brightly lit creating soft and hard edges. I am also fascinated by reflected color bouncing off objects and into the deep shadows. I carry these two themes indoors during the winter by setting up arrangements in a sunny window. This still life uses the strong geometric patterns created by the window mullions, books and coffee cup. All of these design elements (color, shape and texture) originate with strong backlighting.

Create Color-Filled Shadows With Colored Glass

MICHAEL J. WEBER

Light—it curves around, shines through, bends over and bounces off, defining all surfaces. In my studio, I work for complete control of that light. My still life set-up is deliberate. I can create color-filled shadows by juxtaposing and overlapping objects to take advantage of the transparency of the glass. I look for the play of contrasts: hard against soft edges, warm against cool tones.

STILL LIFE IN RED, WHITE
AND BLUE
Michael J. Weber
16" x 28"

I begin with the use of masking fluid to block out the solid areas. The background goes in first (background tone will influence all other glass colors). I then paint in all objects, working from the rear of the composition forward. The shadows in the fabric are established last along with the design on the cloth.

Try a Floodlight Effect for a High-Key Painting

ANN PEMBER

Flowers bathed in light create wonderful abstract shapes. Photos allow me to freeze the lighting, and I refer to several when developing a composition. For a dramatic design I use a spotlight effect and for a sun-filled, high-key painting I use a floodlight effect as in "Piquant Peony." Some out-of-focus areas are used to support the brilliant subject. These are painted transparently and loosely, without too much detail. I push color changes within the whites, going from warm to cool and using many subtle shadows. The warm glow that sunlight imparts to objects is what I am driven to explore.

PIQUANT PEONY
Ann Pember
21¼" x 29"

I pre-wet areas and float colors in, letting them mingle on the surface, achieving the desired intensity with the first wash. This preserves the glow of white paper through the paint. The use of very white paper, such as Bockingford, enhances this effect. Whites are saved rather than masked, so that edges can be easily softened. The paper, clipped to a board, is tilted almost vertically to encourage the paint to move.

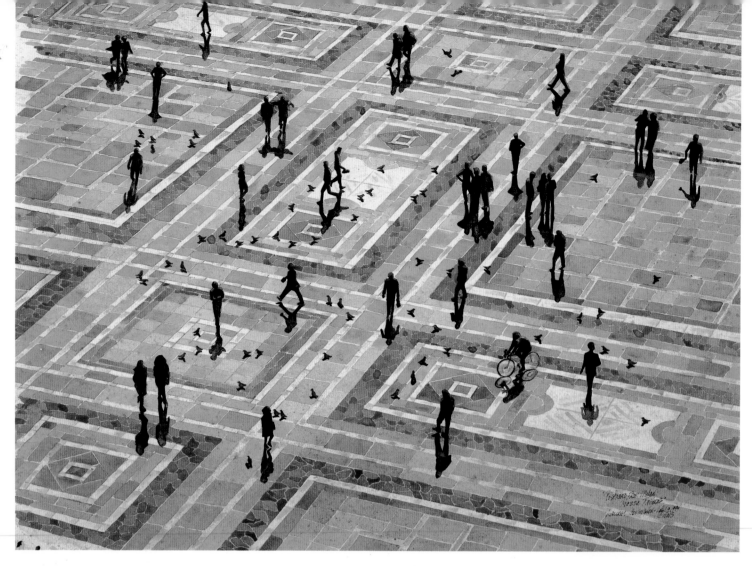

Shadow Patterns for Unusual Viewpoints

LAUREL COVINGTON-VOGL

Shadow patterns are the inspirations for this series of paintings. I take photographs from cathedral rooftops and bell towers, from stairways, and even from the upper levels of shopping malls—from any unusual viewpoint that intrigues me. I begin my paintings with detailed drawings, combining and developing shadows to determine shapes and patterns. I am intrigued by light and the ways in which it alters forms, erodes edges, and creates shadows. The anonymous individual figures create a unified pattern by the interactions of their cast shadows. This series has been a fascinating exploration for me. Each completed painting suggests new directions, new patterns, and new qualities of light to explore.

Weave a Pattern With Your Whites and Lights

DAN BURT

This painting evolved from seeing bright sunlight on old buildings in the Mexican colonial city of Guanajuato. The light appeared even brighter because of the dark shapes and the very dark tunnel. I exaggerated value and color contrasts and distorted shapes to get the viewer's attention. I connected the saved whites and light-value colors, weaving a pattern throughout the darks to hold the composition together. The predominant darks make these lights sparkle and vibrate.

POSTCARD FROM MILAN: PIAZZA PATTERNS
Laurel Covington-Vogl
24" x 30"

The Piazza paintings begin with a light wash of graded color to which I add a variety of spatters and drips to suggest the rough texture of the stones. The individual pavement stones are built up with several layers of glazes. I particularly like to mix Manganese Blue with my base color because of the granular texture it creates when it dries.

right
CALLEJON II
Dan Burt
30" x 22"

I worked light to dark, painting around saved whites and light value colors and around high chroma colors in and around the focal point. I let the colors mix on the paper during much of the painting, especially for the middle and dark values. After the painting was dry, I put in the darkest dark around the focal point, the figure.

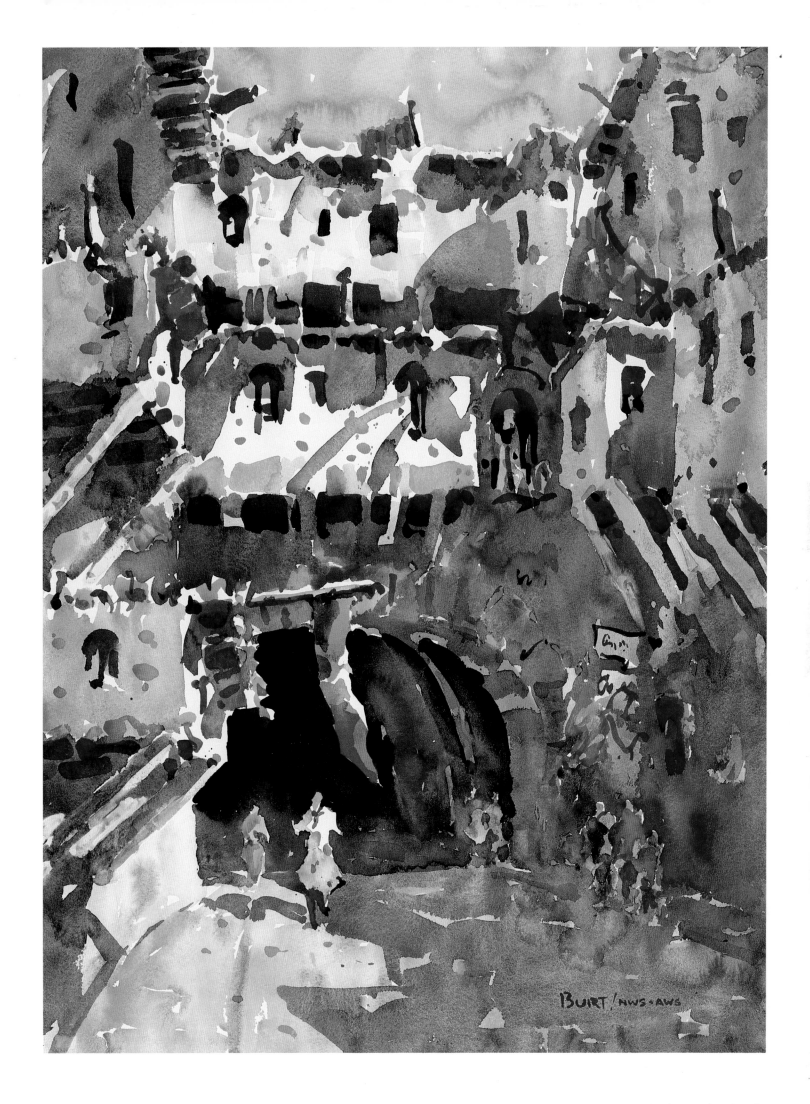

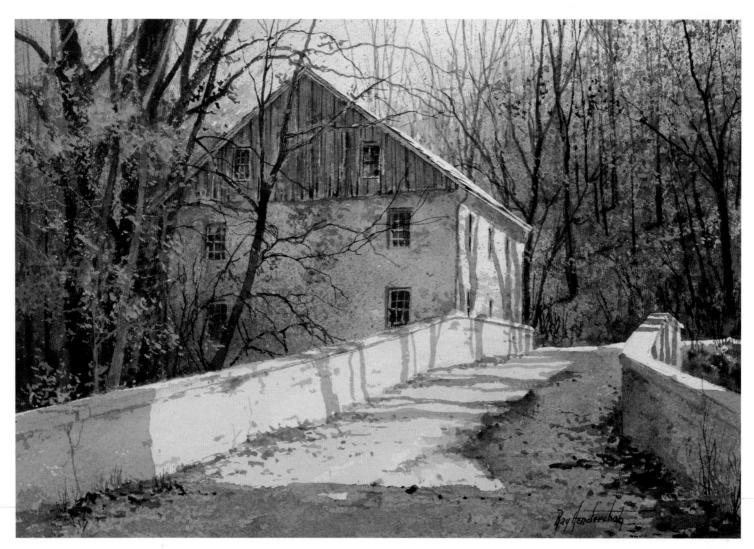

MILLBRIDGE
Ray Hendershot
6³/₄" x 9³/₄"

Fingers of Light Point to the Center of Interest

RAY HENDERSHOT

There is nothing more dramatic than the effects of low-angled, early morning sunlight. Long fingers of light and shadow reach out across the landscape, following the contour of everything in their paths, defining forms, highlighting textures and establishing interesting compositional shapes. In "Millbridge," horizontal bands of light and shadow lead the eye of the viewer from the extreme foreground into the middle distance, to the center of interest, the place of strongest value contrast—the sunlit side of the old mill.

"Millbridge" was painted in three sections, beginning with the background and working forward. Each was brought to near-completion while the other two were masked out with frisket. This provided a distinct separation between layers and created a strong illusion of depth.

right
CADDY CHROME
Charles W. Munday
28" x 22"

Abstract Detail Adds Up to a Realistic Image

CHARLES MUNDAY

The essence of my automotive watercolors is the reflections. Reflected light brings out the various fusions of shape and color. I generally do not light the subject artificially but prefer to view the automobiles in their natural environment. Reflected light, color, shapes and patterns become abstract elements when looking closely, but add up to a realistic image when one views the piece from a distance.

This requires a careful drawing. To this I add wet colorful washes to be used later as an underpainting. I then put down layers of light transparent washes. The heavier and more opaque glazes are used at the end without disturbing the previous layers.

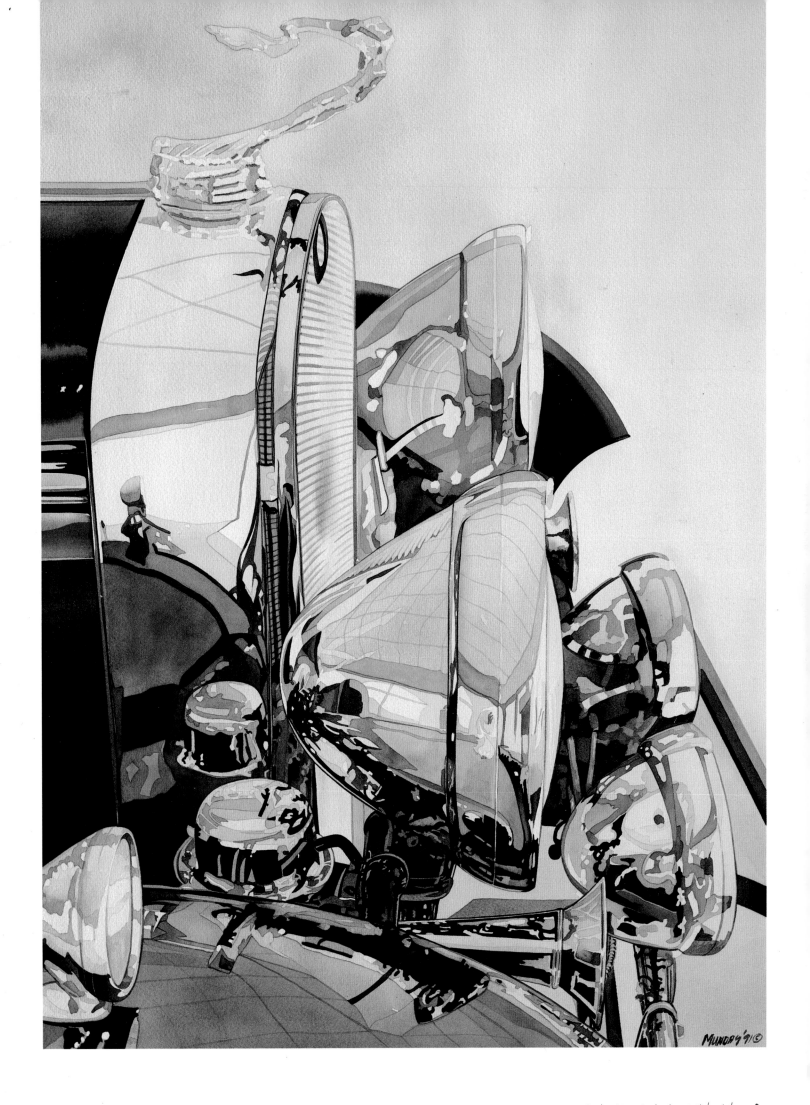

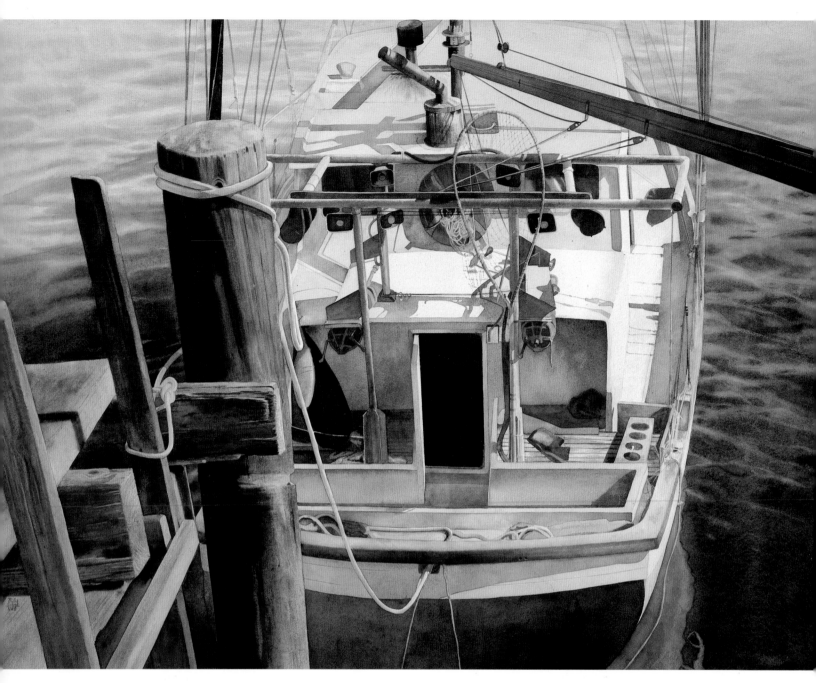

Alter Perspective for Added Interest

PHYLLIS SOLCYK

After endless weeks of smog, heat and crowded freeways, it was a treat to be walking on a pier by the ocean. "Making Ready" started with the smell of fresh paint and the quiet rumble of idling engines. Watching preparations, I walked nearer the edge of the pier; there a ladder descended to the lower platform. The sun glistening off the fresh paint and water created the first painterly spark. A quick sketch and some photos were all there was time for. The boat's crew finished, and they were off. "Making Ready" would have worked as a straightforward composition, but I felt altering or forcing the perspective, especially on the pier and mainsail's boom, would add interest.

MAKING READY
Phyllis Joan Solcyk
30" x 40"

I like rough paper for waterscapes. Here I wanted the newly painted white of the boat to dominate, so sedimentary colors were chosen for the surrounding waters, then discreet lifting suggested the light-struck tops of the ripples. To suggest the weathered wood of the pier, color was applied, dried, then sponged back to lessen the light-reflecting quality of the paper.

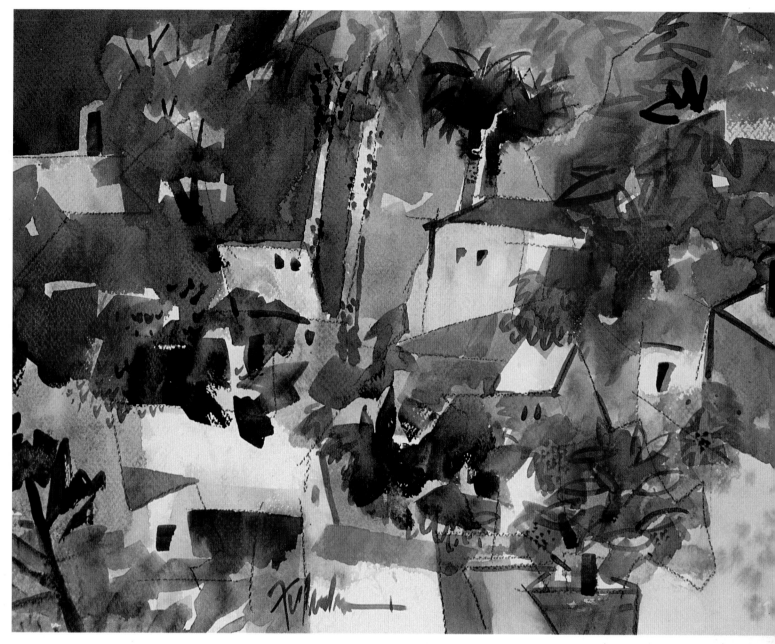

SANTA MONICA CANYON
Henry Fukuhara
18" x 24"

Make Your Largest Area the Center of Interest

HENRY FUKUHARA

When I see the eloquence of light on a landscape, it provokes me to ask if it is a good light shape with eye-catching impact and with good mid- and dark-value shapes interlocking. The first thing that attracts and holds me to a subject is the area where the light has the largest impact. Good subordinate light areas are important, but don't lose sight of the largest area of light; this becomes your center of interest.

I use the "No-Brush Painting" method. This can be combined with any method of watercolor painting. Pigment is applied with a plastic card, after moistening on the palette. Marks are made by using the edge, scraping with a downward or sideways motion. It is also possible to make organic marks, such as foliage shapes. By using a card, stick or fingernail, one can add rocks, grass, tree limbs, etc.

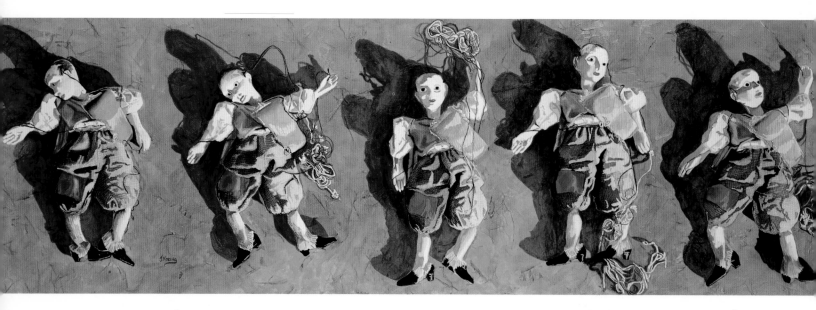

Design With Exaggerated Bottom Lighting

JUDY KOENIG

I use light to create an emotional environment. One of my earliest influences was Rembrandt and his use of chiaroscuro. I have always loved the dramatic quality of bright light and shadows that dissolve the figure. Light also gives form to objects, especially when used in an exaggerated manner such as the bottom lighting in "Who Pulls the Strings?" I found the puppet in an antique shop in Ojai, California, and fell in love with it. It was so old and yet still so expressive, with no machine-made look to it. I photographed the puppet in bright afternoon sunlight to create extreme cast shadows. I combined five of the photos when designing the painting.

I painted the background surface first and then added an overlay of tissue paper collage. When this was almost dry, I gave it a thin wash of dark brown acrylic paint, which antiqued the background surface and achieved the look of an ancient wall. The areas of the puppets did not have any collage and were painted in a standard manner. I used the pointed end of a reed pen to incise the lines in the pants and vests.

Strong Dramatic Light Allows for Bold Background Design

CARLA O'CONNOR

In "After Eight" the strong visual impact of the figure bathed in dramatic light from one side enabled me to exaggerate the background design and suggest limited space. The illumination of my subject produced the play of warm to cool color that was an important factor in the transition from figure to abstraction.

This was painted on very smooth hot-press board using transparent watercolor and gouache mixed freely on my palette. Gouache sits on the paper surface giving me the freedom to lift color and make changes as I go.

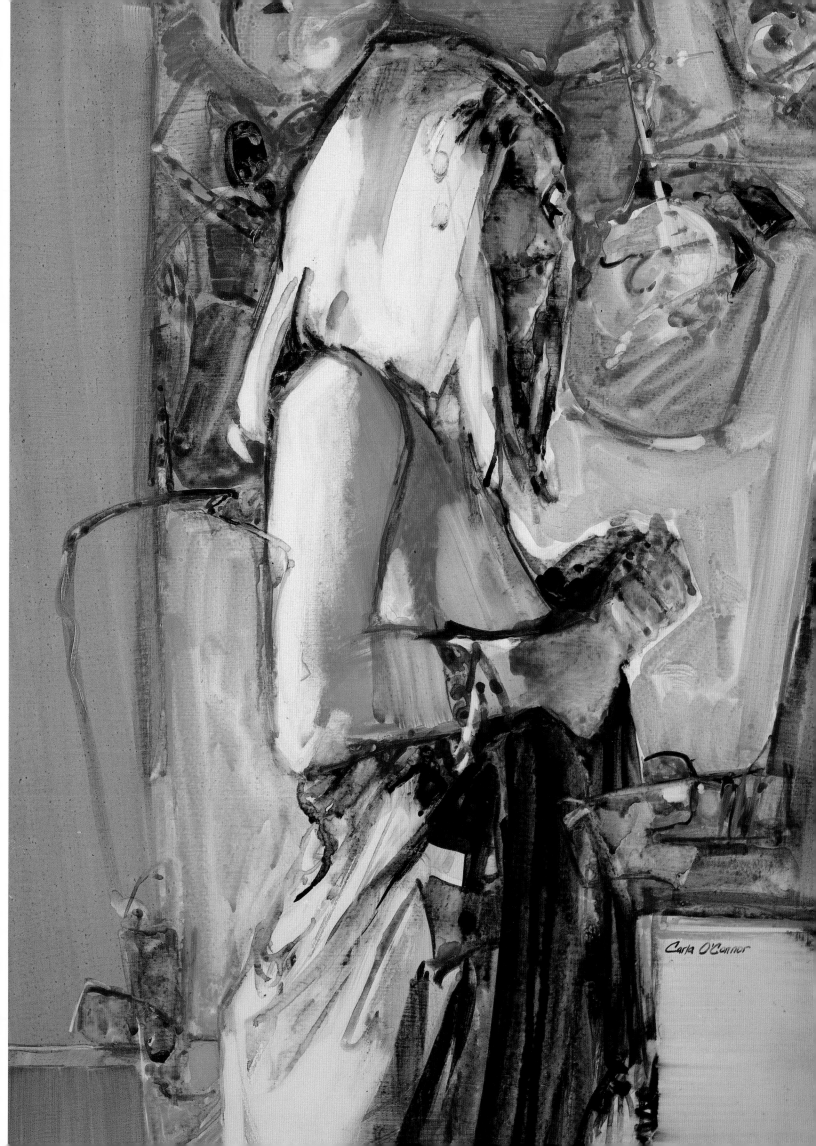

Carla O'Connor

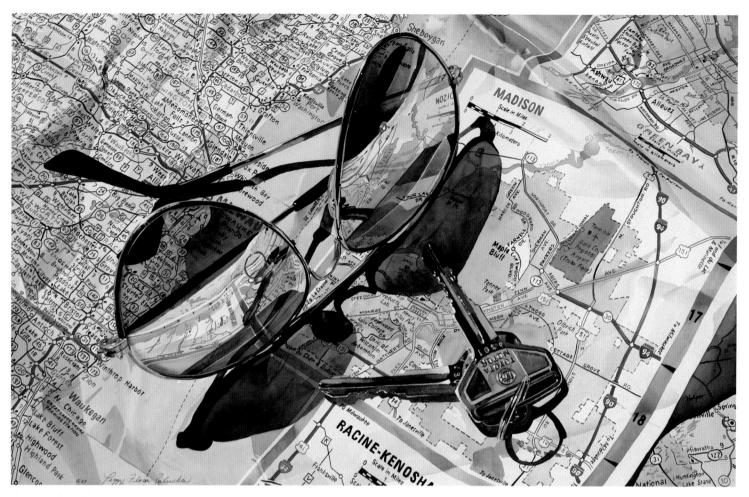

Introduce Reflective Surfaces

PEGGY FLORA ZALUCHA

The way that light and objects change when reflective surfaces are introduced into a painting is interesting to me. Not only do you see the object, but also the world around it. In some of my paintings, I reflect myself into the surfaces (see pages 68-69). In this one, the keys are a symbol of my presence. The keys and glasses refer to our mobile society; the map is of areas I travel most frequently (mostly delivering paintings).

Arrange Design Elements to Set the Mood

BILL JAMES

The main objective for this watercolor was to paint an emotion—sadness—that affects everyone from time to time. To convey loneliness, I placed the figure with a lot of negative space around her and positioned her arms in an embrace as though to comfort herself. I chose blues and purples for the background and painted the face and arms with subdued washes of raw umber to give her a pale, withdrawn look. To make the mood even more somber, I glazed over areas with Davy's Gray.

READY TO ROLL
Peggy Flora Zalucha
26" x 40"

The map was painted first as if it were white paper with no printing on it, defining the folds and wrinkles, using mixes of transparent watercolor or acrylic. Then the lettering was applied in India ink or watercolor. The other objects are of transparent watercolor.

right
MELANCHOLY
Bill James
27" x 18¹/₂"

My watercolors are painted with gouache, primarily on a smooth gesso-coated surface of either illustration board or watercolor paper. Because the pigment doesn't sink into the surface, I can maneuver the paint easily and work over areas with glazes of color.

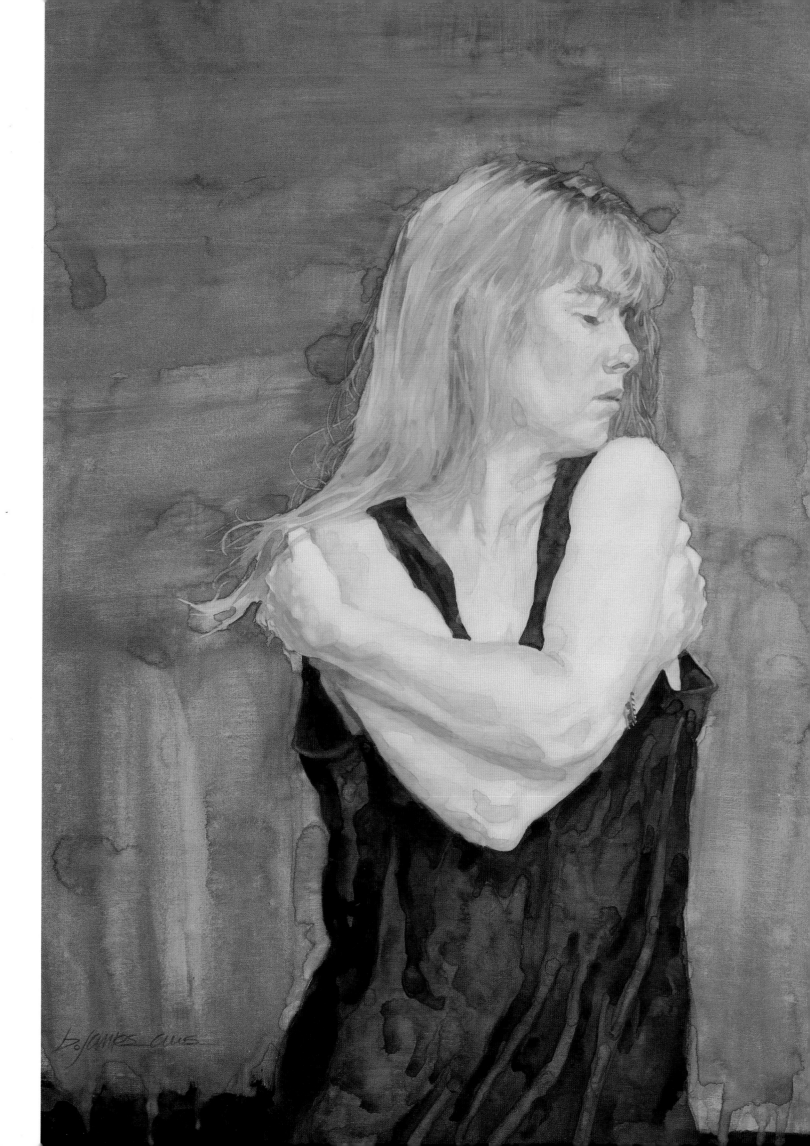

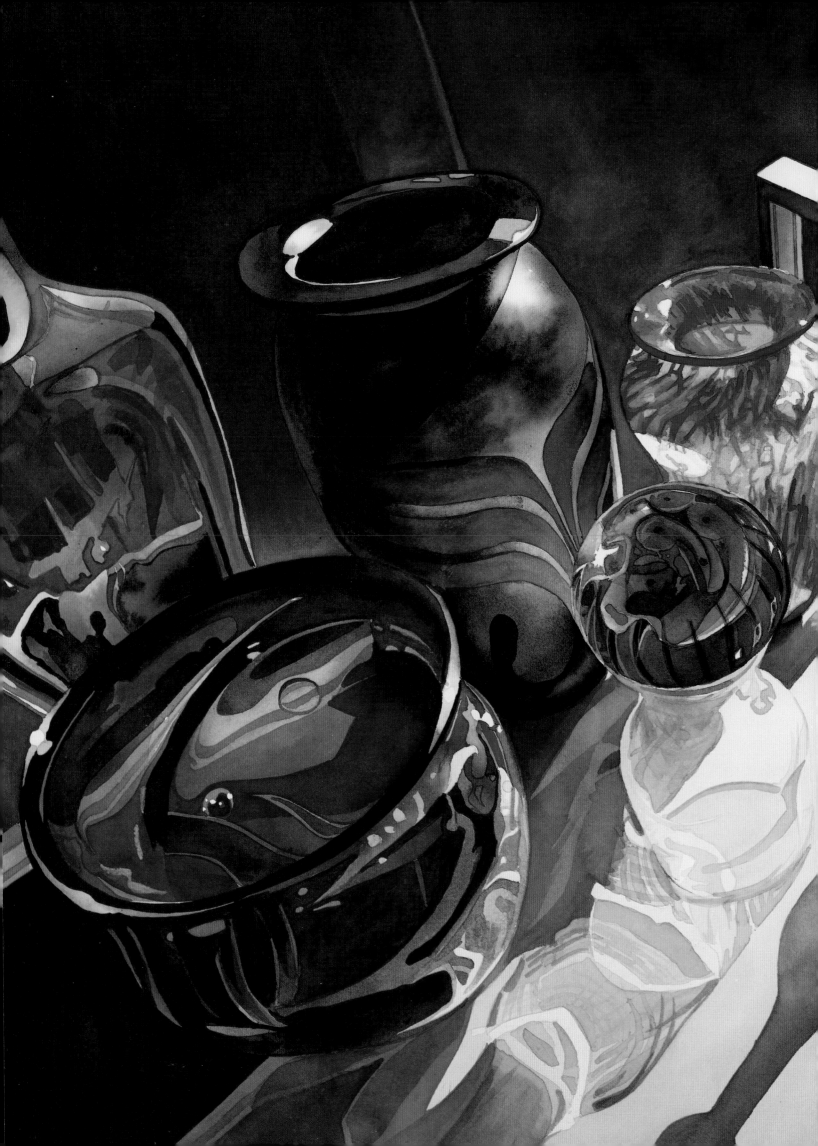

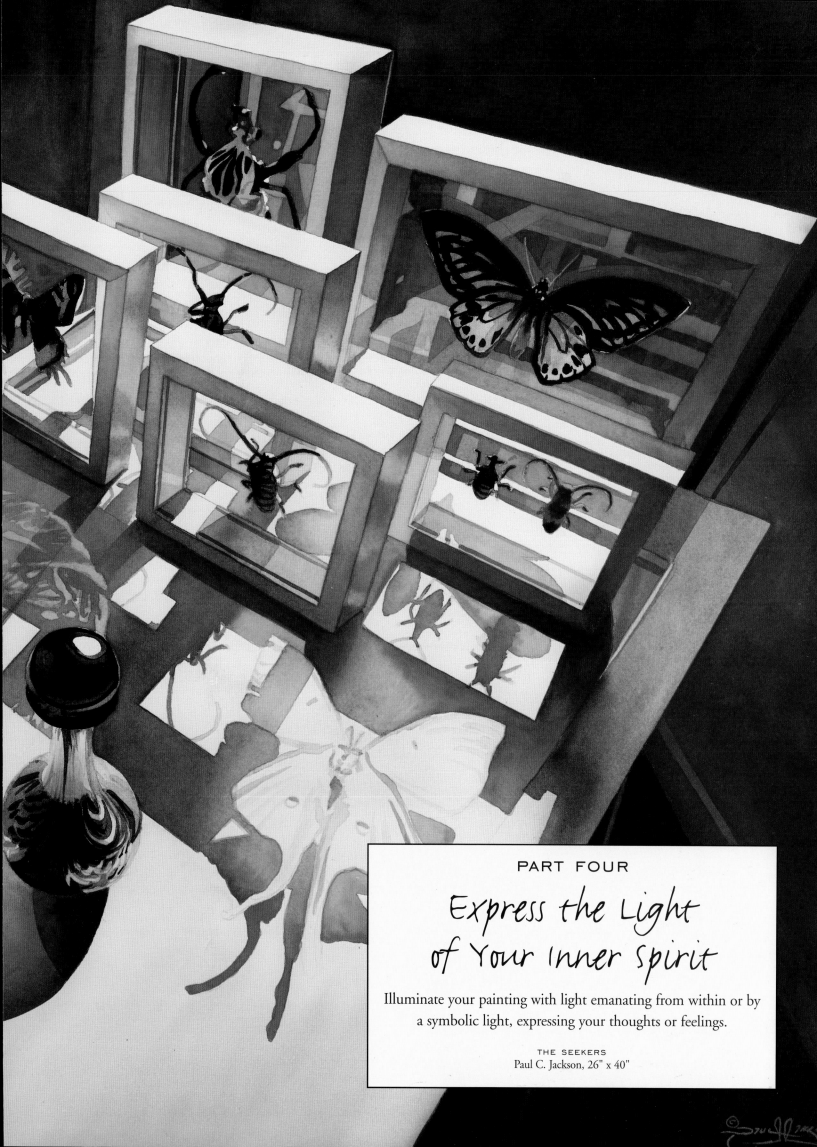

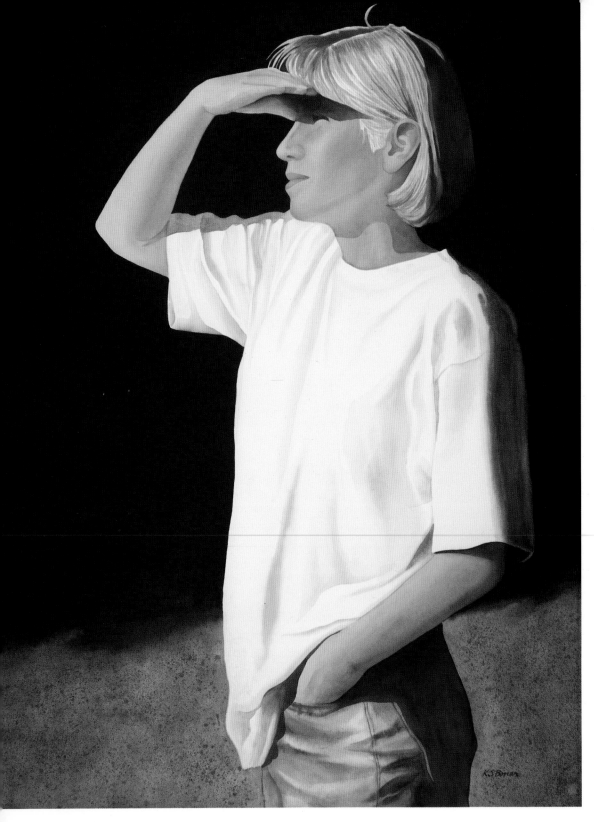

The Eternal Struggle Between Light and Darkness

KIM STANLEY BONAR

Soft light with subtle shadows is most commonly used when rendering the figure, especially in portraits, because it is the most flattering. The figure in this painting, however, is standing in direct sunlight which blurs details and creates harsh, angular cast shadows. "Into the Light" is part of a series of paintings documenting my personal relationship with Jesus Christ. Before me shines God's perfect love and behind me lurks my selfish nature, characterizing the eternal struggle to walk out of the dark and into the light.

INTO THE LIGHT
Kim Stanley Bonar
30" x 22"

I begin with thin washes to block in the shapes and define the composition. The values are built up gradually with repeated glazes to create the illusion of depth. The image is faint at first and slowly grows in intensity like watching a photograph develop.

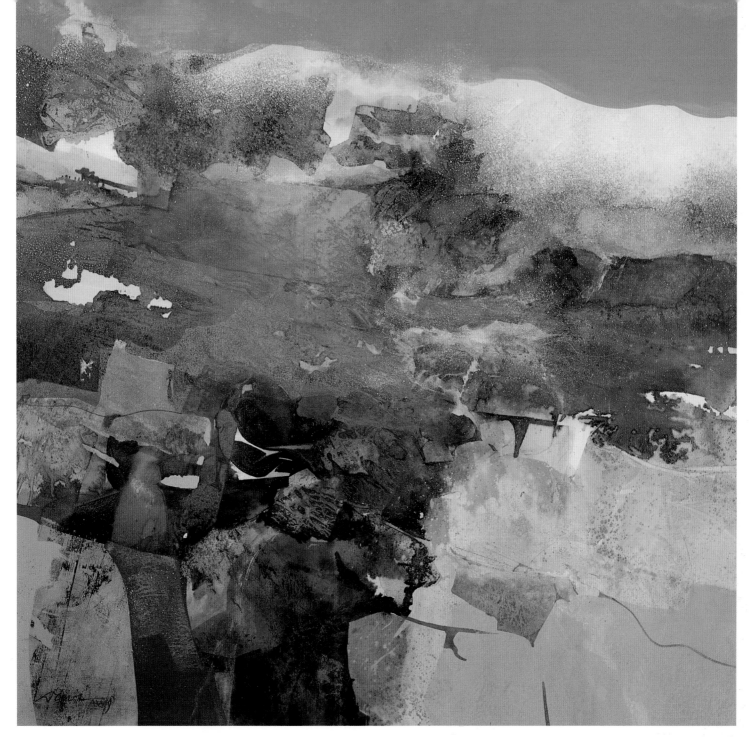

Internal Light Emanates From the Painting

PAT DEWS

ACADIA REMEMBERED
Pat Dews
27" x 27"

I used to paint to create an internal rather than external light. I am more concerned with creating illumination that emanates from within the painting than one created by a fixed light source or physical phenomenon.

"Acadia Remembered" began with a preliminary pour of paint. In my mind's eye I envisioned a landscape so I selected colors toward that theme. I poured a wash of gold ochre to signify light and to act as underlying structure.

I was careful to leave small sections of exposed white paper as lights to move your eye through the painting.

Memories and photos from trips to Acadia National Park inspired this work; while not a particular scene, it is the essence of the Maine Coast I love.

In my initial pours, I used plastic wrap and waxed paper to create textures. In subsequent layers I cut waxed paper shapes and brayered these onto the painting, removing them when dry. Opaque white ink was sprayed to form the white wave section. I used alcohol to create foam and diluted bleach to recapture some of my lights. I use any and all techniques.

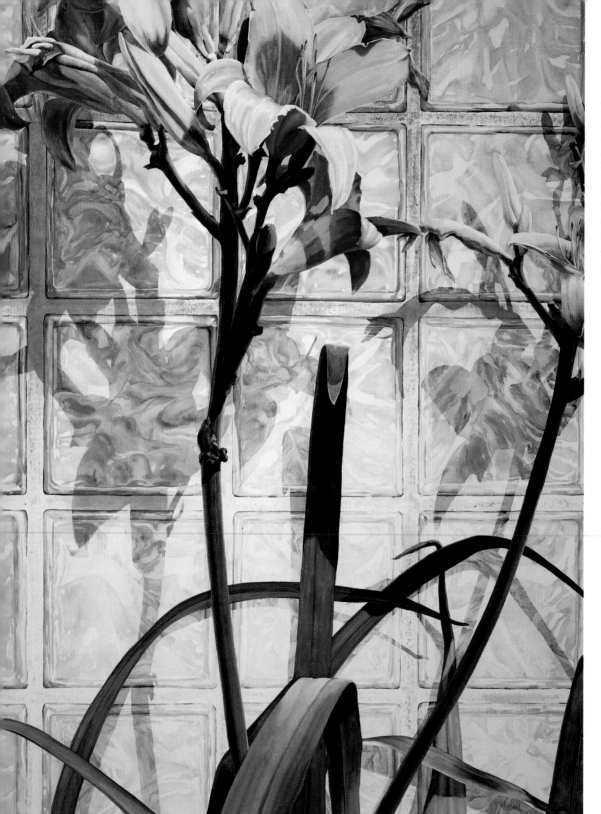

LILIES AND GLASS BLOCKS
Mary Lou Ferbert
54¹/₄" x 39¹/₄"

I masked out critical areas with ordinary cellophane tape in order to retain the clean whites of the paper for later use. By doing this, I was not restricted to small brushes and carefully controlled painting strokes. I could use freer arm gestures with larger brushes that carry more pigment and/or water, creating a bolder, more full-bodied image.

Let Glass Transmit an Interior Light

MARY LOU FERBERT

Several years ago I stumbled on a scene in Cleveland's industrial valley that riveted my attention. Early morning light illuminated a large glass block window in an abandoned structure. The glass blocks reflected, refracted and absorbed the sunlight, and transmitted the interior light. The sight was so compelling it inspired a large series of paintings. For me, the shadows are fossil imprints of the spirit of the plant, locked in time by the painting of the piece. The glass blocks with their enigmatic hieroglyphics, which obscure the space beyond, have become my metaphor for immortality.

Depict Endurance With Intense Top-Lighting

WARREN TAYLOR

In Acuna, I wanted to communicate the intense hot light of midday in the intensely crowded and disheveled Mexican border cities. The light is from straight above as at high noon. I worked from an assemblage of broken Mexican ceramics, observing the setup on an outside deck. I raised the flowers in my garden specifically for this painting and they came to represent the resilient and resourceful natives of these barrios and ciudads. From the beginning, I knew a golden ochre palette would be central to depicting the feeling of hot white light. Cast shadows are minimal at midday which helped accent the feeling of crowding and congestion. All participants assemble in tight ranks to endure the searing light from above.

ACŪNA
Warren Taylor
40" x 60"

The golden ochre is a key color, so the top open area was done first to set the tone, literally. The pattern in the foreground was painted and over-glazed with the same ochre. The strategic flower forms were masked out during the entire painting process and were the last elements to be painted.

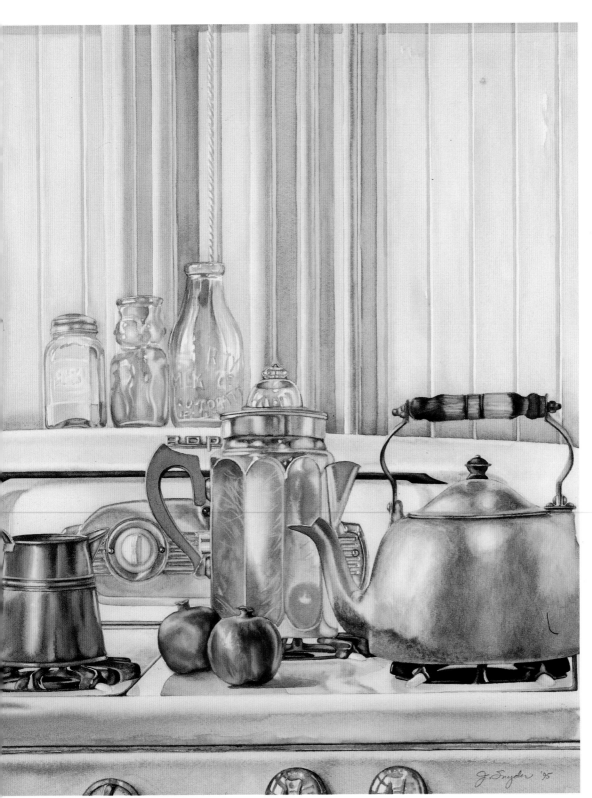

STILL LIFE WITH POMEGRANATES
Jennie K. Snyder
21" x 27"

In keeping with the theme of simplicity, my paintings are done in transparent watercolor, without the use of masking fluid or other media. I work directly from life, mostly wet-into-wet, my darkest values first (darker than I think they need to be), so I don't have to go back into a wash and risk overworking it.

A Soft Constant Light That Whispers of Simplicity

JENNIE K. SNYDER

This antique Roper stove stands just to the right of a kitchen window. Because that side of the house gets no direct sunlight, there is a soft, incandescent and constant glow as the brightness reflects off the white enamel stovetop and yellow ochre wall. The significance of that subtle, unwavering radiance lies at the core of my current series, "A Simple Life": Like the familiar, utilitarian objects it illuminates, it speaks in whispers of the simplicity, safety, strength and endurance that so elude us in a modern world.

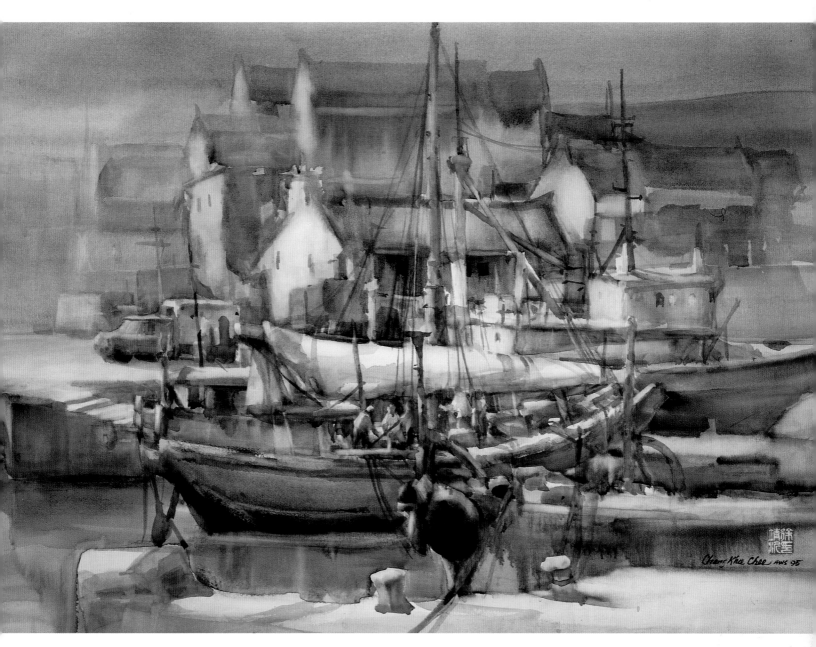

Capture the Gentle Veil of Morning Mist

CHENG-KEE CHEE

I am an early riser. The freshness of a new day gives me the feeling of cheerfulness, hope and optimism. Objects wrapped in the soft and gentle morning light form subtle and magical patterns. The morning mist forms a veil that minimizes value contrasts yet gives a broad range of edges and spatial relationship. The views are elusive, transient and poetic—irresistible to paint. I visited my hometown in southern China last year. In this painting I tried to recapture the poetry of a morning harbor scene interwoven with my deep feelings. The distant buildings form broad shapes with diffused edges. The mid-ground objects have soft outlines and restrained colors. The foreground boats and people assume distinct colors, light, shapes and value pattern.

MORNING HARBOR
Cheng-Khee Chee
30" x 40"

Here I used the saturated wet technique with Lana cold-press paper. I painted the broad shapes of the back- and mid-ground first when the paper was still quite wet and lifted out lights. By the time I proceeded to the foreground, the paper became drier and I was able to establish harder edges yet still lift out shapes.

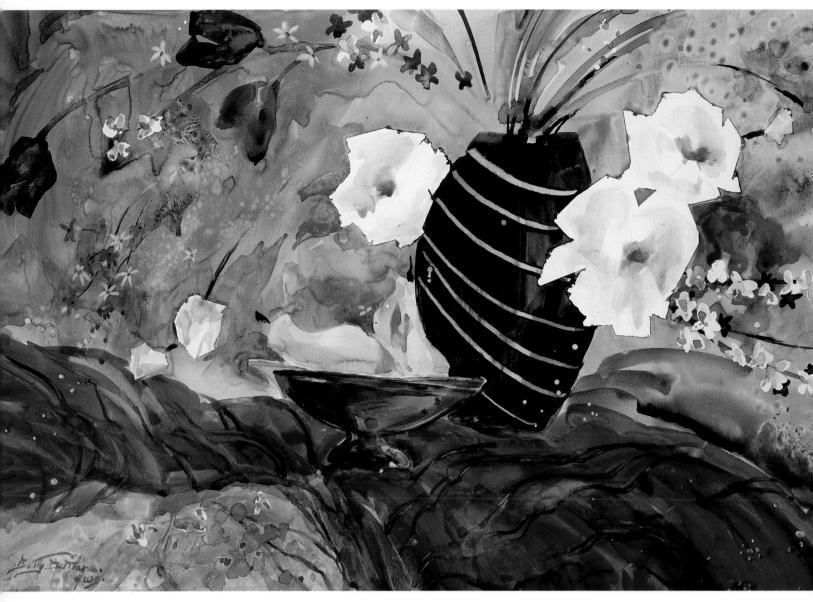

Send a Bold Message of Joy and Excitement

BETTY DEMAREE

Painting is communicating—letting the abundance of your love flow out to the world through your use of paint on paper. I painted "Black Porcelain" with this in mind—to communicate the bold excitement and rich drama of black and white with an underlying glow of color with a wild splash of red drape below. The huge white poppies gave me an enormous feeling of satisfaction, with their jagged edges and chunky forms. The scraped-out stripes on the vase were a delightful afterthought. Later I added echoing sparkles of light with tiny white flowers. Light is something sacred like life itself. I want my paintings to send out messages of joy and love that glow with that light.

BLACK PORCELAIN
Betty DeMaree
20" x 30"

Before wetting the Strathmore plate illustration board I applied masking fluid (very sparingly) for a sparkle of white in the spray of white flowers. The pears, tulips and stems were shaped with vigorous, free strokes and chiseling around objects. The crude and chunky poppies were formed by laying down strips of torn, twisted masking tape as a masking device.

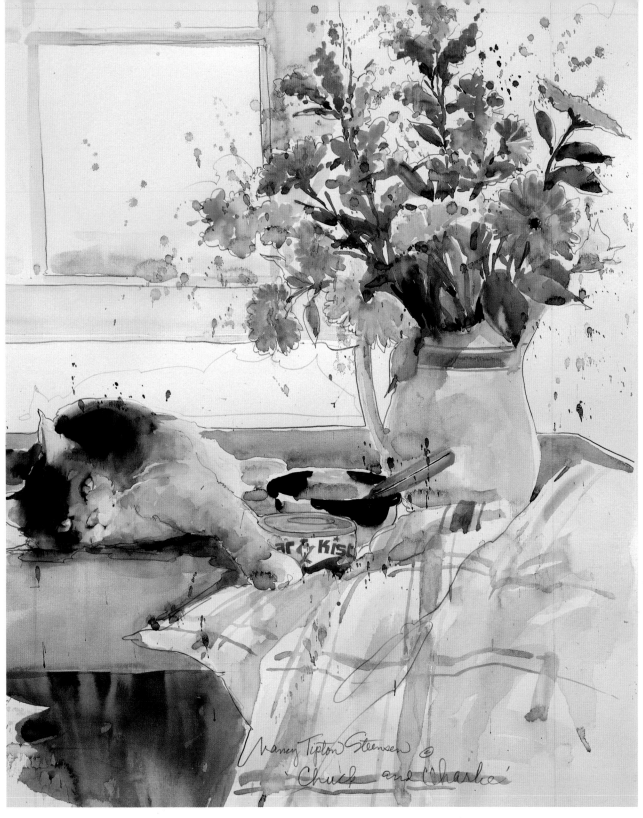

Let the Glow and Mood of Watercolor Emerge

NANCY TIPTON STEENSON

Sometime during the process of each painting, I realize the light has "emerged." It doesn't happen at any specific time . . . each painting is different . . . it just happens. It's there. "Soft and diffused" is often the case in my paintings. Nothing shouts. When that light appears, it gives my subjects their true color. It's a glow and mood the watercolor gives . . . melting into itself, color into color, to create its own softness of light.

CHUCK AND CHARLIE
Nancy Tipton Steensen
30" x 24"

I first draw my subject onto the watercolor paper as detailed as possible. Then comes the fun part—the watercolor itself. Later, I re-draw with wandering pencil lines to emphasize or to show movement and to connect areas to each other.

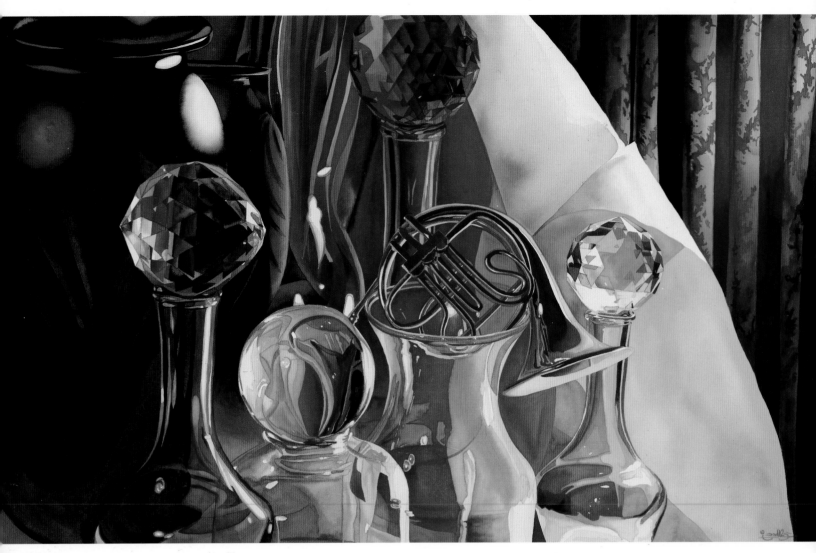

Glass as a Symbol of the Life Force of the Sun

PAUL C. JACKSON

Since ancient times people have placed objects in the path of the sun to track and honor its movements. My watercolors are dramatic depictions of art glass and other objects in my studio, brilliantly lit by the sun streaming through large windows. Each object is a symbol of a different time or place I have been and each was carefully chosen for the way it reacts to light. As the sun hits the glass, color bounces from object to object, giving them life. The glass bends the light and projects colored shadows that dance with the movement of the sun. Everything about the glass indicates the life force of the sun. Thus the glass becomes an eloquent symbol; it is the medium through which the idea of the sun is expressed.

Although the sun rises as regularly as clockwork it is always a surprise. It is these surprises that motivate me to paint. My intent is to capture and crystallize those ephemeral moments when an object catches the light, illuminating the darkness, a reference to the everchanging reality of light.

"Backstage" is a reference to the glow of theatre stage lights from behind the curtain. It is about drama and suspense as an anxious cast waits in the wings. The dramatic lighting techniques of a theatre are similar to effects created in my darkened studio when the sun enters as shafts of light.

BACKSTAGE
Paul C. Jackson
26" x 40"

These pieces were done with transparent watercolor on paper. Each was built with a seemingly endless series of glazes of transparent color. My palette consists of only the primary colors and violet. From these I layer colors in the glazing process to build a desired range. The highlights are the white of the paper saved without the use of masking mediums.

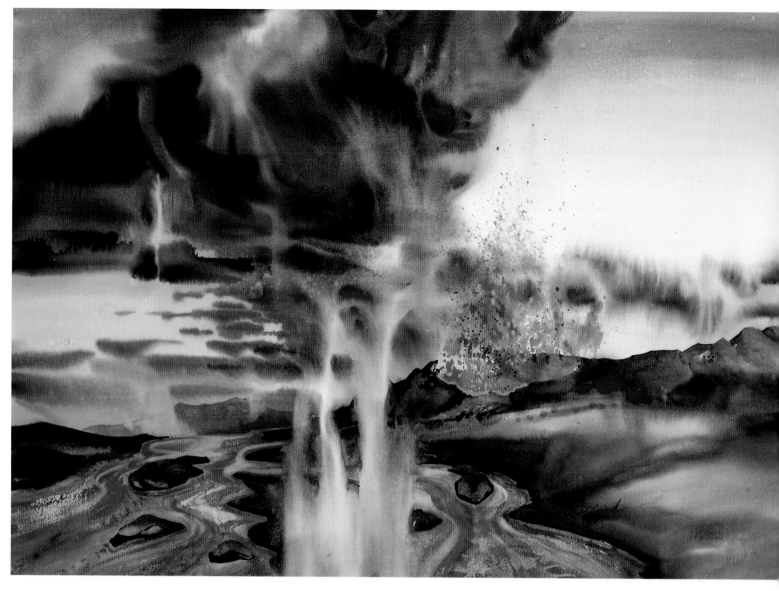

Imagine the Volcanic Power of Light

ROBBIE LAIRD

The drama of an explosive volcanic eruption proved to be a wonderful way to express and use light. As this painting evolved from its wet beginning, the unique attributes of transparent watercolor enabled me to express the various qualities of light emanating from the volcano, from the blast of scintillating light in the explosion to the fiery glow of pouring lava. Intentional hard-edge painting of hot light emanating from the earth against the luminous wet-into-wet painting of the sky creates the brilliance of light throughout this painting. This interplay between soft and hard, transparent and opaque, is continually compelling.

KILAUEA SPIRIT
Robbie Laird
29" x 41"

Because I paint large, with expressed emotion, on very wet paper, I often find myself "painting" with both hands. I use a large brush (2-inch to 3-inch flat) loaded with highly saturated pigment in one hand and a spray bottle or another brush with water in the other hand, directing the careful flow and charging-together of colors. When the painting is thoroughly dry, I paint just enough detail to give the wandering imagination a place to focus.

A sense of spirituality

CHERYL CRISS

My use of light in "Heaven and Earth Series #4" and "Canciones de Josephina" was dictated not only by the subjects themselves, but by a desire and intent to breathe a provocative sense of spirituality into these works. These paintings were derived from sacred places. I felt compelled to capture the reverence that surrounds such places as these, places where omnipotence hangs in the air and transforms my attitudes and emotions on simple subjects such as these into profound personal revelations.

My message is impacted by the "quality" of light. I visualize and ultimately attempt to describe light's source, hue and vibrancy projecting an emotional quality that draws the audience into sharing the artist's experience.

I am fascinated with developing drama through depth of color. I may start a background with Gamboge, Cadmium Orange or Burnt Sienna, followed with a wash of Alizarin Crimson and Gamboge and then drybrush it with Raw Umber. It's great fun to tackle the almost-dry paint with semi-moist brushes, or scrape or blot it. But the color becomes intensely deep with a series of thin subsequent washes carefully applied over the original texture you've created.

HEAVEN AND EARTH SERIES #4
Cheryl Criss
22" x 28"

right
CANCIONES DE JOSEPHINA
Cheryl Criss
30" x 22"

The heavier the paint you put down, the easier it is to lift off, so as timid as some watercolorists feel about the fragility of their medium, I find excitement in laying down a lot of paint with the knowledge that I can spread it around.

Capture the Essence of Memories

JOAN PLUMMER

It is especially meaningful for me to use antique store windows as a subject. I strive to capture the essence of memories that evoke an era, while endeavoring to create a spiritual feeling. The subjects here are not light sources themselves, but merely reflect other light. By using the natural brilliance of late afternoon as my dominant source of illumination, I could let the blue sky affect colors and mood. Since red holds its identity well, it was natural to capitalize on this and to intensify the light on the focal point. I felt the use of filtered light gave an aura to subdued places and animation to neutral areas.

HALLOWELL LIGHTS
Joan Plummer
20" x 28"

I began with washes of abstract shapes, lifting some lights out while still damp. Next, colors were intensified, shapes delineated and glazes added to suggest depth and atmosphere. In finishing, I used some pastel to diminish the intensity of the red lamp.

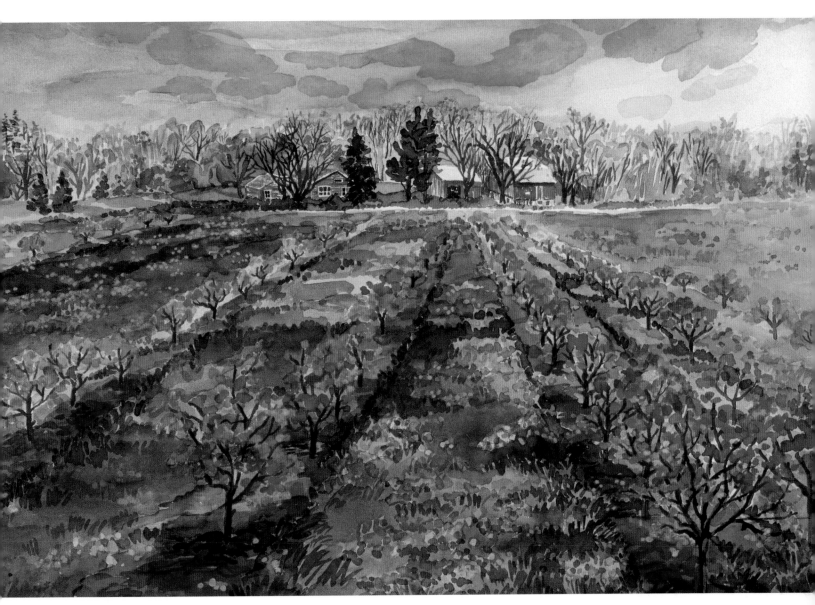

Express the Radiance of Spring in a Special Place

GWEN TOMKOW

In the landscape "Orchard of Northport," I tried to depict the radiant joy of spring. The sunbeams caress row upon row of radiant pink apple blossoms lined with the freshness of yellow green grass. Blankets of dandelions warm the rich earth from the chill of the past winter, as they melt into butter. Peachy orchid clouds funnel down with halos of light above the wispy treetops, beckoning us to embrace this special place. Another spectacular day in northern Michigan's Leelanau peninsula painted with the freedom of one who knows it well!

ORCHARD OF NORTHPORT
Gwen Tomkow
20" x 28"

A V-shaped composition of orchard and sky merges into the background buildings. Using dry 140-lb. Arches cold-press paper, I masked out tree trunks, rooftops and dandelions. I layered on washes of brilliant color from the foreground up the middle, varying the edges to create an in-focus/out-of-focus feeling.

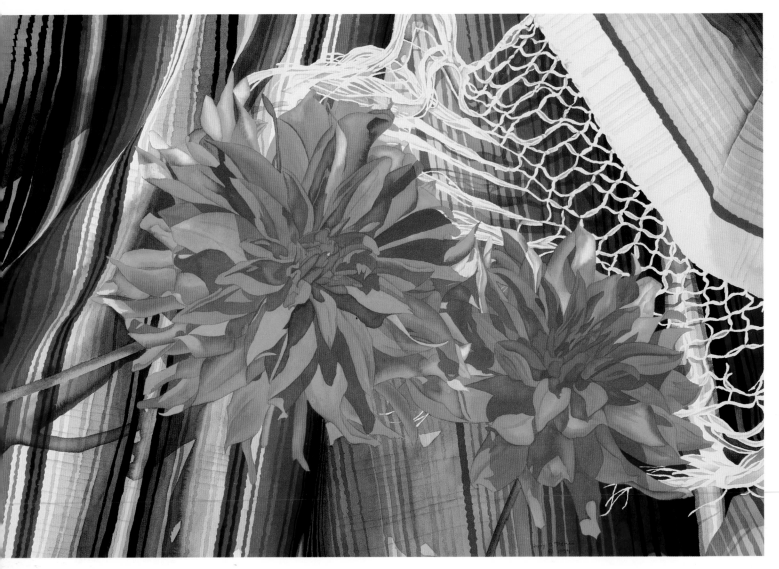

Paint a Dance in Motion

JUDY D. TREMAN

In "Fandango," the serape blanket makes a colorful and dramatic background for these dazzling dahlias from my garden. The shimmering warm hue of the flowers and the curling effect of the petals remind me of the whirling skirts of Spanish dancers—thus the name. Instead of making the stripes flat and straight, I made folds and shadows to echo the swirling effect, as does the fringe. The active mood of the painting comes from the brilliant colors juxtaposed against each other, as well as the way the eye jumps from the twisting petals to the rolling stripes to the fringe and back again. The shadows and lights all contribute to the dynamic feeling of perpetual motion, like the live fandango dance.

FANDANGO
Judy D. Treman
27" x 39"

First, I placed all the shadows in shades of purple. I used frisket to save the whites in the fringe and the lightest areas of the flowers. For the stripes, I painted the palest shade of each color over the entire band and then added the darker colors in layers of glazes on top.

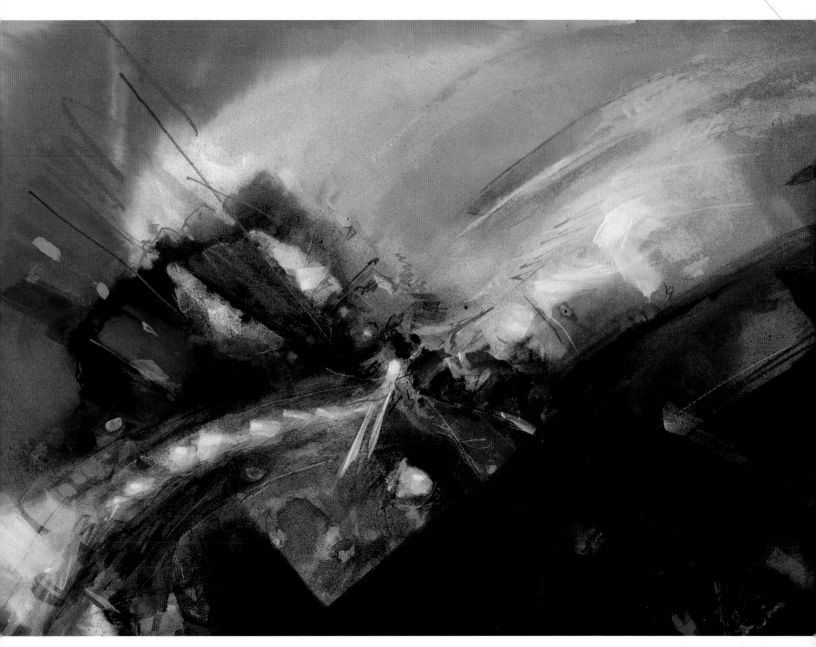

A Thunderstorm Lit an Inner Light

J. LURAY SCHAFFNER

Light is energy because it makes things happen. While I was working on "Rising Sun," a terrible thunderstorm developed. I didn't realize until later how the brilliant flashes of light from the outside influenced my own inner light as I created this piece. At the moment of that flash light is everything. Shadowless light streams through the abstract composition looking almost like an atmospheric disturbance. The whiteness of the light seems to be pushing its way into the open spaces of the design with the directed intensity of the brilliant flashes, or lines, of lightning.

RISING SUN
J. Luray Schaffner
16" x 20"

I used a palette knife to float and scrape the color onto and into the wet 100-percent rag board. A frisket was used in some selected areas. Other areas have been airbrushed and some accented with pastel or printing ink. Lastly, a neutral gray ink was used to create a few dramatic shadows.

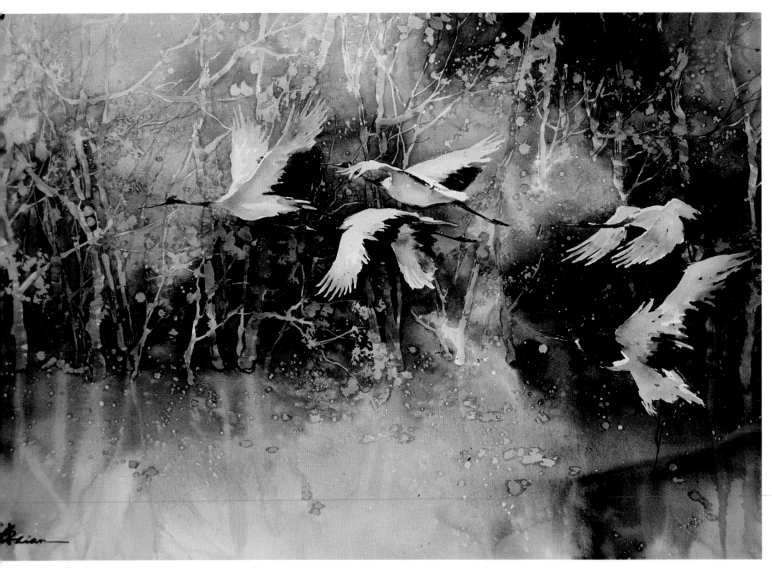

Harmony Is Found Between Imagination and Reality

LIAN QUAN ZHEN

A Chinese art theory says that the most beautiful and harmonious paintings are those that capture scenes between imagination and reality. In both Chinese brush-painting and watercolor painting, I have found that ambient light allows me to express my passion. It illuminates objects with soft edges and light shadow. Objects are profoundly beautiful because they appear as in between imagination and reality. In "Morning Fly," the clouds are lit by the rising sun while the water reflects the colors of the sky. The egrets and vegetation were painted without details and strong shadows. Together they create a moment of harmony: Egrets fly with clouds while water and sky meet in similar colors.

#2 MORNING FLY
Lian Quan Zhen
21" x 29"

A technique I call "color pouring and blending" that I derived from Chinese brush-painting was used here. I applied masking fluid to the egrets, some vegetation and the scales and fins of the fish before I poured colors on the papers. I used only the three primary colors. When I painted the vegetation, I held the brush both straight and sideways in the Chinese style to create textures in few strokes.

I masked the planet with frisket film and airbrushed the black void. Then I masked the background and cut away the planet frisket for the Dioxene Purple where I needed perfect coverage graded dark to light. I finished the rest with watercolor and used tinted gouache for the stress lines radiating out of the crater.

Invent Your Own Universe

LEE W. RICH

To show the stark brilliance of objects in deep space, I painted the background jet black with brilliant unearthly colors on the planet. I'm intrigued by the wonderful colors shown in deep space photos of nebulae, galaxies and planets and wanted to invent one of my own. I didn't want a cold engineering drawing, however, so I added the Canada geese to the improbable setting for the viewer to muse, "How did they ever get there?"

Creating a Powerful Mood with a Single Light Source

SHARON MACZKO

This painting is from a series titled "The Long Hot Summer," based on strong emotions I was experiencing at a difficult time in my life. "Another Sleepless Night" has a detached, melancholic quality. The single light source emerging from the lamp illuminates a mood bordering on the oppressive; time is suspended, and the humid atmosphere frames a profound restlessness.

Give Your Painting a Life of Its Own

JANE OLIVER

In Key West there is a prevailing sense of flooded light. At the end of every street there is water reflecting light. Light and design and movement are what I aim for—to give the painting a life all its own.

ANOTHER SLEEPLESS NIGHT
Sharon Maczko
25 3/4" x 40"

People familiar with my paintings are already aware of the most significant and unusual aspect of my work: my construction of movie-like sets for the still lifes I paint. This enables me to control the lighting as I please. Painting from life in a realist style translates to meticulously rendered articles vying for attention in the overall drama. By minimizing the lighting on some items and highlighting others, I am able to create the necessary harmony.

right
FACADE; KEY WEST
Jane Oliver
22" x 17"

I try for the "glowy" effects of light, so I work on hot-press paper which gives the paint more fluidity and makes glazing colors easier. I sometimes add opaque white for sparkle where needed, and masking fluid is used in many white or lighter areas.

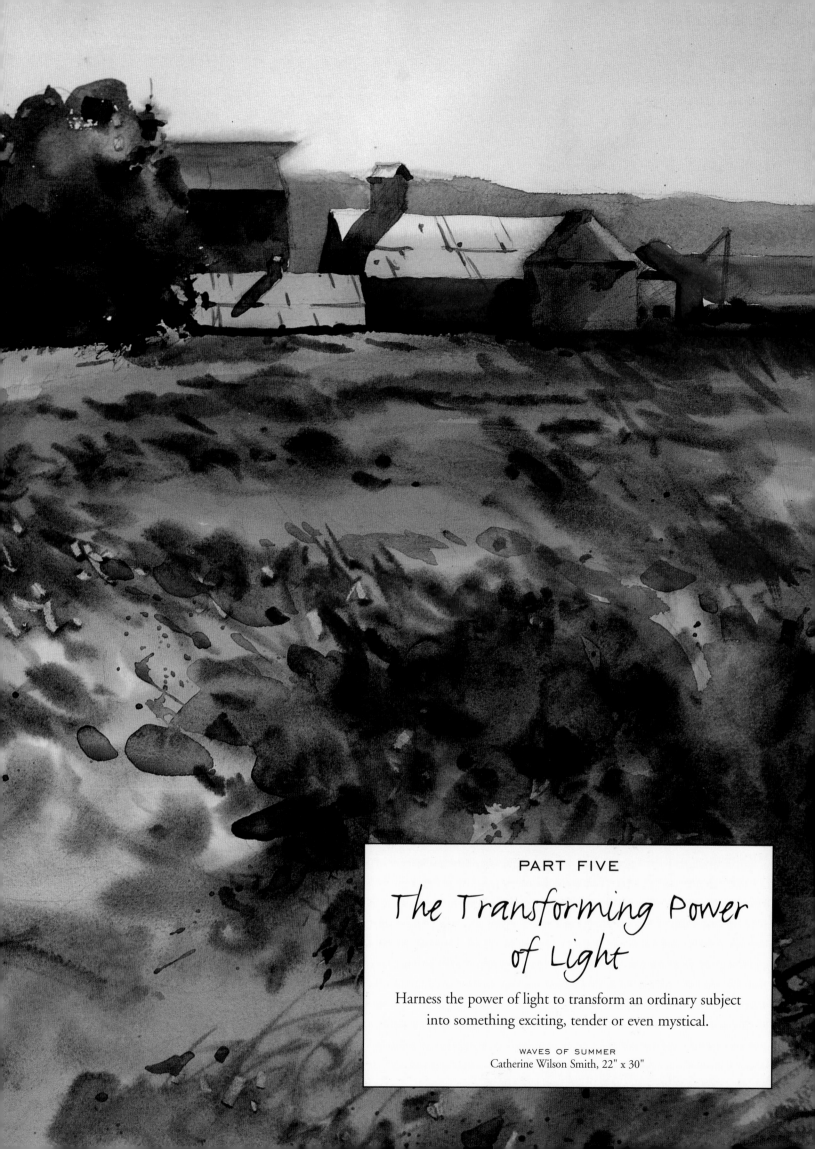

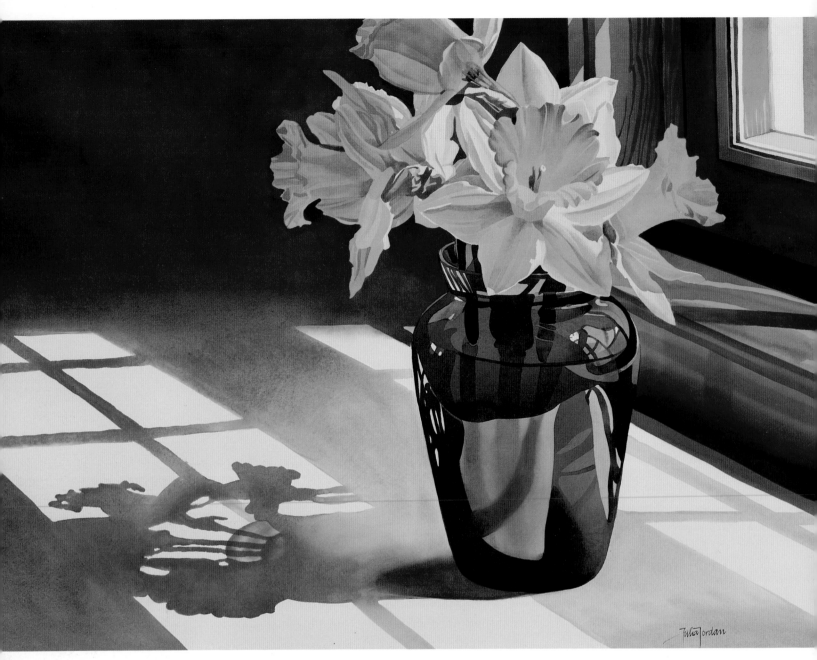

Try Acrylic for Mud-Free Glazes

JULIA JORDAN

DAFFODILS
Julia Jordan
21" x 29"

Light has been my foremost subject matter since I began painting. I especially delight in the way flowers interact with light, since their petals allow light to pass through, yet are substantial enough to reflect light as well. This quality creates opportunities for paintings in which light is seen in various and complex manifestations within the same image. When light strikes glass and metal, other interesting and appealing effects occur. For example, light may pass through colored glass, casting a shadow the color of the glass, and at the same time, reflect off the glass creating mysterious shapes and colors. Shiny metal objects reflect light as well, often with interesting distortions which suggest myriad colors of objects outside the image frame.

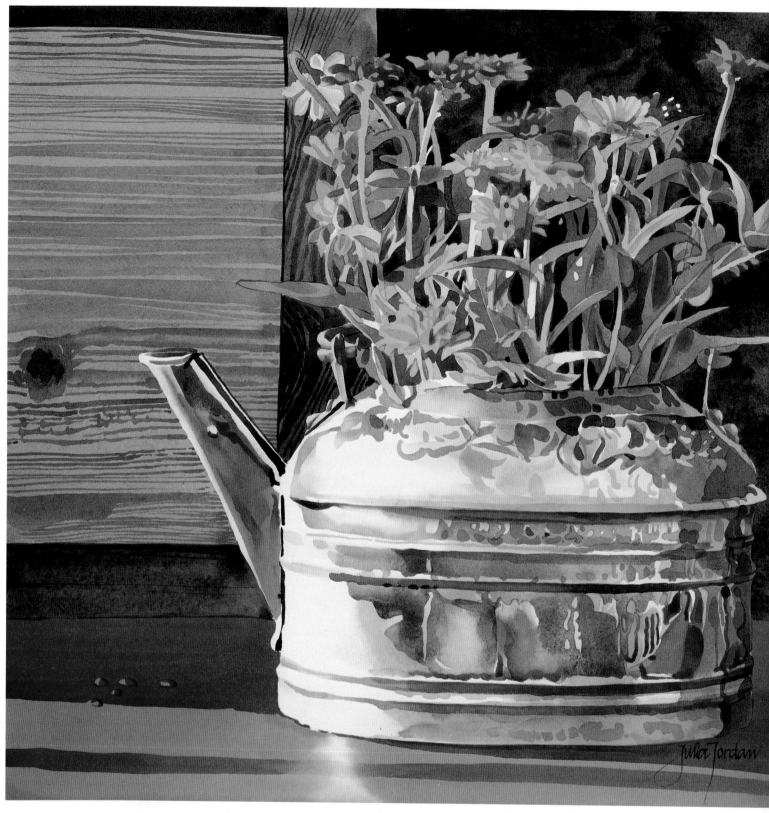

CONFETTI
Julia Jordan
14¹/₂" x 14¹/₂"

I paint transparently in both watercolor and acrylic.
In these images, acrylic has been used with a water-
color method. I generally choose acrylic for those
images with complex glazing requirements, where
watercolor's tendency to lift up or smudge underly-
ing washes would be a handicap. This approach also
allows me to achieve deep, rich background tones,
which I like to use to offset the brilliance of brightly
illuminated flowers.

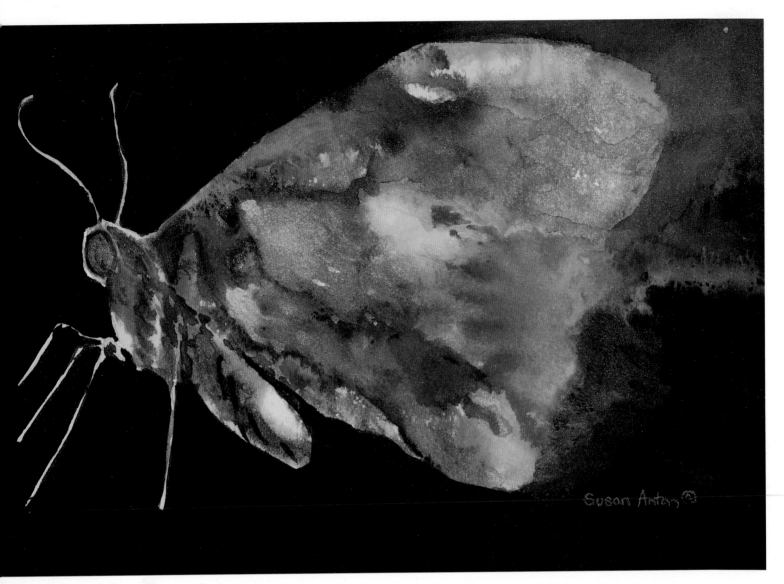

Strong Value Contrasts for a Glowing Subject

SUSAN ANTON

To achieve my lighting goal in "Liquid Butterfly," I used strong value contrasts. I accented the light-drenched, colorful butterfly by contrasting a dark value in the surrounding area. I used hard edges to enhance the brightness of the color; only toward the back of the wings does the color "melt" into the darkness, connecting the butterfly and the background. The butterfly seems to become its own light source and glow from within!

LIQUID BUTTERFLY
Susan Anton
6½" x 10"

After sketching the butterfly in pencil, I wet the paper and dropped in pigment. I tilted the paper to give the colors direction. When this dried I outlined the butterfly shape with Indigo, letting the colors "melt" together toward the back edge of the wings. The last step was to cover portions of the butterfly with a transparent glaze of gold paint which added shimmer and light to the painting.

Sunset Begets a Mystical Landscape

JAMES SCHNIREL

The landscape of southeastern Utah with its variety of sandstone and red rocks can be monumental in its scale and splendor. This painting was inspired by the towering rock monoliths along the Colorado River near Moab, Utah. Towards sunset, the walls of sandstone seem to glow with an inner light, reflecting pinks, reds, vermilion and mauves. Many textures of deep Burnt Umber color are created by iron oxide, called "desert varnish," seeping from rock faces and forming a lacy tapestry. Wind and rain have shaped the rock over the centuries into a variety of sculptural forms that catch and reflect the deep sunset light. The Colorado River has areas of rapids but also flows fast, yet quietly, in many stretches. There are areas of swirling pools which reflect the sandstone and sky colors, all creating a mystical landscape.

RIVER ROCKS REFLECTION
James Schnirel
15" x 21"

"River Rocks Reflection" was created by working wet in a flat shallow pan using Strathmore 80-lb. Aquarius II paper. The desert varnish tapestry was accomplished by using expanded cheesecloth, while large shapes were cut from waxed paper and three-mil plastic strips. Lightfast inks were sprayed and allowed to dry. Waxed paper and plastic strips were moved and collaged, and some light gold spray was added to give the effect of light reflection.

M. Westra-Boonstra © 1992

Light and Shadow Patterns Create Intrigue

MARLENE A. BOONSTRA

Sunlight and shadow can transform the ordinary into the extraordinary. This transformation provides the framework for nearly all of my compositions. The sunlight and shadow patterns become the subject of the painting, creating intrigue and suggesting a story beyond the painting.

In "9/10's of the Law," the viewer sees a cat, croquet ball and mallet, but the person's presence is suggested only by the toe of a shoe and the shadow that falls over the cat. Interest is developed by what is or isn't revealed by the light and shadows.

9/10'S OF THE LAW
Marlene A. Boonstra
20" x 30"

right
TRAVELING COMPANIONS
Marlene A. Boonstra
20" x 30"

For bold, colorful shadow areas, I run many colors together, tilting the board. I work wet-into-wet and apply color after color until I am satisfied with the color transitions as well as the action of the runny paint. Then I lay the painting flat to dry.

M. Westea-Roonstea© 1992

Try "Color Stacking" for Translucent Petals

SUSAN McKINNON

There's nothing like a ray of sunshine dancing on spring blossoms to cheer you up on a gray day. Painted from the intimate perspective of a "bee's-eye view," subjects appear much larger than life and give the impression of extending far beyond the painting's borders. "Spring Palette" seems wrapped in light. The light in the background was used to create interesting shadow patterns and to highlight the beautiful translucent quality of the daffodil petals.

Catch the Moment That Architecture Becomes Art

KAY CARNIE

I love architecture. I am inspired by the mood and spirit that is created by a specific moment when sunlight transforms a flat, ordinary subject into an exciting composition of brilliant sunlight, reflections, interesting shadows and textures. I was immediately drawn to the wonderful architecture of this building in Portugal. The emotional effect of the radiant light reflecting off the white surfaces fascinated me. This image has layers of meaning: the basic abstract design, the play of light and shadows, and the emotions recalling the richness, history, and mystery of an area halfway around the world.

SPRING PALETTE
Susan McKinnon, 21¹/₂" x 29"

I use a technique I call "color stacking." Each watercolor pigment has distinctive properties. Understanding which pigments lift and which ones stain determines the order in which I "stack" them. Each layer of paint either alters the color or value, or adds more detail. "Spring Palette" was created by using exclusively staining transparent colors. Some areas required five or six glazes to achieve the desired effect.

right
TILES AND BELL
Kay Carnie, 39" x 26"

I normally use only three colors for my paintings—Alizarin Crimson, Cadmium Yellow Medium and Thalo Blue. I often use a methodical mixing technique to obtain a smooth gradation from one color to another. I use two colors and measure them into five mixtures with specific ratios. These seven colors can produce beautiful, gradated, smooth washes, or can be used in looser variations, such as in the textural areas of this painting.

Paint the Three Contrasts That Light Reveals

JUDY MORRIS

When the light is just right, "ordinary" becomes "breathtaking" as the shadows that are created by strong light give a quality of life to objects that they wouldn't otherwise have. This quality of light reveals the three contrasts with which I love to work. It allows me to use a value range from white to black. It intensifies color so that I feel compelled to contrast red with green, blue with orange, and yellow with violet. And it emphasizes the contrast of rough texture against smooth texture.

The contrasts created by light are evident in both "Picnic at Milton Abbas" and "Number 13, Portofino"—images found in England and Italy. Travel is not, however, a requirement for finding subject matter. Some of my favorite paintings are of images found around my own home. Light is the requirement!

PICNIC AT MILTON ABBAS
Judy Morris
21" x 27"

right
NUMBER 13, PORTOFINO
Judy Morris
29" x 20"

A favorite technique is created by drawing a narrow line of dark watercolor around some of the shapes in my paintings. I fill the ink chamber of a Rapidograph technical pen with a thinned mixture of my "almost black" (a mixture of Winsor Red and Winsor Green with a small squeeze each of Warm Sepia and Cerulean Blue) and add the "cloisonne" lines that have become a very important part of my personal style.

Judy Morris NWS

Light Transforms Water Into a Sea of Diamonds

DONALD PATTERSON

Invariably, it is how light plays on a subject that first captivates me. Because of this fascination, water has always held a special attraction for me. The play of light on the surface of water will get my attention every time, as in "Sparkling Water." The almost blinding bursts of light bouncing off these waters was beautiful beyond description. It was as if the waters were filled with thousands of diamonds, each flashing its own burst of light as they rolled with the undulating surface.

Light Works Its Magic on Crystal

JAN KUNZ

I love to paint many things, but when light performs its special magic, flowers in a crystal vase become an irresistible subject. At first, the thought of painting a convincing crystal vase may appear a bit daunting, but in fact it is much easier than you may think.

SPARKLING WATER
Donald W. Patterson
17 1/2" x 27"

The large light reflections (upper left) were created by first placing connected and unconnected dots of masking fluid, with a ruling pen, over these areas. After applying watercolor, I removed the masking fluid and selectively airbrushed the area with semiopaque white to diffuse the dots.

right
FACETS AND REFLECTIONS
Jan Kunz
30" x 22"

To paint crystal, carefully observe the many shapes within the vase and paint what you see. It is impossible to see, let alone paint, every shape. But almost like magic, the myriad of shapes combine to form the illusion of a sparkling crystal vase.

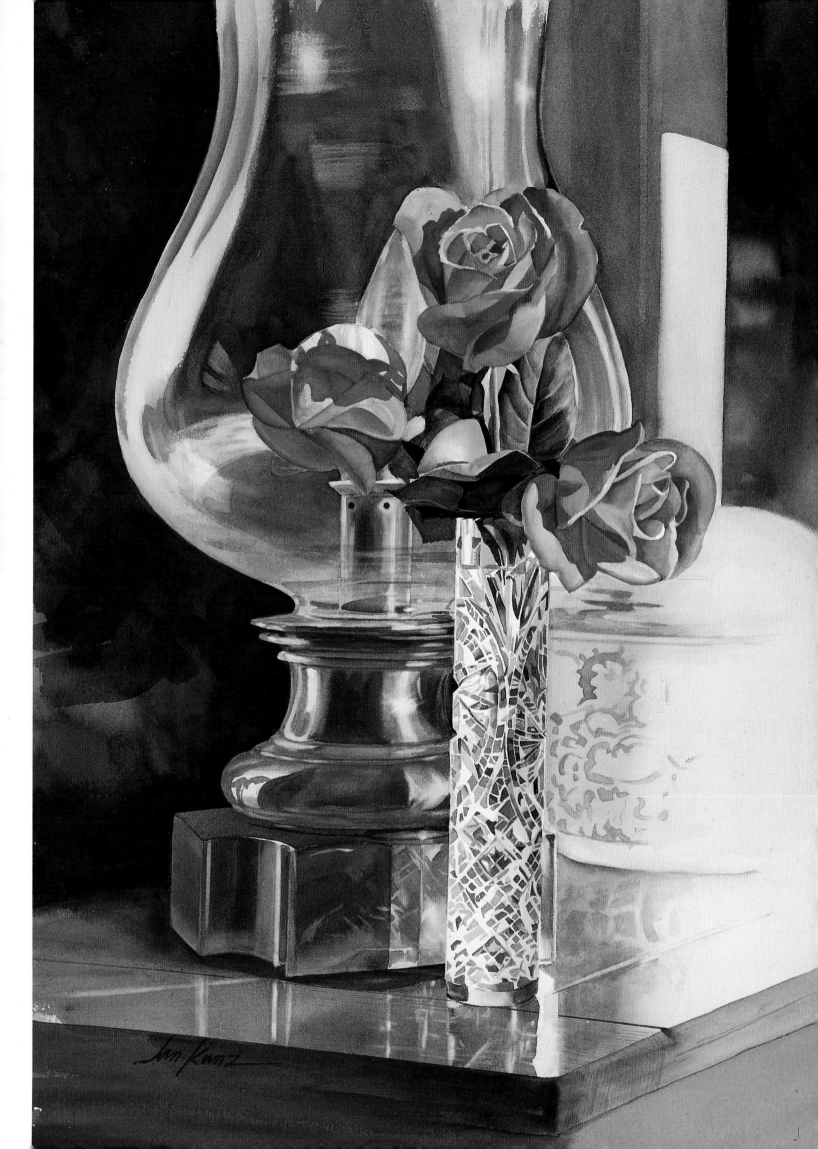

Light Imparts Dignity to Otherwise Commonplace Subjects

ALEX McKIBBON

The palm tree has become so commonplace, so banal through calendars and posters (the palm: the emblem of commercial tropical resorts) that powerful light seemed the only means of reinvesting this subject with its own just dignity. While it may be just a matter of time before progress obliterates their "Last Stand," these trees of the tropics were working their magic. The sense of freedom in this scraggly flora is played off against the staid regularity of the architecture beyond. Viewers are encouraged to enjoy a sense of abandon, indulging themselves in the pleasure of this last remnant of paradise. The technique emphasizes the importance of touch, of the "right-the-first-time attack" (economy of means), and of saying the most with the least.

Flower Petals Glow From Within in Bright Sun

NEDRA TORNAY

The quality of light, the quantity of light and the lack of light all contribute to the image of "Two Violet Irises." I painted these irises by not painting them! That is to say, I defined the irises' shapes by painting the dark background, utilizing the white of the paper to depict their light-struck areas. I then described the irises' forms with a variety of colors and values, painting only the shadows that were created by overlapping shapes.

IMAGE WITH PALM TREE
Alex McKibbin
22" x 30"

I like to steep my landscapes in color, drenching them with vaporous lights and tones and giving the impression that the light and color are being exhaled from the forms themselves. Sparkle must be obtained without obvious use of frisket and masking. Light must be integral—emanating from the body of the painting.

right
TWO VIOLET IRISES
Nedra Tornay
42" x 30"

I tried to achieve a rich, dark color in the background of "Two Violet Irises" with just one application of paint, including some staining colors. However, when the paint dried, the effect was a disaster! I wet the area and wiped away the loose pigment with a damp elephant ear sponge. I scrubbed the paper, removing all the color I could, before layering the permanent washes. I credit the scrubbing, which changed the surface of the paper, for this special soft effect.

Be Bold to Express Radiant Sunlight

DONNA ZAGOTTA

I once read that you cannot look at a Joaquín Sorolla painting without seeing, almost feeling the sun. That statement perfectly expresses what I was trying to accomplish in my painting, "Breezin." My aim was to capture the dazzling summer sunlight as it really felt. In essence I painted only the shadow shapes, leaving the light patterns as brilliant unpainted paper for a bold, almost black-and-white effect. Bright sunlight both reveals and dissolves form, requiring a variety of edge treatments. Where sunlight reveals form I use firm edges; where sunlight dissolves form I scrub out the sun-struck areas, losing edges and merging shapes together.

Go "Beyond Dark Enough" for Luminous Shadows

L. KATHY DEATON

A trip to the market for fresh vegetables, the impulsive purchase of a shiny copper sieve, a torn shopping bag emptying its contents across the floor, and I had the makings not only for lunch, but for "Summer's Bounty." I watched as the sunlight washed across broccoli, carrots and plum tomatoes, transforming the ordinary into an extraordinary interplay of sparkling, glowing textures and long, luminous shadows. Lunch was quickly forgotten. It was time to paint!

BREEZIN
Donna Zagotta
20" x 27"

The figures' sunlit left sides were painted in and then scrubbed out with a firm toothbrush to merge with the sunlit edge of the boat.

right
SUMMER'S BOUNTY
L. Kathy Deaton
30" x 22"

I masked out only the tiniest areas (the holes, broccoli buds, the rim of the sieve, etc.), painting around the larger white and light areas. To capture the luminosity and depth of the shadows, I saturated these areas with juicy, deep darks, going far beyond what I thought might be "dark enough." Finishing touches included glazing the warmest shadows with a very transparent red oxide.

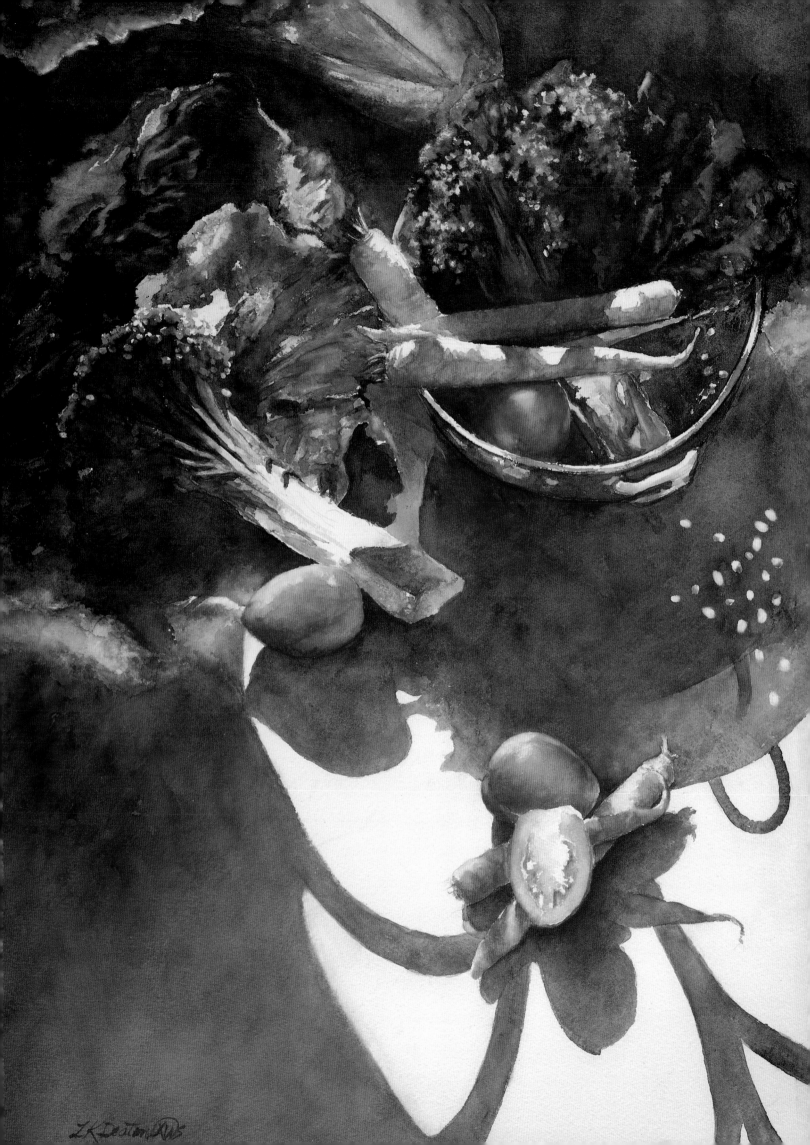

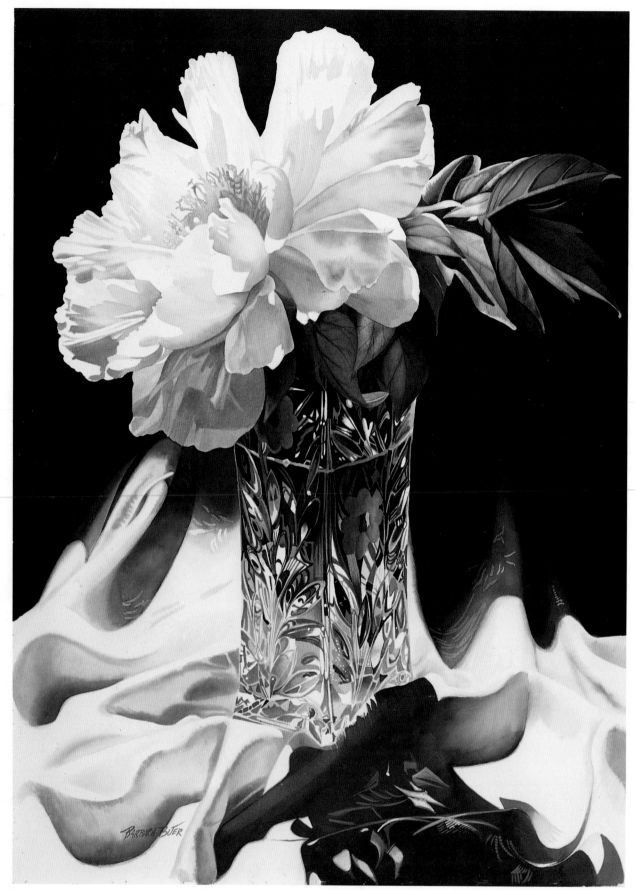

WHITE PEONY
Barbara R. Buer
30" x 22"

Painting my still-life watercolors with acrylics in a glazing technique, I am able to paint the center of interest first and then mask it out in order to execute the background freely, glazing away without having to worry about edges.

Explore the Myriad Nuances of Large White Petals

BARBARA R. BUER

White flowers with large petals pick up and reflect a tremendous amount of light. When backlit, shadows are cast by petals onto petals and surrounding surfaces are dappled with light and shadows, affording the artist a myriad of nuances to explore.

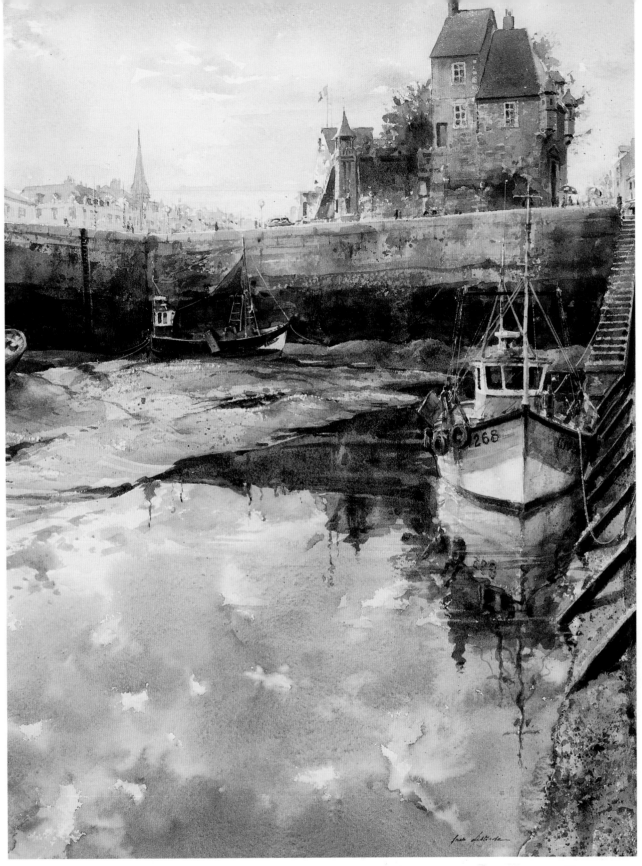

Sky and Water

JACK LESTRADE

The essence of a watercolor painting can be expressed with light alone. In this painting, I played with a combination of sky and water to transform the low tide of this beautiful port of Honfleur in Normandy, France.

CLOUD IN THE WATER
Jack Lestrade
18" x 13½"

I use an English handmade cold-press 300-lb. paper. All colors are transparent; no white or black. As I don't use white or masking agents, I do a lot of thinking first and scratching later.

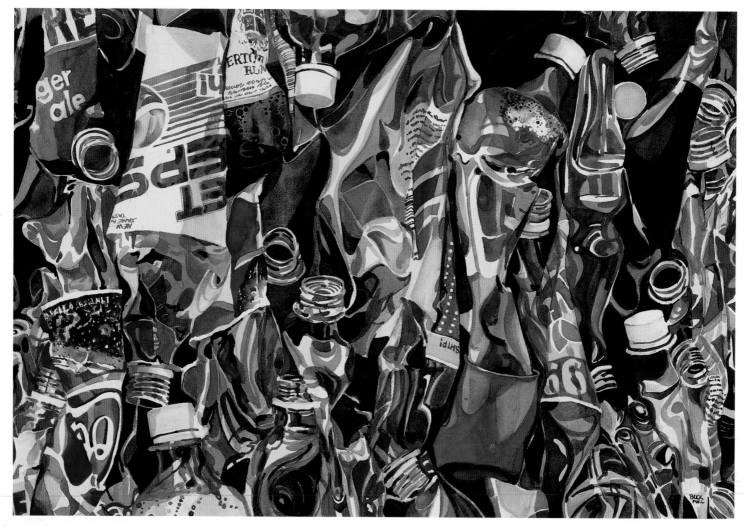

Vibrant Sunlight Enlivens Unlikely Objects

LISA BUCK

"Bottleneck" gave me the opportunity to paint startling organic shapes thrown together, deep rich colors and wonderful patterns of light. Wrapped in bright sunlight, these recycled bottles vibrate with energy both playful and sensual as they twist, turn and bend. Whites aren't white at all, but mirrors of the surrounding colors. Shadows go from cool into total darkness. Edges disappear and reappear in constant rhythm, each bottle folding into the next, negative spaces melting into positive shapes on a surprising visual journey.

Set Up Your Still Life in Front of a Window

TERESA STARKWEATHER

I gravitate more and more toward setting up still-life objects in front of a window to achieve rich lights and darks, as well as a sense of space from shadows. I particularly like painting transparent objects through which natural light glows, changing colors and creating drama. "Sunflowers and Coffee" was painted to commemorate the fiftieth wedding anniversary of my parents-in-law. The medals were earned in World War II at the beginning of their romance. The sunflowers are the state flower of Kansas, where they reside, and the coffee cups and cards symbolize their daily life together. All these objects are bathed in the glow of a golden, late afternoon sun.

BOTTLENECK
Lisa Buck-Goldstein
19" x 28"

To unify a detailed watercolor like this, I start with an initial wash applied over the entire drawing. Leaving the white of the paper for highlights, I apply a mixture of Cerulean and Cobalt Blue to the coolest areas, Naples Yellow to the brightest and Opera (pink) by Holbein to the warmest areas and foreground, careful to keep the colors translucent and distinct.

right
SUNFLOWERS & COFFEE
Teresa Starkweather
40" x 30"

I usually shoot a roll of slides for each still-life setup, photographing at the time of day the sun shines into the room the way I like. I project the selected slide onto my watercolor paper and trace a light outline of the objects. I paint directly, using a color photocopy for reference, mixing color as I go with a wet-into-wet technique.

Pour Your Midtones for Surprising Results

JEAN H. GRASTORF

The moment I saw this steel drum player, I envisioned a painting. Part of a high-school band playing in the noontime sun, her drums reflected strong, hard-edged shapes around her. The value range from pure whites to darkest shadows made a powerful, exciting composition.

"Push" Your Colors to Maximize Contrast

CLAIRE SCHROEVEN VERBIEST

As a student, I remember often agonizing over what to paint. The revelation came during a plein air painting session in an instructor's garden, on a dreary and uninspiring morning. When the sun's rays finally broke through the clouds, the grays of an overcast dawn became a medley of saturated colors, pulsating edges, deep shadows and sharp contrasts. I knew then that light with its infinite variations was going to be my inspiration. Here, I was fascinated by the magical glow created by the bright sunshine falling on the luscious foliage of the giant sunflowers. Strong outdoor light is still my favorite.

WOMAN OF STEEL
Jean Grastorf
20" x 28"

When veils of transparent color are poured, light can penetrate to the paper's surface and bounce back to the eye. A pattern of lights, darks and mid-tones was established by masking the whites, pouring the mid-values and painting the darks. Pre-planning, good drawing and simplification of forms is essential. With this technique, the major compositional shapes are established, but the results are always a surprise and keep your interest high.

right
THREE GIANT RUSSIANS
Claire Schroeven Verbiest
30" x 23"

To echo the almost monumental proportions of these sunflowers, I pushed the color of the sky and foliage to the maximum. Except for the use of masking fluid to "save" the pollen-laden areas in the flowers' centers, the rest of the painting was done in a traditional manner.

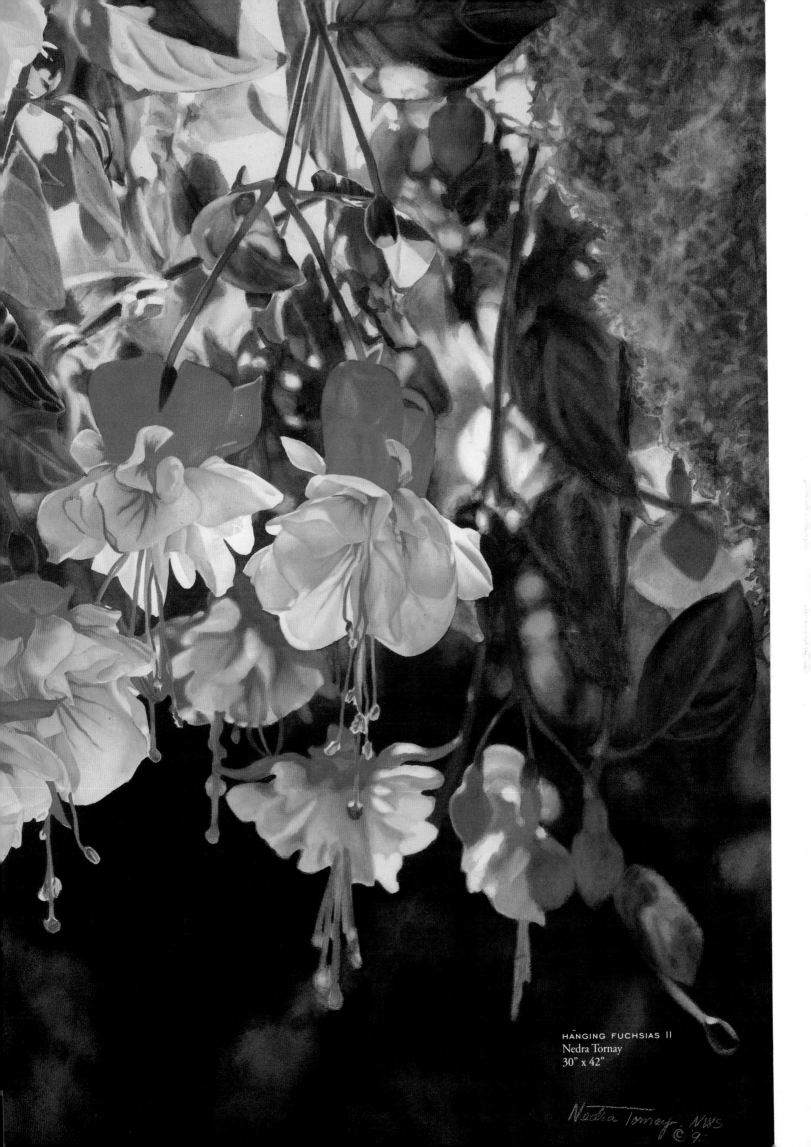

HANGING FUCHSIAS II
Nedra Tornay
30" x 42"

Nedra Tornay, NWS
© '9.

Contributors

Neil H. Adamson
Traditional Images Inc.
7089 South Shore Drive
South Pasadena Isle FL 33707
Great Blue Heron ©Neil H. Adamson

Susan Anton
7448 Louisiana Ave. North
Brooklyn Park MN 55428
Liquid Butterfly ©Susan Anton, collection of
the artist

Nancy Baldrica
3305 Brenner Place
Colorado Springs CO 80917
Hacienda Shadows ©Nancy Baldrica

Leslie Rhae Barber
1870 Evening Star Dr.
Park City UT 84060
A Quiet Moment ©Leslie Rhae Barber
Sunbathing I ©Leslie Rhae Barber

Joseph Bohler
P.O. Box 387
Monument CO 80132
October Gold—Grand Canyon ©Joseph
Bohler, collection of Lois Joseph

Kim Stanley Bonar
9870 Van Dyke
Dallas TX 75218
Into the Light ©Kim Stanley Bonar

Marlene A. Boonstra
12901 S. Central Avenue
Crestwood IL 60445
9/10's of the Law ©Marlene A. Boonstra
Traveling Companions ©Marlene A.
Boonstra

Betty C. Boyle
5081 S. Poplar Drive
Columbus IN 47201
Morning in the City ©Betty C. Boyle,
collection of Mr. and Mrs. Fred Reams,
Columbus, IN

Lisa Buck-Goldstein
RR 4, Box 4014
Stroudsburg PA 18360
Bottleneck © Lisa Buck-Goldstein

Barbara R. Buer
5438 Oxford Drive
Mechanicsburg PA 17055
White Peony © Barbara Buer; Capricorn
Galleries, Bethesda, Maryland; Wm. Ris
Galleries, Camp Hill, PA

Dan Burt
2110-B West Lane
Kerrville TX 78028
Callejon II ©Dan Burt

Louise Cadillac
880 S. Dudley St., Lakewood CO 80226
Codestone ©Louise Cadillac, collection of
Brownstein Hyatt Farber & Strickland PC

Cheryl Campbell
P.O. Box 3165
Mission, British Columbia
CANADA V2V 4J4
Red Shawl ©Cheryl Campbell

Kay Carnie
10439 Heney Creek Place
Cupertino CA 95014
Tiles and Bell ©Kay Carnie

Marc Castelli
Dam Creek Farm
7098 Wilkins Lane
Chestertown MD 21620
Lark Light/Island Lark ©Marc Castelli,
Massoni-Sommer Gallery, 210 High St.,
Chestertown, MD 21620

Cheng-Khee Chee
1508 Vermilion Road
Duluth MN 55812
Morning Harbor ©Cheng-Khee Chee

Roberta Carter Clark
47-B Cheshire Square
Little Silver NJ 07739
Molly in Blue Glasses ©Roberta Carter Clark

William H. Condit
1256 S. Pearl Street, Denver CO 80210
Sun & Rain On The Mountain ©William H.
Condit, collection of Mr. and Mrs. Richard
E. Steele, Evergreen, CO

Laurel Covington-Vogl
333 Northeast Circle
Durango CO 81301
Postcard From Milan: Piazza Patterns
©Laurel Covington-Vogl, collection of
William R.C. Murphy, Wichita, Kansas;
Toh-Atin Gallery, Durango, CO, Telluride
Gallery of Fine Art, Telluride, CO

Cheryl Criss
9574 Paseo Montril
San Diego CA 92129
Heaven and Earth Series #4 ©Cheryl Criss;
Nedra Matteucci Fine Art, 555 Canyon Rd.,
Santa Fe, NM
Canciones de Josephina ©Cheryl Criss; Nedra
Matteucci Fine Art, 555 Canyon Rd., Santa
Fe, NM

L. Kathy Deaton
217 McKenzie Street
Santa Fe NM 87501
Summer's Bounty ©L. Kathy Deaton
Vintage '42 ©L. Kathy Deaton

Betty DeMaree
4725 W. Quincy Avenue #1403
Denver CO 80236
Black Porcelain ©Betty DeMaree, Gallery A,
Taos, NM

Gayle Denington-Anderson
661 South Ridge East, Geneva OH 44041
Orion Galaxy ©Gayle Denington-Anderson

Don Dernovich
Box 163-210 Taylor
Culbertson NE 69024
Frenchman Glow ©Don Dernovich, collec-
tion of Mr. Van Korell, AmFirst Bank of
McCook, Nebraska

Marilynn Derwenskus
3716 Lakeside, Muncie IN 47304
Anticipation Brazil ©Marilynn Derwenskus,
collection of the artist

Pat Dews
84 Onyx Place, Matawan NJ 07747
Acadia Remembered ©Pat Dews, collection
of the artist

Benjamin Eisenstat
3639 Bryant St.
Palo Alto CA 94306
Noon ©Benjamin Eisenstat
57th St., N.Y. ©Benjamin Eisenstat

Nita Engle
177 County Road 550
Marquette MI 49855
Sun and Skiers ©Nita Engle, courtesy of
Mill Pond Press, Inc., Venice, FL 34292
Edge of Winter ©Nita Engle, courtesy of
Mill Pond Press, Inc., Venice, FL 34292

Rich Ernsting
6024 Birchwood Ave.
Indianapolis IN 46220
Nautical Departure ©Rich Ernsting

Mary Lou Ferbert
334 Parklawn Drive, Cleveland OH 44116
Lilies and Glass Blocks ©Mary Lou Ferbert,
collection of Mr. and Mrs. Thomas L.
Dempsey

Karen Frey
1781 Brandon Street, Oakland CA 94611
Tiny Elvis, Up Close ©Karen Frey
One Red Leaf ©Karen Frey

Gerald J. Fritzler
1051 50 Rd./Box 253
Mesa CO 81643-0253
Gondolas ©Gerald J. Fritzler; 17th Annual
Northwest Rendezvous Group Exhibition;
128th American Watercolor Society
International Exhibition

Henry Fukuhara
1214 Marine Street
Santa Monica CA 90405
Santa Monica Canyon ©Henry Fukuhara;
Stary Sheets Fine Art Galleries, Irvine, CA

Jean Grastorf
6049 Fourth Avenue North
St. Petersburg FL 33710
Woman of Steel ©Jean Grastorf, private
collection

Geri Gretan
2230 Lynn Rd., #303
Thousand Oaks CA 91360
Prudential—For Lease ©Geri Gretan

Bev Hagan
10 Woodthrush Court, Willowdale, Ontario
CANADA M2K 2B1
Pots Reflected ©Bev Hagan, private collection

Joan Hansen
Creative Art and Design Studio
599 Galveston Way
Bonita CA 91902
Luminous Surf ©Joan Hansen

Patricia Hansen
63 Ramsgate Court
Danville CA 94526
From Her Garden ©Patricia Hansen
English Blue and White With Rabbit Pillow
©Patricia Hansen

Dawn Heim
P.O. Box 2593
Dublin CA 94568
The Ghost of the Yankee Clipper ©Dawn
Heim, collection of the artist

Ray Hendershot
1007 Lakeview Terrace
Pennsburg PA 18073
Millbridge ©Ray Hendershot, collection of
the artist

Donald Holden
128 Deertrack Lane
Irvington NY 10533
Mendocino Storm I ©Donald Holden

Ken Hosmer
Box 3431
Ruidoso NM 88345
Spring Calves ©Ken Hosmer, collection of
Lee Heinsen-Ligocki

Paul C. Jackson
2918 Bluegrass Ct.
Columbia MO 65201
Backstage ©Paul C. Jackson, collection of
Lee and Andrea Borowsky
The Seekers ©Paul C. Jackson, collection of
William and Judith Emerson

Bill James
15840 S.W. 79th Court, Miami FL 33157
Melancholy ©Bill James

Julia Jordan
14325 W. Crabapple Rd.
Golden CO 80401
Daffodils ©Julia Jordan, private collection
Confetti ©Julia Jordan, collection of Dennis
R. Anderson

Steven Jordan
463 W. Coleman Blvd.
Mt. Pleasant SC 29464
Lisa ©Steven Jordan
Laid Back ©Steven Jordan; full color repro-
ductions available from the artist

Mary Lou King
4513 Cardinal Lane
Midland TX 79707
Titan Triumph ©Mary Lou King, collection
of Jean Haggerman

Dee Knott
700 Ann Street
Beaufort NC 28516
Dory ©Dee Knott

Judy Koenig
1152 Rambling Road
Simi Valley CA 93065
Who Pulls the Strings? ©Judy Koenig,
collection of the artist

Linda Kooluris Dobbs
330 Spadina Rd., Suite 1005
Toronto, Ontario
CANADA M5R 2V9
Isla Mujeres Remembered '94 ©Linda
Kooluris Dobbs, collection of Essop Mia,
Vancouver, Canada

Loren Kovich
114 N. Huback
Helena MT 59601
Missouri River Afternoon ©Loren Kovich; St.
James Bed & Breakfast Gallery, Helena, MT
59601

Jan Kunz
P.O. 868, Newport OR 97365
Facets and Reflections ©Jan Kunz

Melanie Lacki
7962 Kentwood Way
Pleasanton CA 94588
Top Banana ©Melanie Lacki, collection of
the artist

Mark Lague
46 Ponner Avenue
Pointe Claire, Quebec
CANADA H9R 4X9
Montreal Building Tops ©Mark Lague

Robbie Laird
712 W. Mountain Ridge Rd.
Lake Almanor CA 96137
Kilauea Spirit ©Robbie Laird, collection of
Village Galleries, Lahaina, Maui, Hawaii

Dale Laitinen
5896 Old Emigrant Trail W.
Mountain Ranch CA 95246
Rotoring Over Melones ©Dale Laitinen
Blue Oak Home ©Dale Laitinen, collection
of Stephen L. Waggle

Estelle Lavin
11 Riverside Drive
New York NY 10023
Market At Vence ©Estelle Lavin; Bruce R.
Lewin Gallery, 136 Prince Street, New York,
NY 10012, D. James Dee Photo ©1995

Jack Lestrade
Lapèze
Montgesty
FRANCE 46150
Cloud in the Water ©Jack Lestrade,
collection of the artist

Sharon Maczko
3830 Zeolite Circle
Wellington NV 89444
*Another Sleepless Night (Long Hot Summer
Series)* ©Sharon Maczko

Anne Adams Robertson Massie
Lynchburg VA
Night Music II ©Anne Adams Robertson
Massie, private collection
Tour Dupont I ©Anne Adams Robertson
Massie, collection of the artist

William McAllister
20914 Pilar Road
Woodland Hills CA 91364
Anticipo Venezia ©William McAllister,
collection of Paul and Julie Geiger
Prospecting London ©William McAllister,
collection of the artist, photograph by
Image Ination Photography for the Fine Arts

Alex McKibbin
3726 Pamajera Drive
Oxford OH 45056
Image With Palm Tree ©Alex McKibbin,
collection of Judith A. Kehrle, photographed
by Carl Potteiger

Susan McKinnon
2225 SW Winchester
Portland OR 97225
Spring Palette ©Susan McKinnon, private
collection

continued

Judy Morris
2404 East Main Street
Medford OR 97504
Picnic at Milton Abbas ©Judy Morris,
private collection
Number 13, Portofino ©Judy Morris;
Hanson Howard Gallery, Ashland, OR

Ned Mueller
13621 182nd Avenue SE
Renton WA 98059
Lagos Harbor - Portugal ©Ned Mueller;
Award of Excellence, 1995 Northwest
Rendezvous Exhibition, Park City, UT

Charles W. Munday
632 Tanglewood Avenue
Auburn AL 36830
Caddy Chrome ©Charles W. Munday;
prints available, edition 960

Carla O'Connor
3619 47th Street Court NW
Gig Harbor WA 98335
After Eight ©Carla O'Connor

John O'Connor
3231-C Via Carrizo
Laguna Hills CA 92653
Desert Song ©John O'Connor

Jane Oliver
20 Park Avenue
Maplewood NJ 07040
Facade; Key West ©Jane Oliver

Howard Olson
711 Harter Drive
Rapid City SD 57702
Reflections ©Howard Olson, collection of
James M. Miles

Donald W. Patterson
441 Cardinal Court North
New Hope PA 18938
Sparkling Water ©Donald W. Patterson

Ann Pember
14 Water Edge Road
Keeseville NY 12944
Piquant Peony ©Ann Pember, collection of
the artist; Watercolor West Annual 1994
award winner

Joan Plummer
WINTER: 10 Monument Hill Rd.
Chelmsford MA 01824
SUMMER: HC65 Box 802
East Boothbay ME 04544
Hallowell Lights ©Joan Plummer, collection
of the artist

Carl Podszus
4 The Loch
Rockville Centre NY 11570
First Light, Lake Garda ©Carl Podszus

Robert Reynolds
958 Skyline Drive
San Luis Obispo CA 93405
Red Horizon ©Robert Reynolds

Lee W. Rich
P.O. Box 308
Wilmington VT 05363
Homeward Bound ©Lee W. Rich, collection
of the artist

Ted Rose
P.O. Box 266
Santa Fe NM 87504
Midnight Call ©Ted Rose, private collection

Robert Sakson
10 Stacey Avenue, Trenton NJ 08618
Marion Francis ©Robert Sakson

J. Luray Schaffner
14727 Chermoore Drive
Chesterfield MO 63017
Rising Sun ©J. Luray Schaffner

James Schnirel
Summit Art Studio
515 Crestview Drive
Summit Park UT 84098
River Rocks Reflection ©James Schnirel

Ong Kim Seng
Blk 522 Hougang Ave. 6
#10-27 Singapore 1953
Morning in Bali ©Ong Kim Seng

Catherine Wilson Smith
9N273 Oak Tree Lane
Elgin IL 60123
Waves of Summer ©Catherine Wilson Smith;
Dillman's Creative Workshops Award,
Midwest Watercolor Society 18th National
Exhibition of Transparent Watercolors;
Thomas Prater Purchase Award, Watercolor
USA 1995

Jennie K. Snyder
4949 Foothill Road
Ventura CA 93003
Still Life With Pomegranates ©Jennie K.
Snyder, collection of Pat and Marie
Beckman-Clifton

Phyllis Joan Solcyk
20223 Labrador Street
Chatsworth CA 91311
Making Ready ©Phyllis Joan Solcyk, photo-
graph by Image • Ination Photography for
the Fine Arts

Teresa Starkweather
7914 Jason Ave.
West Hills CA 91304
Troll Bouquet ©Teresa Starkweather
Sunflowers & Coffee ©Teresa Starkweather

Nancy Tipton Steensen
313 Niemi Road
Woodland WA 98674
Chuck and Charlie ©Nancy Tipton
Steensen, collection of Patty Govoni and
Greg Wornell

Donald Stoltenberg
947 Satucket Road
Brewster MA 02631
S.S. America ©Donald Stoltenberg

Paul Strisik
123 Marmion Way, Rockport MA 01966
Autumn Meadows ©Paul Strisik

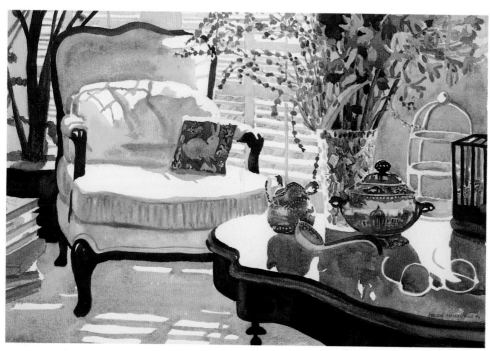

ENGLISH BLUE AND WHITE WITH RABBIT PILLOW
Patricia Hansen, 15" x 22"

Carol P. Surface
2617 Mathews Ave., #1
Redondo Beach CA 90278
New Morality ©Carol P. Surface

Warren Taylor
1908 Oak Lawn
Midland TX 79705
Acūna ©Warren Taylor, collection of Scott,
Douglass and Luton Law Offices, Austin, TX

Vivian R. Thierfelder
P.O. Box 3568
Spruce Grove, Alberta
CANADA T7X 3A8
Some Like It Hot ©Vivian R. Thierfelder,
private collection
All Bottled Up ©Vivian R. Thierfelder,
private collection

Noel Thomas
Box 213, Seaview WA 98644
Cranberry Bogs ©Noel Thomas

Gwen A. Tomkow
P.O. Box 2263
Farmington Hills MI 48333
Orchard of Northport ©Gwen Tomkow;
Joppichs Bay Street Gallery, Northport, MI

Nedra Tornay
2131 Salt Air Drive
Santa Ana CA 92705
Hanging Fuchsias II ©Nedra Tornay,
collection of the artist
Two Violet Irises ©Nedra Tornay, private
collection

Judy D. Treman
Judy D. Treman Studio/Gallery
1981 Russell Creek Road
Walla Walla WA 99362
Fandango ©Judy D. Treman, private collection

Francisco Valverde
2400 McCue Rd., Apt. 17
Houston TX 77056
Deep Texas ©Francisco Valverde, collection of
Mr. and Mrs. John F. Carter II, Houston, TX

Claire Schroeven Verbiest
3126 Brightwood Court
San Jose CA 95148
Three Giant Russians ©Claire Schroeven
Verbiest, collection of the artist; available for
purchase

Judi Wagner
WINTER: 1563 Canterbury Lane
Fernandina Beach FL 32034
SUMMER: HC65 Box 834
E. Boothbay ME 04544
Monhegan Lighthouse ©Judi Wagner, collec-
tion of Mr. and Mrs. Andrew La Vigne, 504
Running Horse Rd., Seffner, FL 33584

Harold Walkup
5605 SW Rockwood Court
Beaverton OR 97007
The Apprentice ©Harold Walkup, collection
of Steven C. Pumphrey

Ben Watson III
3506 Brook Glen
Garland TX 75044
Beyond Our Dreams ©Ben Watson III, col-
lection of Ruth Rossman

Frank Webb
108 Washington Street
Pittsburgh PA 15218
Glennville ©Frank Webb

Michael J. Weber
12780 59th St. North
Royal Palm Beach FL 33411
Still Life in Red, White and Blue ©Michael J.
Weber, collection of Barbara Biondo

Marion Welch
c/o Gallery 71
974 Lexington Ave.
New York NY 10021
Geraniums ©Marion Welch, collection of
Henry Waxman

Arne Westerman
Westerman Studio
711 SW Alder #313
Portland OR 97205
Harmonica Player, Grand Central ©Arne
Westerman

William C. Wright
Box 21, Stevenson MD 21153
Coffee With Cutting Garden ©William C.
Wright; Munson Gallery, Chatham,
Massachusetts; M.A. Doran Gallery, Tulsa, OK

Lynne Yancha
RD #1, Box 223AA
Mt. Pleasant Mills, PA 17853
Amber in the Hay ©Lynne Yancha

Donna Zagotta
7147 Winding Trail
Brighton MI 48116
Breezin ©Donna Zagotta, collection of Mr.
Michael Hoppe

Peggy Flora Zalucha
109 Sunset Lane
Mt. Horeb WI 53572
Ready to Roll ©Peggy Flora Zalucha
Copper Pots With Artist Reflected (2) ©Peggy
Flora Zalucha

Lian Quan Zhen
5741 West Rose Drive
Chandler AZ 85226
#2 Morning Fly ©Lian Quan Zhen

Finalists

John Atwater
David M. Band
Judi Betts
Jennifer D. Boget
Joan Burr
Ranulph Bye
Pat Cairns
Elaine Clarfield-Gitalis
Elizabeth Concannon
Grace Cowling
Ratindra Das
Mary Deloyht-Arendt
H. C. Dodd
Jerry M. Ellis
Carolyn Fairall-Piepgrass
Dorothy Ganek
Walter Garver
Betty Grace Gibson
Nessa Grainger
Dorothy D. Greene
Jane R. Hofstetter
Karen Honaker
Sally Jorgensen
Kwan Y. Jung
Frederick Kubitz
Judy Lavoie
Susan Morris McGee
Frances Miller
Wanda Montgomery
Carl Purcell
David Rankin
Herb Rather
Joan Ashley Rothermel
Roland Roycraft
Janice Schafir
Wendy Scheirer
Susanna Spann
Peter Stimeling
Zoltan Szabo
Tony Van Hasselt
Ted Vaught
William M. Vrscak
Wayne Waldron
Elizabeth A. Yarosz

Index